ROCK ART SAVVY

The Responsible Visitor's Guide
to Public Sites of the Southwest

RONALD D. SANDERS

2005
Mountain Press Publishing Company
Missoula, Montana

Cover photo © Bill Moeller
Arch formation, Valley of Fire State Park, Nevada

Library of Congress Cataloging-in-Publication Data

Sanders, Ronald D., 1944-2004.
 Rock art savvy : the responsible visitors guide to public sites of the Southwest / Ronald D. Sanders.
 p. cm.
 Includes bibliographical references and index.
 ISBN 0-87842-510-1 (pbk. : alk. paper)
 1. Indians of North America—Southwest, New—Antiquities—Guidebooks. 2. Rock paintings—Southwest, New—Guidebooks. 3. Southwest, New—Antiquities—Guidebooks. I. Title.
 E78.S7S255 2005
 759.01′130978—dc22
 2005025135

PRINTED IN THE UNITED STATES

Mountain Press Publishing Company
P.O. Box 2399 • Missoula, Montana
406-728-1900

Rock Art Savvy *was published posthumously.*
Ronald Sanders's wife, Fran Kerivan,
dedicates the book to his memory.

CONTENTS

ACKNOWLEDGMENTS

During my years of research for this book, the staff people at the state Bureaus of Land Management have been invaluable. Two of the most helpful were archaeologists Garth Portillo of the Utah BLM office and Russ Kaldenburg of the California BLM. Not only did they give me a short list of appropriate sites and directions to them, they put me in contact with other BLM archaeologists in various areas.

Many other management offices in California, Utah, and Colorado were quite cooperative, and they actively promote visitation to sites in their areas. Most notable were the southeastern California BLM offices; the BLM office in Moab, Utah; the Forest Service office in charge of the Comanche National Grasslands in Colorado; the Forest Service offices in Arizona; National Park Service officials at Hovenweep National Monument in Colorado; the BLM office in charge of Canyon Pintado in Colorado; and Chris Judson of Bandelier National Monument in New Mexico.

PREFACE

I wrote *Rock Art Savvy* partially out of frustration. Many books on rock art offer reams of theory and jargon but little practical information on visiting the sites, giving only vague references to site locations. I wanted to visit the sites in person, take my own photographs, and form my own opinions. On the assumption that there are other people with similar desires, I decided to write this book. In doing so, I have tried to use plain language and include only relevant information. Furthermore, I give explicit directions to most of the sites.

This brings me to another reason I compiled this guide: to encourage people to visit rock art sites. Like many rock art preservation advocates, I believe that most vandalism is done out of ignorance, so the best way to protect these fragile treasures is to increase public awareness. When people see rock art for themselves, they quickly understand its beauty and value. They can feel the power of these remarkable places where cultures from hundreds and even thousands of years ago have left their mark on the landscape.

Writing this book involved many years of research, thousands of miles of travel, and taking hundreds of photographs—all of which I've thoroughly enjoyed. Probably the most difficult part of writing this book was not the research, but trying to interpret the data gathered from many divergent sources, much of which is somewhat contradictory. Different authorities have different theories on interpreting rock art and use different frameworks for estimating time periods. This is not to mention the ongoing debates about proper terminology. Since this book is meant for the general public, not for scholars or archaeologists, I have not adopted any particular philosophy or theory in writing it.

Rock art is my hobby and my passion. I have personally visited and photographed hundreds of sites in nine western states and Baja California. In the process I have "discovered" several previously unrecorded sites. Although I have studied the subject for many years, I do not have a college degree in archaeology. The purpose of this book is not to teach archaeology or to break new ground in the field, but simply to increase public awareness, interest, and appreciation of rock art and of the past and present cultures it represents. I hope you enjoy it.

ALL ABOUT ROCK ART

I have divided this book into two parts. Part I attempts to answer most of the general questions people have about rock art in layman's terms, without all the scientific jargon found in many other books on the subject. In the first chapter, I offer basic definitions of forms and styles of rock art and cover the things you need to know when visiting sites. Chapter 2 discusses the Indians who made the rock art, including when and where they lived, their cultures, and their design styles. In chapter 3, I present some of the theories people have put forth about the meaning of rock art in general and certain images in particular. Finally, chapter 4 explains the various threats to rock art sites and some of the ways we can protect them. Many rock art enthusiasts would consider this the most important chapter of all.

Part II provides specific information on numerous rock art sites in Arizona, Colorado, Nevada, New Mexico, Utah, and parts of California and Texas. I have also included a bonus chapter about Baja California, Mexico. In the back of the book is a list of organizations that can provide information about rock art and a glossary that explains unfamiliar terms.

1

ROCK ART BASICS

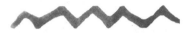

What is rock art? Rock art is defined as deliberate marks or graphic representations made on rock surfaces. Generally when we speak of rock art, we are referring to images made by indigenous Americans, though rock art can be found on every continent of the world except Antarctica. The term "rock art" itself may be something of a misnomer, insofar as it implies that the image makers were engaged in an artistic endeavor and that they meant the images to be seen as "art" in the usual, European sense. No one knows what purpose rock art served or what its creators' intentions were. There are many theories about this, and we'll take a look at some of those theories later. But before we tackle the question of meaning, it makes sense to define the different kinds of rock art and examine how it was made.

FORMS OF ROCK ART

There are three basic forms of rock art: petroglyphs, pictographs, and geoglyphs. These three terms distinguish the forms of rock art based on how it was made.

Petroglyphs

Petroglyphs, the most common form of rock art, are images made by cutting into the surface of rock. The most frequent methods of producing images were pecking (striking with a hammerstone) and engraving (scratching or carving with a sharp tool). These techniques were sometimes used together.

Most petroglyphs are lighter images against a darker background, as the rocks commonly chosen were dark from patination. Patination is the gradual covering of rock with a natural dark varnish, called *patina* or *desert varnish*, through chemical and bacterial action. This type of exposed, patinated rock surface is widespread throughout the Southwest desert.

3

A typical petroglyph panel pecked into the dark surface patina of a rock in northern Arizona

Pictographs

The second most common form of rock art, pictographs, are images drawn or painted onto rock surfaces. (See color plates.) The most frequently used pigment was red, but black and white were also common. Yellow or orange ocher were not unusual in some areas; blue and green are rare. When more than one color was used on a figure, it is called a *polychrome* image.

The paint used for pictographs was a mixture of pigment and a binding substance. The pigment was made by grinding minerals into a powder using a small mortar and pestle. Red was usually made from an iron oxide; black, from charred wood or a black mineral; white was often from gypsum, talc, or other chalky minerals, sometimes from white clay or ash; and yellow tones were frequently made from limonite or ocher. The ground pigment was mixed with an organic substance—such as blood, sap, seed oil, animal fat, or egg—to bind it. The resulting paint was quite durable. Many rock paintings have withstood hundreds of years of weathering.

Pictographs are found primarily in caves and rock overhangs, where the pigment is better protected from the elements. Thus pictographs

are more common in the mountains of New Mexico, on the Colorado Plateau, and near the Pacific coast. In some places, such as Baja California, Mexico, pictographs are referred to as *cave paintings.*

Sometimes petroglyphs were painted over with pigment, and thus are a composite of the two types.

Geoglyphs

Geoglyphs, the least common form of rock art, are very large images, often in the shape of animals or humans, made on the earth's surface. Geoglyphs can be made in several ways. The most common method was to scrape away the surface rocks and rubble along the outline of the image, exposing the earth or sand underneath. This type of geoglyph is called an *intaglio.* Another method was to place rocks along the outline of a figure. Some geoglyphs measure over a hundred feet in length. In the Southwest, most geoglyphs are found along the lower Colorado River from southwestern Arizona to Southern California. Because they are so large, geoglyphs can best be seen from the air.

An anthropomorphic geoglyph, or intaglio, near Blythe, California, as seen from the ground

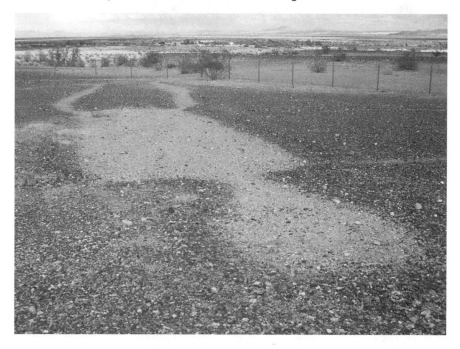

DESIGN STYLES

Rock art styles are divided into two broad categories that describe the type of design: abstract and representational. Styles are further broken down according to subject matter. The detailed categorization of specific cultural styles is a more complex subject, which we will look at in the next chapter.

Abstract Styles

Abstract styles usually consist of geometric figures and patterns, and do not represent anything recognizable in the natural world. *Curvilinear* patterns employ curves, circles, and wavy lines. *Rectilinear* patterns are made with straight lines and are often represented by grid patterns, ladders, and rakes.

The *pit-and-groove* style, a very ancient type of abstract petroglyph, usually consists of a random-patterned collection of cavities, or pits, generally about ½ to 2 inches in diameter, deeply pecked, ground, or carved into a large rock or boulder, sometimes as deeply as ½ inch. Near and/or between the pits are long furrows, or grooves, usually about ½ inch wide.

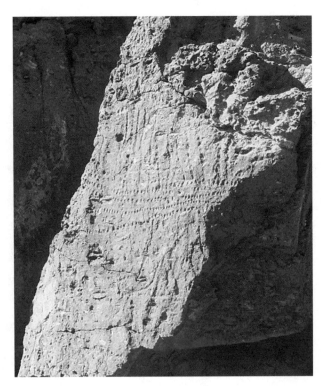

A typical pit-and-groove panel from the northern Great Basin

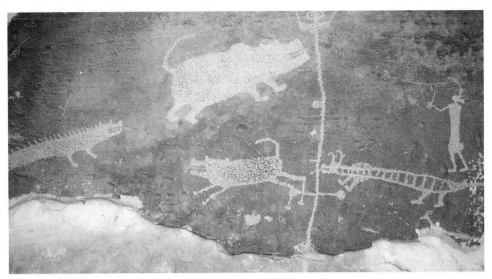

A human figure alongside what could be animals or monsters at the Rochester site in Emery County, Utah

Representational Styles

Representational rock art consists primarily of human or animal figures, and occasionally images of plants (especially corn) and other elements of the natural world, such as constellations. Representational rock art is almost always stylized to some degree, rarely naturalistic.

Animal-like figures, or *zoomorphs,* include large and small mammals, fish, reptiles, and birds. The most common animal depicted is the bighorn sheep. Often parts of animal shapes are greatly exaggerated or elaborate. There are even drawings of what appear to be monsters or sea serpents in a few places in the West.

Humanlike figures, or *anthropomorphs,* can be male, female, or genderless. Any creature with two legs may be considered anthropomorphic, including demons and spirits. Many anthropomorphs have elaborate headdresses, and some experts believe these figures may represent shamans, chiefs, or spirit creatures. Occasionally half-human–half-animal figures appear, such as man-goat figures or duck-headed people.

Shapes representing stars, the sun, and the moon are also found in rock art. Occasionally ancient humans recorded celestial occurrences, such as an eclipse or the passing of a comet. When agriculture came to be practiced, rock art was often used as a calendar to show planting and harvesting times, using the sun's shadow falling across markings in the rock faces to indicate the days and seasons.

DETERMINING AGE

Some rock art in Europe dates back more than 20,000 years, but the oldest examples in America are only around 10,000 years old. Most is believed to be less than 4,000 years old, and some was made in Historic times. Scientifically dating rock art is a complicated and expensive process. Because neither government nor private sources provide much money for American archaeology in general and particularly for the study of rock art, little research has been done in this field. Nevertheless, there are strategies that even the amateur can use to estimate the age of a petroglyph or pictograph.

Archaeologists are aided in their determinations by methods such as radiocarbon dating of pigment and analyzing the chemical composition of the patina. For the amateur, there are less technical (though less reliable) dating methods. With close observation and some deductive reasoning, the rock art enthusiast can often determine the approximate age or relative age of a rock art image. Clues might be found in the images themselves or in the surrounding environment. The relative age of a rock art site can sometimes be determined by comparing it with other sites, especially those nearby, that are better documented.

In estimating of the age of petroglyphs, one can look at the degree of patination for hints. For pictographs, the amount of weathering can suggest an approximate age. With any type of rock art, style and content of the image can also be indications of its age.

Patination

The general age of a petroglyph or the relative age between different petroglyphs can often be estimated according to the degree of patination, or natural darkening, of the image. In a dry, warm climate, it may take several thousand years for a glyph to be completely overpatinated. Therefore, glyphs in desert areas that show the same degree of patina as the background stone may be as old as 10,000 years, and glyphs showing a lot of contrast in patination are relatively new, possibly a few hundred years old or less. Likewise, when glyphs on different panels show a difference in degree of patination—if both panels receive about the same amount of sunlight and moisture—then it is fairly safe to assume that the darker ones are older.

Weathering

Pictographs deteriorate much faster than petroglyphs from sun, rain, wind, and other weathering. Though studies show that the paint used in pictographs was far more durable than modern paint, acid rain in some areas is believed to accelerate pictograph deterioration. Probably very few pictographs are more than 1,000 years old, unless they were done on protected surfaces, such as cave walls.

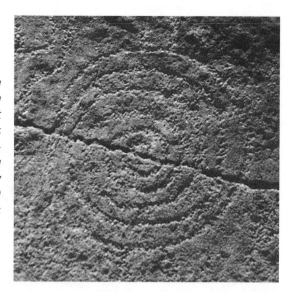

This spiral glyph from Petroglyph National Monument in New Mexico is completely overpatinated, indicating great age, possibly more than 4,000 years

As with patination, comparing the degree of weathering of different pictographs in the same area can be a way to determine their relative age. A bright, vivid image on an exposed cliff face is probably much more recent than a faded one in a similar spot.

Design Style

In some cases, the design style of a glyph can be a clue about its age. Patina-dating studies have shown that in the Coso Range of southeastern California, for instance, curvilinear glyphs were the oldest, about 6,400 years old, and rectilinear glyphs were around 4,300 years old. Therefore, if a site in that region is composed entirely of curvilinear glyphs, it may have been made 6,000 or 7,000 years ago. During the Historic period, rock art was often more naturalistic in style, realistically depicting horses, men, and things.

Another clue to look for is how deeply petroglyphs are engraved into the rock. Typically, the deeper they are, the older they are. As time went by, it seems that people became less energetic when making glyphs. Very recent glyphs are often barely deep enough to break through the thin layer of desert varnish on the surface of the rock. On the other hand, pit-and-groove sites and many old rectilinear and curvilinear images are deeply incised.

Content

The items depicted on a rock art panel can often indicate the period in which it was made. For example, if a panel shows a bow and arrow, an item introduced into the Southwest around A.D. 500, it is undoubtedly

9

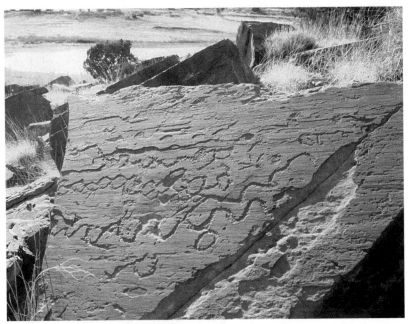

Deeply cut glyphs, like these at Lyman Lake in Arizona, are usually very old.

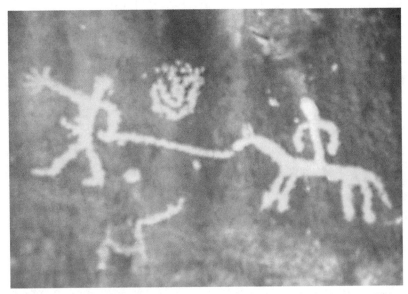

An example of one of the many petroglyphs in Nine Mile Canyon. This one was made in Historic times, apparent by the person riding a horse. It is also apparent that the person leading the horse is a man.

less than 1,500 years old. The *atlatl*, or spear thrower, predates the bow and arrow. An atlatl image might indicate an age of at least 1,500 years, unless it appears in an area such as the Great Basin, where hunter-gatherer cultures continued to use the atlatl into Historic times.

Corn motifs suggest that a panel is less than 2,000 years old, since humans in the Southwest first started cultivating corn around A.D. 1. Images of ships, men on horseback, men shooting rifles, and men wearing brimmed hats all indicate the Historic period, within the last 500 years.

VISITING SITES

Treading Lightly

One of the most important things to understand about visiting rock art sites is that the sites are fragile. Be aware of the impact of your visit and take steps to minimize it. Inform yourself about rock art in general and about the site you are visiting. At public sites, read and follow all postings and obey the instructions of site officials. And always, at every site, observe the rules of visitor etiquette and encourage others to do the same. (See list.)

VISITORS ETIQUETTE

1. Do not climb on rocks. If you need to get a better look, use binoculars or a telephoto lens.
2. Never remove anything (except litter) from a site. Artifacts that may be lying on the ground in the vicinity of a rock art site, such as pottery shards or projectile points, could provide valuable archaeological information. Removing artifacts is also illegal.
3. Do not disclose site locations to people you do not know to be honest, law-abiding citizens.
4. Do not litter. Litter can contaminate the soil at a site and alter scientific soil tests. Leave the site in better condition than you found it. If you see any litter, be a good citizen and pack it out.
5. Do not make tracings or rubbings. Such practices damage rock art.
6. Do not build fires or smoke near sites. Smoke contains carbon which can adhere to the rock art and impair archaeological dating.
7. Do not touch rock art. Even oils from your skin can contaminate the surface of rock art and contribute to its deterioration.
8. Do not bring dogs to rock art sites. Dogs can damage or contaminate rock art sites by digging, defecating, and urinating on them.
9. Stay on established trails when provided. Do not step on or otherwise disturb plants in the area. The surrounding environment is an important part of the site—help protect site ecosystems.

10. Supervise children carefully. Children have a tendency to climb on rocks and create dust by running around. When taking children to rock art sites, see that they do not touch anything and that they treat these sacred sites with due respect.

11. Report vandals. If you see anyone damaging a site, make notes of the incident. Write down their description, their vehicle description, and license plate number if possible; then phone the authorities. I have included phone numbers at the beginning of each state's site listing in Part 2. See also the Resources list in the back of this book.

Photographing Rock Art

Taking pictures of rock art can be a significant challenge. Many pictographs are quite faded, and petroglyphs sometimes have little contrast and heavy patination, even obstructions, over the images. Moreover, most rock art is not in full sunshine all day, and you cannot reposition a panel to take advantage of the best lighting conditions. There are a few tricks, however, that may help minimize these problems.

Most photographs of rock art are taken by nonprofessionals using fully automatic (point-and-shoot) or semiautomatic (SLR) 35 mm cameras. Using a medium format camera instead can reduce graininess. For film, I have successfully used 400 ISO film on many occasions, but if you have enough light, 100 or 200 ISO produces finer-textured images. If you are using a telephoto lens, choose medium-speed (400 ISO) film.

At the site, the first thing to consider is the amount of sunlight. You want to shoot during whatever time of day the light is best at that particular location, usually early morning or late afternoon. Shooting on an overcast day often produces good results because there is less glare. If the site is half in shade and half in bright sunlight, taking a good photo is difficult. Using a Mylar foil blanket as a reflector can be very helpful.

Many rock art sites are in caves or under deep overhangs with very low light. If you have a fully automatic camera, simply using the flash may work, but you'll have to be careful of the glare. If you are using an SLR camera, you can adjust the f-stop to a low setting, such as f/2, and/or slow the shutter speed. In either case, use a tripod to keep the image from blurring. A remote shutter release helps even more. In addition, faster film (400 ISO or higher) can be used. Bring a light meter to determine the right adjustments.

To take photographs up close, use a macro lens or a macro adapter. For sites that are far away, you'll need a telephoto or zoom lens. Special filters are also often necessary, depending on the light. A polarizing filter is practically a necessity for reducing glare. There are also special

color-enhancing filters which can be used to improve the color and contrast of red pictographs. In addition, I recommend that a "haze" or UV filter be kept on all lenses, not so much for UV protection as for protection against banging your expensive camera lenses against a rock.

Friendly Reminders

Before you venture into unknown territory, make some commonsense preparations. Be sure that your vehicle is up to the trip, especially the cooling system. Have your car checked out and the fluids filled. Research where you are going and acquire good maps for the areas you plan to visit. Many back roads are not well marked, and some have no signs or markings at all. Note that some sites listed in this book require a high-clearance vehicle to reach.

Many sites are in somewhat isolated desert areas, so be sure you have plenty of water and emergency supplies such as a first aid kit, food, and blankets in your vehicle. Toilet paper is also a good idea. For exploring on foot, in addition to your camera equipment and binoculars, be sure to bring sun protection including sunblock, sunglasses, and a hat. When hiking to remote locations, wear appropriate clothing

Vermillion Falls is an unexpected sight in the middle of the northwestern Colorado desert.

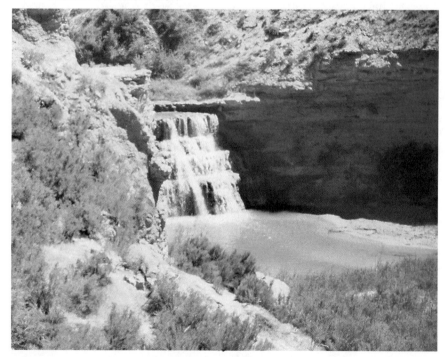

and bring a detailed map, a compass, emergency supplies including matches, and, of course, water.

While you're out there, don't neglect to enjoy the scenery. Southwestern landscapes are often breathtaking. Mountain ranges of blues and purples, buttes and cliffs of brilliant reds and oranges, and golden deserts covered with a rainbow of wildflowers in the spring. Sandstone formations carved into mysterious shapes by the wind and rain are common sights. Streams, lakes, and even waterfalls can be found in the most arid places. Perhaps most beautiful of all are the spectacular desert sunrises and sunsets, which are unmatched anywhere else on earth.

Exploring Southwest Rock Art on Your Own

You may want to visit some of the thousands of rock art sites throughout the Southwest that are not listed in this book. Many of them are open to the public, but few are improved or easily accessible. In many cases, a four-wheel-drive vehicle and/or a several-mile hike is required to reach them. In addition, you will have to do some independent research and purchase detailed topographic maps to find the locations.

Sometimes, if you know where to look, you can discover rock art by chance. In general, rock art can be found almost anywhere people have lived near rocks. Indians usually set up camps in relatively flat areas near water. Hot springs were a special attraction. Natural shelters, especially caves and rock overhangs, would also be likely spots. Proximity to food sources is another thing to look for. Mountain passes were often migration paths for game animals, and forests of piñion and berry bushes would have provided nuts and fruits. Lakes were good places to hunt waterfowl and catch fish.

Old fire pits within a small area indicate a campsite. Some places show a series of shallow indentations where people had built pit houses. The presence of "lithic scatter" material left over from weapon or tool production is another sign of human occupation, as are rubble, pottery shards, and middens.

Another thing to keep in mind while searching for rock art is that the rock had to be suitable for drawing. Most rock art in the West is found on flat rock faces at least two feet square. Typical spots are on the lower portions of cliff faces where there is a flat ledge at the top of the talus slope, or below cliffs on large boulders at the base of the talus slope. On rock faces that are smooth and heavily patinated, petroglyphs are common; on rough rock, pictographs are more likely.

One last clue to finding rock art: Wherever you find one panel, there are often others nearby. I have visited several sites numerous times, and I continually find more glyphs that I had previously overlooked, sometimes hidden in unusual places.

Happy hunting!

NATIVE SOUTHWESTERN CULTURES AND THEIR ROCK ART

Since Paleolithic Indians first arrived in the Southwest more than 10,000 years ago, humans have been making marks upon stone. As Archaic hunter-gatherers wandered over the southwestern plains and deserts looking for sustenance, they left their marks along the way. Later, Prehistoric people and their Historic descendants also left their legacy etched or painted on rocks, cliffs, and caves.

The earliest people to occupy the Southwest were Paleolithic Indians, or Paleo-Indians, big-game (megafauna) hunters who traveled in small bands following herds of woolly mammoth, giant sloths, and other ice age mammals. After the end of the ice age, the megafauna disappeared and people adapted to hunting smaller game and gathering wild nuts, seeds, roots, and berries for subsistence. This is known as the Archaic, or hunter-gatherer, cultural period, sometimes referred to as the Desert Culture.

Some of these Archaic groups evolved through several stages of development during what is called the Transitional period. They began to live in villages, develop technologies, and grow crops, eventually becoming in Prehistoric time what we now refer to as Puebloans and other Prehistoric farming cultures. Other groups remained nomadic hunter-gathers, and a few, such as the Patayan of the lower Colorado River, were semiagricultural. By Historic time, after about 1500, the various Indian groups of the Southwest had begun to develop into some of the tribal cultures we know today.

There is a great deal of variation among scholars in their terminology and estimated timelines for the development of these cultures over the past 14,000 years. The dates between Paleolithic and Archaic periods can vary by thousands of years, and the division between the other periods may vary by several hundred years. Nevertheless, it is helpful to draw some rough lines between these cultural periods to help organize

Chronological chart of Southwestern cultural traditions by region

REGION	Time Period			
	Paleo-Indians (12,000 to 6000 BC) → Western Archaic Hunter-Gatherers (Desert Culture)	Prehistoric	Protohistoric (1400–1500)	Historic (1500–2000)
Southern California Desert	Paleo-Indians / Western Archaic Hunter-Gatherers (Desert Culture)	Prehistoric Takic (N)	Prehistoric Takic (N)	Serrano, Cahuilla, Kumeyaay, Chemehuevi
Lower Colorado River (western Arizona, SE California, southern tip of Nevada)	Paleo-Indians / Western Archaic Hunter-Gatherers	Patayan (Ancestral Yuman) (A)	Patayan (Ancestral Yuman) (A)	Mojave, Yuma (Quechan), Cocopa, Yavapai, Havasupai, Halchidoma, Maricopa
Western Great Basin (most of Nevada, part of SE California); Virgin River Basin	Paleo-Indians / Western Archaic Hunter-Gatherers	Prehistoric Numic (N) / Virgin River Puebloan (A)	Protohistoric Numic (N)	Southern Paiute, Western Shoshone
Primary Utah area (most of Utah, NW Colorado, SE Nevada)	Paleo-Indians / Western Archaic Hunter-Gatherers	Fremont (A)	Protohistoric Numic (N)	Ute
Southern Colorado Plateau (SW Colorado, southern Utah, NW New Mexico, northern Arizona); Santa Fe area	Paleo-Indians / Western Archaic Hunter-Gatherers	Basketmakers (A); Ancestral Puebloan (Anasazi) (A)	Protohistoric Puebloan (A) and ranging Numic (N) and Athabascan (N)	Hopi, Tewa, Navajo, Ute
Central Arizona	Paleo-Indians / Western Archaic Hunter-Gatherers	Basketmakers (A), Hohokam (A); Hohokam (A); Ancestral Puebloan (A), Salado (A), Hohokam (A), Sinagua (A)	Protohistoric Puebloan (A) and ranging Numic (A) and Athabascan (N)	W. Apache, Hopi
South-central Arizona	Paleo-Indians / Western Archaic Hunter-Gatherers	Ancestral Mogollon (A); Hohokam (A)	Protohistoric Athabascan (N)	W. Apache, Tonto Apache, Pima, Maricopa, Tonto O'odham
SE Arizona and SW New Mexico	Paleo-Indians / Western Archaic Hunter-Gatherers	Ancestral Mogollon (A); Mountain Mogollon (A)	Protohistoric Athabascan (N)	Zuni, Acoma, Hopi, Laguna, Western Apache, Chiricahua Apache
SE New Mexico and Western Texas	Paleo-Indians / Western Archaic Hunter-Gatherers	Jornada (Desert) Mogollon (A)	Protohistoric Athabascan (N)	Mescalero Apache, Comanche, Kiowa

Time scale (BC/AD): 12,000 to 6000 BC, 5000 BC, 4000 BC, 3000 BC, 2000 BC, 1000 BC, 500 BC, 400 BC, 300 BC, 200 BC, 100 BC, 0, AD 100, 200, 300, 400, 500, 600, 700, 800, 900, 1000, 1100, 1200, 1300, 1400, 1500, 1600, 1700, 1800, 1900, 2000

A = Agricultural / N = Nonagricultural

ROCK ART STYLES

In studying rock art, it is impossible to know for sure which culture made which particular petroglyph or pictograph panel. But numerous public sites have been examined and interpreted by archaeologists who have estimated the age and probable cultural origin of the main panels. From their work and that of other rock art scholars, we can make some educated generalizations about much southwestern rock art and the cultures who created it.

Still, the study of rock art styles is far from an exact science. Different cultures employed different styles of rock art, and like the cultures themselves, the styles changed through time. In addition, several cultures may have used the same panel over hundreds or even thousands of years. The introduction of a newer style of rock art did not eliminate the use of previous designs—styles were frequently integrated, even within the same image.

Cultural styles are organized and named according to perceived differences in images that suggest different groupings based on subject matter, location, and/ or technique. A style is presumed to have been characteristic of a particular culture at a particular time, but a style can include a wide variety of elements and may overlap with other styles. The date ranges of the different styles are very rough and are subject to ongoing research and study.

our discussion. I adopted a mostly middle-of-the-road approach in developing the timelines and terminology I present here.

Southwestern cultures and their rock art fall roughly within the following time periods:

Paleolithic	12,000 to 5000 B.C.
Archaic	5000 to 500 B.C.
Transitional	500 B.C. to A.D. 500
Prehistoric	A.D. 500 to 1500
Historic	A.D. 1500 to present

PALEOLITHIC CULTURES
(12,000 to 5000 B.C.)

Paleo-Indians occupied areas of the western United States at least 12,000 years ago, and probably arrived in the Southwest before the end of the last ice age, between 10,000 and 12,000 years ago. While it has not been conclusively proven, it was probably Paleo-Indians who made some of the oldest rock art in the West, more than 8,000 years ago.

PALEO-INDIAN ROCK ART

Some experts believe that Paleo-Indians probably produced rock art, but there is no scientific evidence to prove it. Any rock art that may have been created thousands of years ago would probably have been lost from overpatination, the growth of lichen and other vegetation, and erosion. However, pit-and-groove petroglyphs in the Great Basin, which some consider to be among the oldest and most primitive styles of rock art, possibly date back to 8000 B.C.

Paleo-Indians lived in small family groups and took shelter in caves and under rock overhangs. They hunted ice age megafauna such as giant sloths, giant bison, and woolly mammoths with simple spears tipped with stone. These spears were either thrown or jabbed into an animal at close range. Another hunting method was to chase the animal off a cliff.

It is possible that later Paleo-Indians hunted with the aid of an atlatl, a predecessor of the archery bow. The atlatl was a throwing stick with leather finger loops attached near one end; it could hurl light spears a considerable distance. Archaeological remains found at Lovelock Cave in Nevada shows that the atlatl is at least 3,000 years old and probably much older.

Paleo-Indians were nomadic by necessity, following the game herds during seasonal migrations and moving whenever game in the area became scarce or too wary of hunters. They had to find shelter and water wherever they could along the way. Thus they never established any permanent camps, and their artifacts are widely scattered. Many Paleo-Indians migrated down the Pacific coast near the end of the last ice age, and they may eventually have traveled as far south as the tip of Baja California. Megafauna kill sites have been found as far south as western Texas.

After the ice age glaciers melted, the megafauna gradually disappeared, probably because of climate changes and possibly from overhunting as the human population grew. It is generally accepted that all the megafauna were gone by about 6000 B.C. After that, humans had to adjust to a new way of life and find new sources of food.

ARCHAIC CULTURES
(5000 to 500 B.C., in some areas to Historic times)

Early Archaic people of around 8,000 years ago developed a hunter-gatherer way of life to expand their food sources. Remaining nomadic,

ARCHAIC ROCK ART

Found throughout the Southwest, Archaic styles are those created by hunter-gatherer cultures after around 6000 B.C. In some areas, this style continued into Historic times, while in other places, later rock art styles evolved. There is some overlap, especially between late Archaic and early Transitional styles. Some cultures incorporated Archaic images into newer styles.

Many petroglyphs have been discovered that are believed to be 2,000 to 7,000 years old. These ancient glyphs are often heavily patinated. Pictographs cannot survive this long except in caves.

Early Archaic styles are predominantly abstract, consisting of geometric designs such as circles, zigzags, straight and curved lines, mazes, and cross-hatches, in various combinations. Later Archaic styles often incorporated simple anthropomorphic and zoomorphic stick figures. Because the cultures who made Archaic rock art are ambiguous, styles are categorized by region rather than by culture.

ROCHESTER CREEK STYLE (3000 TO 0 B.C.)

The Rochester Creek style is found in only a few sites in the Rochester Creek area of central Utah. This petroglyph style is characterized by animal and human bodies with distinctive forms that seem to depict fluid movement. Unlike most Archaic styles, it is a realistic style, often showing hairstyles, and human sexual activity is a common theme.

Visit Site UT-21, Rochester Panel.

LOWER PECOS RIVER STYLE (2000 TO 1000 B.C.)

The Lower Pecos River style of pictograph is unique to western Texas. The more than 250 known sites of the Lower Pecos River style are all in a 100-square-mile area of the lower Pecos and Devil Rivers near their confluence with the Rio Grande.

The Lower Pecos River stylized polychrome pictographs are considered to be some the best in the world. Colors include dark and light red, yellow, orange, black, and white. Many of the animal and human figures are thought to be shamanistic. The primary anthropomorphic figures are often faceless, costumed shaman figures holding atlatls, spears, or fending sticks, or carrying fringed or fur pouches at their sides. Sometimes several figures appear in a row, depicting someone going through an intricate transformation sequence. The figures often have their arms extended, and in later pictographs the arms are stylized to look like wings. Often the shaman is represented in association with snake or water symbols.

The most common animal figure is a fork-antlered quadruped, perhaps a deer. Also seen are birds, fish, reptiles, rabbits, and insects. The panther figure found at many sites seems to have as much importance as the shaman figures.

Visit Site TX-1, Amistad National Recreation Area; Site TX-3, Devils River; Site TX-5, Lewis Canyon; Site TX-8, Seminole Canyon State Historical Park.

BARRIER CANYON STYLE (2000 B.C. TO A.D. 500)

Barrier Canyon style is a pre-Fremont style made by hunter-gatherers in eastern Utah. Images are mostly pictographs, often black or reddish brown, of anthropomorphs with broad shoulders and tapering bodies but without arms or legs (called "carrot men"). Frequently, several figures without facial features or limbs are crowded together. In other panels, figures appear to be holding snakes. Abstract images are rare.

Visit Site UT-1, Arches National Park; Site UT-2 Black Dragon Canyon; Site UT-4 Buckhorn Wash; Site UT-13 Head of Sinbad; Site UT-23 Sego Canyon; Site UT-25 Temple Mountain Wash.

GLEN CANYON LINEAR STYLE (1000 B.C. TO A.D. 500)

Glen Canyon Linear is a late Archaic and early Basketmaker style of petroglyph found in the Glen Canyon region of southeastern Utah and northeastern Arizona, and in adjacent areas. The representational images are often stylized and filled in with stripes or crosshatched designs. Anthropomorphic and zoomorphic figures with exaggerated bodies are characteristic. Appendages, including heads, are usually small, and the human figures often have no arms. Some petroglyphs of the Glen Canyon style seem to interact with solar light beams during the winter solstice.

Visit Site UT-24, Shay Canyon.

UNCOMPAHGRE ARCHAIC STYLE (1000 B.C. TO A.D. 1000)

The Uncompahgre Archaic style, seen on the Uncompahgre Plateau of west-central Colorado, is a typical Archaic abstract style. Petroglyphs are pecked, and the images are abstract wavy and zigzag lines combined with stylized zoomorphs and, less commonly, anthropomorphs.

Visit Uncompahgre National Forest and Uncompahgre Plateau BLM lands in Colorado (not listed).

GREAT BASIN ABSTRACT STYLE (1000 B.C. TO A.D. 1500)

Great Basin Abstract rock art has been found throughout the Great Basin desert in Arizona, California, Utah, and especially Nevada. This abstract style consists primarily of curvilinear and rectilinear patterns. Some of the oldest Great Basin glyphs are deeply pecked in elaborate gridlike patterns, often incorporating curvilinear elements such as wheels. Many of these glyphs are almost totally repatinated.

Newer Great Basin glyphs often employ less elaborate designs of rakes, circles, wavy lines, and zigzags, sometimes connected by straight or curved lines. These are usually heavily repatinated, but they still show a difference in color from the base rock. In a few cases, rock art with some degree of repatination also contains zoomorphic images such as lizards and snakes.

Visit Site NV-6, Valley of Fire State Park.

CHIHUAHUAN POLYCHROME ABSTRACT STYLE
(700 B.C. TO A.D. 300)

Chihuahuan Polychrome Abstract is an Archaic style of pictograph seen mostly in natural rock shelters in the Chihuahuan Desert of southern New Mexico and western Texas, as well as in eastern Utah. A variety of colors were used, including red, yellow, black, and white. Common designs are zigzags, short parallel lines, rakes, circles, dots, and an occasional stick-figure anthropomorph.

Visit Site NM-3, Carlsbad Caverns; Brownstone Canyon, Nevada (not listed).

RED LINEAR STYLE (600 B.C. TO A.D. 600)

After 600 B.C., the same culture who created the Pecos River pictographs may have developed the Red Linear style, or the latter style may have been created by another culture. The Red Linear style is characterized by very small, dark red stick figures engaged in various activities and fertility rites.

Visit Site TX-8, Seminole Canyon State Park.

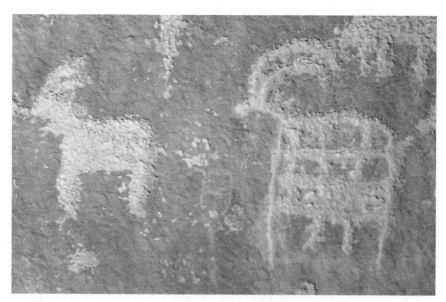

The bighorn sheep glyph is a Glen Canyon style glyph from Shay Canyon, Utah. Note the oversize, rectangular, crosshatched body.

they made seasonal migrations not only to follow game herds but also to gather plant foods such as nuts, fruits, berries, seeds, and roots. They still hunted with spears, but their game now included deer, antelope, rabbits, bighorn sheep, waterfowl, and fish. They also harvested birds' eggs and probably ate snakes, lizards, and frogs. Those in coastal areas dug for clams and hunted sea mammals as well. It is believed that the Archaic Indians traveled in small family groups of about twenty-five people and lived primarily in caves and rock shelters. Pictographs are commonly found on the walls of these shelters.

Later in the Archaic period, people began to make simple shelters from poles, skins, reed mats, and brush. They set up winter camps in protected areas where they would return every year, often in large groups. As time went on, they expanded their technology. Their storage containers evolved from animal-skin bags to basketry, and they developed more advanced tools such as needles, a type of fish hook called a *gorge*, and tools for making buttons and beads from bones, horns, and shells. They ground seeds into flour in shallow rock depressions called *metates*, with grinding stones called *manos*. Some metates in the West have been dated at more than 7,000 years old. When, over the centuries, the warming climate changed the plant life of many areas,

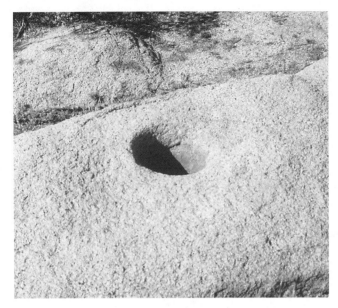

Typical bedrock mortar used for crushing and grinding seeds and other foods. This one is at the Morteros Village site in California.

people had to hammer deep mortars into the bedrock to make a place to grind courser seeds, nuts, and grains into flour.

While sharing similarities in their way of life (or presumed way of life), these Archaic cultures produced many types and styles of rock art. Some of the oldest pictographs known are also among the most sophisticated and beautiful. For example, the 3,000- to 4,000-year-old polychrome pictographs of the lower Pecos River are considered to be among the finest in the world.

TRANSITIONAL CULTURES
(500 B.C. to A.D. 500)

In parts of the Great Basin, the southeastern California desert, Baja California, and elsewhere, the Archaic hunter-gatherer culture continued through Prehistoric time and beyond. The people there never formed complex villages or farmed significant crops, perhaps because of the scarcity of reliable water sources. But in other areas of the Southwest, native cultures developed in a completely different way.

On the Colorado Plateau and into southern Arizona and New Mexico, the geography and climate set the stage for numerous diverse cultures to flourish. Between 500 and 0 B.C., several distinct cultures began to emerge, including the Basketmakers (early Anasazi), the Hohokam, and the Mogollon. These are known as Transitional (or Late Archaic, or pre–Puebloan) cultures. The developments of the Transitional period,

during which certain cultures gradually evolved from hunter-gatherers to farmers living in complex villages, may have taken as long as 1,000 years.

Probably the most important of these developments was the introduction of corn to the Southwest shortly after 500 B.C. Most experts believe corn came from Mexico or Mesoamerica into what is now the United States through trade. At about the same time, other major changes were taking place. The bow and arrow gradually replaced the atlatl and had become the weapon of choice in most cultures by A.D. 100. Cave excavations in Lovelock, Nevada, show evidence of the bow and arrow from about 500 B.C. By that time, many people had also begun to form temporary villages, particularly during the winter months. These camps were always near a reliable source of water and were often partially sheltered by cliffs. They also occasionally joined with neighboring groups in organized hunting and gathering activities.

To supplement their hunting and gathering of food, Transitional cultures began planting a few seeds here and there. By the late Transitional period, they were practicing simple agriculture, cultivating gardens of beans, corn, and possibly squash. They also began to develop sophisticated basketry (hence the term Basketmaker).

This petroglyph of a plant, probably a cornstalk, from the Four Corners region suggests that the people in the area practiced agriculture.

23

Basketmakers, Hohokam, and Mogollon

The three major Transitional cultures, the Basketmakers, the Hohokam, and the Mogollon, all adopted a semiagricultural way of life at around the same time, but their cultural development differed. On the Colorado Plateau, the Basketmakers may have become the Prehistoric farming culture we now call the Ancestral Puebloans (Anasazi), though some think the latter were descendants of Aztecs who had migrated from Mexico. The Fremont of Utah were another farming culture that may have evolved from the Basketmakers, but no one really knows. Most books I've read refer to the Basketmaker culture as an early stage of "Anasazi" culture and maintain that the Fremont culture developed independently of the Ancestral Puebloans, though many allow that the Fremont could have been a subgroup of the Basketmakers. In any case, during the Prehistoric period, the Basketmaker culture was either replaced by or evolved into various farming cultures.

The Hohokam of south-central Arizona were a Transitional culture roughly parallel to the Basketmakers, as were the Mogollon, who occupied southeastern Arizona, southwestern New Mexico, and parts of northern Mexico. Both the Hohokam and the Mogollon are thought to have preceded the Basketmakers, whose culture probably began in the first century. The Hohokam appeared in Arizona sometime around 300 B.C.; the Mogollon may have preceded the other southwestern pre–Puebloan cultures by hundreds of years, but they emerged as a semiagricultural culture about the same time as the Hohokam. The Hohokam remained a distinct, stable culture through the end of the Prehistoric period. Meanwhile, the Mogollon expanded, and after about A.D. 700, they are divided into two main branches with regional differences. Those living in the original area were called the Mountain Mogollon; the Desert Mogollon occupied eastern New Mexico and western Texas.

EARLY HOHOKAM ROCK ART

Hohokam rock art sites, almost exclusively petroglyphs, are found throughout central and south-central Arizona. All Hohokam rock art is categorized as the Gila Petroglyph style, with only slight regional differences. Images from different time periods often appear together on the same panel, so dating Hohokam glyphs is difficult. Most are probably from the Prehistoric period.

See Gila Petroglyph style, p. 39.

The Hohokam may have evolved from Great Basin Archaic hunter-gatherers, though other research suggests that they came from Mexico. For the first few centuries, they lived in scattered small villages near all the rivers in central and southern Arizona, including the lower Verde, the middle and lower Gila, the lower Salado (Salt), the San Pedro, and the Santa Cruz. No trace of their civilization has been found outside

BASKETMAKER ROCK ART

The Basketmakers were a pre-Puebloan culture contemporaneous with the early Hohokam and Mogollon. Their rock art styles are considered Transitional styles, developed after corn had been introduced to the region but before agriculture was widespread. There are several other styles thought to be Basketmaker, but I have listed only a few here.

HIDDEN VALLEY POLYCHROME STYLE (A.D. 1 TO 700)

Hidden Valley Polychrome is a Basketmaker style found only in the Animas Valley of southwestern Colorado. The colorful pictographs are small figures, three to eight inches tall, painted on rock shelter walls in white, black, red, yellow, and green pigments. The images include abstract designs as well as early flute-player images; anthropomorphs with headdresses; zoomorphs such as bighorn sheep, deer, and birds; and hand and paw prints. Groups of small, red human faces are one of the unique designs seen here. Another is rows of ducks, shown two to twenty in a line.

Visit the Falls Creek Archaeological Area just north of Durango, Colorado (not listed).

SAN JUAN ANTHROPOMORPHIC STYLE (A.D. 100 to 750)

San Juan Anthropomorphic is another Basketmaker style, found in the San Juan River drainage in the Four Corners area. In this style, pictographs are more common than petroglyphs. The San Juan Anthropomorphic style is typified by large handprints and broad-shouldered human figures that often occur in rows. Details such as headgear, necklaces, and earrings often appear. A distinctive feature of this style is the elaborate headdresses shown on some anthropomorphs.

Visit Site UT-3, Bluff Area; Site UT-22, Sand Island; Site AZ-1, Canyon de Chelly.

CHINLE REPRESENTATIONAL STYLE (A.D. 450 TO 1000)

Chinle Representational is a late Basketmaker and early Ancestral Puebloan style. Both pictographs and petroglyphs in this style can be seen at Canyon de Chelly and Canyon del Muerto in northeastern Arizona. Distinctive anthropomorphic figures with triangular bodies and long necks are one of the most recognizable design elements of this style. Some human figures are painted in one color and outlined in another, and others are divided vertically in two different colors. Some of the earliest flute-player images appear in this style, and birds are prominent. Solid crescent shapes believed to represent birds are also common.

EARLY MOGOLLON ROCK ART

MOGOLLON ABSTRACT STYLE (A.D. 1 TO 1000)

The style of early Mogollon petroglyphs, found in central and south-central New Mexico, is an extension of the Archaic Great Basin Abstract styles of the region. After about A.D. 800, the Mogollon added to the abstract designs simple stick-figure humans, animal shapes, and animal tracks. Further Mogollon styles are from the Prehistoric period.

Visit Site NM-14, Rio Bonito Petroglyph Trail.

Arizona. Around A.D. 300, the Hohokam began to build elaborate irrigation systems; some people refer to them as the "canal builders." Their way of life changed little through about A.D. 1100, thus their culture overlaps the Transitional and Prehistoric periods.

The Mogollon originally occupied southern New Mexico, southeastern Arizona, and northern Chihuahua and Sonora, Mexico. They are thought to have evolved from the Archaic culture of the region (known as Cochise Culture). By about 0 B.C., they had developed some agriculture, farming corn, squash, and beans. As they established crops, they began to form small but stable villages of semisubterranean pit houses. Later, during the Prehistoric period, their villages grew larger and their territory expanded. We will revisit the Hohokam and Mogollon cultures and their development through the Prehistoric period in the next section.

PREHISTORIC CULTURES
(A.D. 500 to 1500)

Some people associate the term "prehistoric" with dinosaurs, but it simply refers to the time before recorded history. In North America this means before about 1500. And when discussing Southwest archaeology, the Prehistoric period begins with the establishment of fully agricultural societies and the widespread use of technologies such as pottery, around A.D. 500. During the Prehistoric period, the cultural distinctions that began to develop among pre–Puebloan cultures in the Transitional period became further defined as their agriculture became more established and their technology grew more sophisticated. Meanwhile, other cultures in the Southwest, such as those in the western Great Basin, continued to live as nomadic hunter-gatherers throughout this period, some well into Historic time.

The main agricultural groups in the Southwest were the Fremont, the Ancestral Puebloan (Anasazi), the Hohokam, and the Mogollon. The Patayan of the lower Colorado River may have been semiagricultural. Two

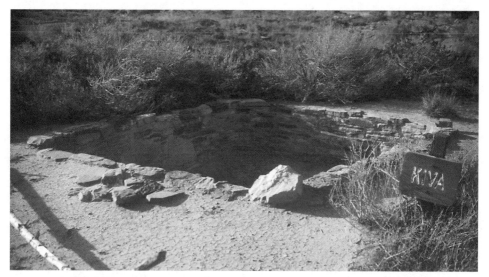

A kiva at Petrified Forest National Monument. Typically, Ancestral Puebloan kivas were round, but along the lower Little Colorado River in northeastern Arizona, they were rectangular like Mogollon kivas. This shows how some cultures may have been influenced by their neighbors.

small but significant Puebloan farming cultures were the Sinagua and the Salado, both exclusive to central Arizona.

The nonagriculturalists are often referred to by their language group. Among these cultures are the Takic speakers, the Numic speakers, and the Athabascan speakers. The Athabascans are thought to have migrated to the Southwest from the north, arriving later than the other groups, perhaps around 1500. We will begin our discussion with the agriculturalists.

By the year A.D. 500, several distinctive Prehistoric farming cultures emerged that thrived for over 1,000 years and along the way developed architecture, pottery, textile weaving, and astronomy as well as agriculture. They lived in ever-expanding permanent villages and traded with other groups. As time passed, their buildings became increasingly sophisticated. They began to line the log cover frames of their pit houses with mud, and later, using mud for mortar, they made houses out of flat rocks. Eventually, some groups learned how to make adobe bricks.

Another feature common to most Prehistoric farming groups was the use of underground (or partially underground) rooms called *kivas* for religious ceremonies. The Ancestral Puebloan kiva was usually round, but other cultures built rectangular or square ones. Kivas were generally entered through the roof and down a ladder.

While there were many similarities among Prehistoric farming cultures, there were differences as well. The complexity of social organization varied. Some groups built complex pueblo cities on hilltops, sometimes with large watchtowers, elaborate grain silos, even massive fortresses. Other cultures remained relatively simple.

There is no evidence of the existence of any of the Prehistoric farming cultures after about A.D. 1400. Puebloan culture did survive, but a different form, and the connections between the original groups and later ones are uncertain. Until rather recently, the assumption was that the populations of the Ancestral Puebloan, Fremont, Hohokam, Mogollon, and other cultures died out for some reason or combination of reasons, such as drought, overpopulation, disease, or warfare. However, many scholars now believe that the people of these cultures did not die but merely moved away from their villages and started over someplace else. Other possible explanations are that they were forced to adapt to some dramatic outside change or that they were assimilated into other cultures. Many Native Americans and others maintain that modern Puebloan peoples are descendants of these early cultures.

Let's examine each of the Prehistoric farming cultures in turn, going roughly by territory, north to south and west to east.

Patayan

The Patayan, or Ancestral Yuman, were an agricultural or semiagricultural people who lived along the lower Colorado River. Their culture can be traced back to about A.D. 500. The Patayan lived in small bands and moved with the seasons, though they shared some Mogollon, Hohokam, and Anasazi traditions. They grew corn, beans, and squash along the riverbanks but still relied heavily on hunting and gathering to supplement their unpredictable agricultural production. The river supported a large game population as well as wild plant foods, so the Colorado River Indians did not have to range as far as other southwestern peoples did.

Their semipermanent housing included earth lodges and pit houses lined with timber. They used sealed vessels for food storage and metates for grinding grains into flour. It was probably the Patayan who created the geoglyphs, or intaglios, along the Colorado River basin. Among their descendants are the Quechan (Yuma), the Mojave, the Halchidoma (who merged with the Maricopa in the nineteenth century), the Cocopa, and many others.

Fremont

Around A.D. 500, slightly before the Ancestral Puebloans began to emerge as a distinct culture, the Fremont people started to develop their own farming culture in Utah, eastern Nevada, and northwestern

PATAYAN ROCK ART

PATAYAN INTAGLIOS (DATES UNKNOWN)

The Blythe Intaglios of California are thought to have been made by the Ancestral Yuman, or Patayan, culture hundreds if not thousands of years ago. Intaglios are a type of geoglyph, a rarely found form of rock art in which gigantic images were made on the ground either by scraping away the surface rocks and soil (intaglios) or by building up rocks and soil to form a shape.

Visit Site CA-3, Blythe Intaglios.

PATAYAN PETROGLYPH STYLE (A.D. 500 TO 1400)

In addition to geoglyphs, the Patayan people, who occupied the area around the lower Colorado River in Arizona, California, and Nevada, made petroglyphs. Patayan glyph images include anthropomorphs with prominent hands and feet as well as complex panels of geometric shapes.

Visit Site AZ-3, Deer Valley Rock Art Center; Site NV-1, Grapevine Canyon; Site NV-5, Red Rock Canyon National Conservation Area.

Colorado. The Fremont were named after the Fremont River in Utah, near which many of their artifacts were first discovered. They may have evolved from the Archaic peoples of the region, or they might have been a subgroup of the Basketmakers. For whatever reason, they did not seem to emulate the Aztecs as closely as some other farming cultures did.

Fremont Indians became the prominent culture in Utah and adjacent areas. Though they lived in large villages, they did not build elaborate adobe or rock-and-mortar structures. Therefore, all that remains of most of their villages are depressions where their pit houses were built, remnants of a few grain bins and rubbish piles (middens), and their distinct rock art.

The Fremont people had strong cultural ties to their Ancestral Puebloan neighbors, and there were similarities between the two cultures' traditions and technologies, such as agriculture, weaving, and pottery. Like the Ancestral Puebloans, the Fremont people cultivated corn, beans, and squash, though they were less dependent on agriculture for their existence. Even after they began to live in villages, they continued to hunt and gather much of their food.

Overall, Fremont culture was simpler than Ancestral Puebloan culture. The Fremont lived in small villages of pit houses, wickiups, or small masonry shelters, never developing true Puebloan architecture. Nor did they build ceremonial kivas. Unlike the Ancestral Puebloans, the

FREMONT ROCK ART

Fremont rock art is found in the Great Basin in western Utah and on the Colorado Plateau in eastern Utah and western Colorado. Petroglyphs are most common, but some pictographs occur as well. Most Fremont styles have in common anthropomorphs with trapezoidal bodies, often showing extensive detail, such as jewelry and headdresses. Pictographs in the Great Salt Lake region and elsewhere consist of triangular-bodied, horned anthropomorphs, usually painted in red.

Another design associated with the Fremont culture is the shield image, typically a large, round, decorated shield with the head and lower legs of a human. The shields are both pecked and painted, and they usually show careful workmanship and great detail. Other common Fremont motifs are mountain sheep with graceful curving horns, as well as snakes, handprints, and corn. Abstract images include rows of dots and concentric circles. There are other regional Fremont styles besides the one listed below, but these are the main ones.

CLASSIC VERNAL STYLE (A.D. 600 TO 950)
The Classic Vernal style appears in the Uinta region of northeastern Utah and northwestern Colorado. Typical of this style are large anthropomorphs, sometimes life-size, with trapezoidal torsos, very broad shoulders, and elaborate ornamentation, including headdresses, necklaces, ear ornaments, sashes, belts, armbands, and kilts. They frequently show facial features, sometimes with what appear to be tear streaks down the face. Spirals and other circular designs are also common. Other images include bear tracks, lizards, and flute players.

Visit Site UT-8, Dinosaur National Monument; Site UT-9, Dry Fork Canyon.

NORTHERN SAN RAFAEL STYLE (A.D. 750 TO 1200)
Compared to other Fremont styles, the Northern San Rafael style, which occurs in west-central Utah, shows less attention to detail, and the anthropomorphic figures often do not have the typical Fremont trapezoidal shape. Animal figures and abstract motifs are more common. Bison glyphs similar to those at nearby Newspaper Rock in Ancestral Puebloan territory appear in this style. Some panels are apparently related to hunting or warfare, with figures carrying what look like severed heads or small shields with faces painted on them. Some think these "fetish heads" represented scalps but were shown with the faces intact. The symbol was believed to have great supernatural powers, specifically to bring rain.

Visit Site UT-17, Nine Mile Canyon.

SOUTHERN SAN RAFAEL STYLE (A.D. 750 TO 1200)
In central Utah, the Southern San Rafael style is characterized by groups of small, trapezoidal-bodied anthropomorphs and a variety of shield figures. The figures are often solidly pecked, but there is much less detail than seen in Vernal-style glyphs. Mountain sheep similar to those of the Ancestral Puebloan are common. Snakes, centipedes, and animal tracks also occur in this style.

Visit Site UT-6, Capitol Reef.

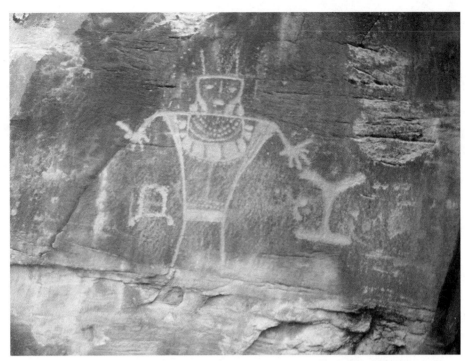

This style of petroglyph, found in northeastern Utah, is called Classic Vernal. Unique to the Fremont people of that region, the glyphs typically showed large anthropomorphic figures with trapezoidal bodies, often adorned with elaborate jewelry and other details. This panel is in Dry Fork Canyon, Utah.

Fremont crafted simple utilitarian pottery, with less emphasis on design and decoration. They made unfired clay figurines, possibly as children's dolls or as religious icons. While the Ancestral Puebloans wore sandals woven of yucca fiber, the Fremont wore deerhide moccasins. The Fremont also had their own distinctive style of basket weaving.

After the disappearance of Fremont culture around A.D. 1300, about the same time as the seeming disappearance of the other Prehistoric agriculturalists, Numic-speaking peoples—particularly the Ute—occupied most of their former territory. It is thought that the Numic speakers migrated into the area and that modern Utes are probably unrelated to the Fremont. Some modern Puebloan tribes may have descended from the Fremont, but specific connections remain uncertain.

Ancestral Puebloan (Anasazi)

In the Four Corners area, where the states of Arizona, Utah, Colorado, and New Mexico come together, a Prehistoric culture based largely

on agriculture developed. They are known as the Anasazi (from a Navajo word sometimes translated as "ancient enemy"), or Ancestral Puebloans. Although some object to the term *Anasazi*, as the name was given to the Puebloans in reference to a possibly adversarial relationship, the term *Puebloan* is not without controversy. I have chosen to use the latter term in most contexts in this book, as it is generally considered preferable. Nevertheless, *Anasazi* is a widely recognized term and is still used in many writings on the subject.

The Ancestral Puebloans occupied most of northern Arizona along the lower Little Colorado River and all of northwestern New Mexico, as well as southern Utah and Colorado. They formed permanent villages of pit houses, and later lived in pueblos made of rock and mortar or adobe bricks. Looms and spindle whorls uncovered at several sites attest to their advanced textile technology.

Some researchers believe that the Ancestral Puebloans were of Aztec origin and migrated into the Four Corners area from Mexico. Ancestral Puebloan architecture, astronomy, and other cultural features resemble

The star figure (right) is a typical motif of the Rio Grande style of Ancestral Puebloan rock art. This panel is at Petroglyph National Monument, New Mexico.

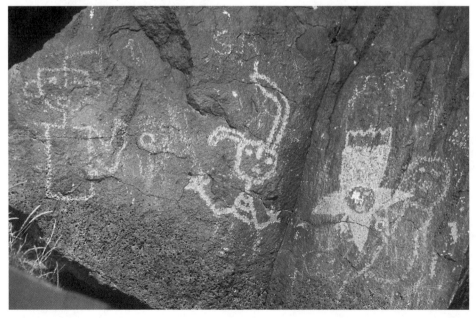

those of the Aztecs. In this hypothosis, the immigrants may have conquered or otherwise displaced the native Archaic peoples, or they may have become assimilated into the established population. Other theorists maintain that the Ancestral Puebloans were an indigenous culture descended from the Basketmakers and that the Aztec influence came from trading with southern peoples.

Whether aboriginal or not, the Ancestral Puebloan culture is thought to have emerged in the Southwest around A.D. 700 and to have gone through several stages of development. In the first stage, known as Pueblo I, the Ancestral Puebloans lived in large, organized villages of pit

ANCESTRAL PUEBLOAN ROCK ART

The Ancestral Puebloans were widely dispersed over the Four Corners area, predominantly in the San Juan, upper Rio Grande, and Little Colorado River basins. In general, Ancestral Puebloan styles, covering a period from about A.D. 700 to 1450, were more patterned and formalized than the earlier Basketmaker styles. The ambiguous stick-figured "lizard man" is common, as is the flute player Kokopelli, who appears with the characteristic humpback. Subcultures in different areas developed their own distinctive rock art styles.

MESA VERDE STYLE (A.D. 700 TO 1300)
Mesa Verde style is a representational Ancestral Puebloan style found in southwestern Colorado in what is now Mesa Verde National Park. Most of the sites, both pictographs and petroglyphs, are at the cliff dwellings. The most prominent design elements are handprints and bird tracks. Both zoomorphs and anthropomorphs can also be seen here. Quadrupeds are fairly common, except for bighorn sheep. Mesa Verde style tends to be less elaborate than Kayenta Representational.
 Visit Site CO-8, Mesa Verde National Park.

KAYENTA REPRESENTATIONAL STYLE (A.D. 1050 TO 1250)
Kayenta Representational is an Ancestral Puebloan style, primarily petroglyphs, found in southeastern Utah and northeastern Arizona. This style is distinguished by excellent workmanship and attention to detail. Bighorn sheep with cloven hooves are common, and other animal motifs include birds, lizards, and snakes. Anthropomorphs have exaggerated limbs and genitals. The flute player Kokopelli is a frequent figure.
 Visit Glen Canyon National Recreation Area and Monument Valley Navajo
 Tribal Park, both in Utah, neither of which is listed in this book.

LITTLE COLORADO STYLE (A.D. 1075 TO 1450)
The Little Colorado style is a late Ancestral Puebloan style found in the Little Colorado River drainage, including the Petrified Forest area, in northeastern Arizona. The petroglyphs of this style are carefully executed and well designed; this is particularly noticeable in the abstract

designs. Animal tracks and human hand- and footprints are common de-signs. Zoomorphs include long-tailed quadrupeds, lizards, centipedes, and scorpions. Human figures often have enlarged hands, feet, and genitalia, and vivid sexual imagery is common, including erect phalluses and copula-tion motifs.

Visit Site AZ-13, Petrified Forest National Park.

TSEGI PAINTED STYLE (A.D. 1250 TO 1300)

Tsegi Painted is an unusual Ancestral Puebloan rock art style found mostly in Tsegi and Navajo Canyons in northeastern Arizona. Also known as "clay painting," this style of rock art employs the use of colored clays as well as more conventional pigments. The clay was casually painted on, smeared on, and sometimes even thrown on the walls. Shield figures, handprints, and bighorn sheep are common designs. Mostly white but also red, purple, brown, and tan paints and clays were used. Also significant in the Tsegi Painted style are the large, white circle designs found on the face of cliff dwellings.

Visit Site AZ-1, Canyon de Chelly; Navajo National Monument (not listed).

RIO GRANDE STYLE (A.D. 1300 TO PRESENT)

Rio Grande style is a late Ancestral Puebloan style that persisted into Historic times among the modern Puebloan people. It is found in the upper Rio Grande region of New Mexico and was influenced by the Mogollon Jor-nada style to the south. Common motifs include shield figures, corn plants, Kokopelli the flute player, snakes, birds, and rabbits.

An interesting motif in the Rio Grande style is the mask, or kachina, thought to be a representation of a benevolent spirit or god. These masks were simple, with little or no detail.

Star figures with human and animal features and sometimes with feather headdresses appear for the first time in this style. Also seen in this style are parrots, often paired or mirrored, and plumed or horned serpents; many scholars think that both of these images were introduced from Mexico.

Visit Site NM-9, Galisteo; Site NM-12, Petroglyph National Monument.

houses and built the first above-ground structures of slab stone. Around A.D. 950, they began using adobe bricks, and by 1100, they had devel-oped their distinctive pueblo architecture. Their culture thriving, they built magnificent cities throughout the Four Corners area. This stage is called Pueblo II.

The Ancestral Puebloans reached their highest level of prosperity around the year 1100, the beginning of the Pueblo III period. They continued to thrive throughout this stage, during which they built the elaborate cliff dwellings they are famous for. Some now think that the vigorous pueblo building during this phase, which lasted until about

1250, was primarily a defensive move and that the cliff pueblos were fortresses. Also during this time, a great drought hit the region. By A.D. 1300, the start of the Pueblo IV phase, many of the Ancestral Puebloans' largest cities were deserted. The culture continued to decline, and by the time the first Spanish explorers ventured into the area around 1500, the Ancestral Puebloans had apparently disappeared, along with the other Prehistoric farming cultures. What remains of their existence are old pueblos, shards of broken pottery, and abundant rock art.

Many members of modern Puebloan tribes—including the Zuni, Hopi, and other tribes—believe they are the descendants of the Ancestral Puebloans.

Virgin River Puebloan

Around A.D. 400, a distinct Puebloan culture emerged in the Virgin River basin of Nevada and southwestern Utah. Called the Virgin River Puebloans, Virgin River Anasazi, or Virgin River Kayenta, they may have been a subculture of the Basketmakers, or they may have been a completely separate group. They built Pueblo Grande, also called the "Lost City" of Nevada, a highly developed Puebloan city, more than 1,000 years ago.

Petroglyphs in the typical Virgin River Representational style, from Valley of Fire State Park, Nevada

VIRGIN RIVER PUEBLOAN ROCK ART

VIRGIN RIVER REPRESENTATIONAL STYLE
(A.D. 1050 TO 1150)

The Virgin River Representational style, found in the Virgin River valley of southern Nevada and southwestern Utah, is a late Virgin River Puebloan style. It appears to be related to Kayenta Representational but may show the influence of Great Basin Abstract as well. Shapes are less angular, more rounded than those of Ancestral Puebloan styles. Two distinctive textile patterns are found in this region, believed to be blanket motifs because of the fringed top and bottom edges of the large rectangular images.

Other characteristics of this style are the absence of Kokopelli flute player images and very few stick-figured lizards. Bighorn sheep are very common, as are deer or elk with multiple forked antlers.

Visit Site NV-6, Valley of Fire State Park.

It was the Virgin River Puebloans who introduced true agriculture into the region. One of their crops was cotton, with which they made textiles. They were also the first to build adobe pueblos and to make pottery in Nevada. In addition, they developed commerce, mining salt and turquoise and trading it with other groups. It is known that the Virgin River Puebloans used parrot feathers for decoration, possibly acquired from the Aztecs of Mexico, as well as seashells from the Pacific coast.

The Virgin River Puebloan culture thrived for about 1,000 years, then ended as mysteriously as the other farming cultures did.

Sinagua

In the Verde River valley of central Arizona, where the Ancestral Puebloan, Mogollon, and Hohokam lands all converged, a small but unique Puebloan culture developed, starting around A.D. 650. They were called the Sinagua. Like the Hohokam, the Sinagua lived exclusively in Arizona, specifically in the Verde Valley and the Flagstaff and Sedona areas. They are believed to have been a subculture of the Ancestral Puebloans. The name *Sinagua,* which means "without water" in Spanish, came from the community's dryland farming practices. Their methods included building diversion dams in washes to channel rainwater to their garden plots and using a mulch of pebbles to reduce the evaporation of dew.

In addition to growing corn, the Sinagua hunted and gathered wild foods. They adopted pueblo building from the Ancestral Puebloans and

SINAGUA ROCK ART

SINAGUA STYLE (A.D. 650 TO 1450)

The Sinagua left rock art along the Verde River valley in central Arizona. Most images are pictographs in either white, red, or yellow. Some petroglyphs can also be found. Sinaguan rock art appears to be heavily influenced by the Ancestral Puebloan of the Little Colorado River and Kayenta regions. It consists mostly of abstract designs and stylized animal and human motifs.

Visit Site AZ-12 Palatki Ruins; Site AZ-18, V-Bar-V Ranch.

BEAVER CREEK STYLE (A.D. 1300 TO 1400)

The Beaver Creek style is a Sinaguan style of petroglyph found only in north-central Arizona's Beaver Creek valley. The style is characterized by the precision with which it was executed, leaving very clearly defined images.

The Beaver Creek style portrays animal figures of many species, including an uncommon heronlike bird. An image found nowhere else looks like a palm tree. Beaver Creek glyphs often show paired designs, such as two animals or humans next to each other. In addition, many designs have a circular pattern. The circles are thought to have been added over the top of the original petroglyphs by a later generation of Sinaguans.

Visit Site AZ-18, V-Bar-V Ranch.

pottery making from the Mogollon. They also built ball courts similar to those of the Hohokam. All of these cultures, large and small, were gone by Historic times.

Salado

Another Prehistoric farming culture unique to east-central Arizona, known as the Salado, first appeared in the area about A.D. 850. Named after the Salado (Salt) River, they occupied most of what is now the southern part of Tonto National Forest, including the areas in and around the Tonto Basin, the towns of Globe, Miami, and Superior, and as far east as the San Carlos River.

It was once widely accepted that the Salado were an Ancestral Puebloan subculture that developed independently, heavily influenced by the Mogollon and Hohokam. But recent archaeological evidence suggests that they were originally Hohokam colonists who migrated north and east from the lower Gila River valley. They gradually moved further away from their Hohokam roots and adopted some Mogollon and Ancestral Puebloan traditions. Some believe it was the Salado who first introduced pueblo architecture to the Hohokam people, and that the Hohokam in turn taught irrigation techniques to the Salado.

SALADO ROCK ART

SALADO POLYCHROME STYLE (A.D. 1150 TO 1450)

The rock art style of the Salado of the Sierra Ancha region, north of the Salt River in central Arizona, consisted of pictographs of multiple colors, including red, white, green, yellow, black, and brown. Images were frequently applied over a white-painted background. Handprints and abstract designs are common in this style, as well as a few human and animal forms.

Visit Site AZ-15, Saguaro National Park.

The Salado people hunted and gathered wild foods, supplemented by minor crops of corn, beans, and squash. They also grew cotton and wove fine cotton cloth. Farming was difficult in much of this mountainous territory, so the Salado also relied on commerce to help support themselves. They traded their excellent cloth and equally excellent pottery for goods from their Mogollon, Ancestral Puebloan, and Hohokam neighbors. The magnificent Salado pottery, especially in the black, white, and red style called Tonto Polychrome, has been found all along the upper Little Colorado River at both Ancestral Puebloan and Mogollon sites.

Sometime between A.D. 1400 and 1450, the Salado disappeared from Arizona, possibly migrating south into Mexico.

Hohokam

Whether the Hohokam originally came from Mexico or whether they were indigenous to Arizona but adopted certain Mexican traditions is not certain. Whatever the case, one of the things that distinguished Hohokam culture from some of the other Prehistoric farming cultures was their Mexican-style ball courts. By about A.D. 600, all larger Hohokam villages had them. Oval-shaped and marked with stone markers, the courts varied in size; the largest was about as big as a modern football field. It is likely that the courts were also used for ceremonies and even as marketplaces when there were no games. The area around the court had banked sides to seat spectators, and some of these arenas could hold over five hundred people. It is thought that the game they played was a team sport similar to soccer. Clay figurines of men wearing hip and shoulder pads have been found. There is evidence that occasionally the captain of the losing team was beheaded.

The Hohokam were farmers, and around A.D. 300, they began to build elaborate canal systems for irrigation. They were probably the most successful farmers in America until modern times. Some of their original canals have been rebuilt and are still used for irrigation today. Starting

LATER HOHOKAM ROCK ART

GILA PETROGLYPH STYLE (A.D. 300 TO 1450)

The rock art style of the Hohokam is called the Gila Petroglyph style. It can be seen throughout the Gila and Salt River drainages and around the Tucson region in central and southern Arizona. There are some regional variations, but overall Hohokam rock art is unusually consistent.

As the name implies, this style consists primarily of petroglyphs, though an occasional pictograph may be found. Abstract and representational images often appear together on the same panel, usually placed in a seemingly random manner. Representational images include various anthropomorphs, such as the distinctive hourglass-shaped human. Quadrupeds include mountain sheep and deer, as well as dogs or coyotes in stick-figure and full-figure forms. Quadrupeds are often depicted with a pot-bellied shape, possibly indicating pregnancy. Other zoomorphic figures include snakes, turtles, birds, and lizards.

Abstract images are often curvilinear and include wavy lines, meanders, circles, and spirals. Spirals are the most prominent. Some rectilinear designs, such as parallel lines, rakes, and grids, also occur.

Visit Site AZ-11, Painted Rocks; Site AZ-14, Picture Rocks Retreat; Site AZ-15, Saguaro National Park; Site AZ-16, South Mountain Park; Site AZ-19, White Tank Mountain Regional Park.

around A.D. 1100, the Hohokam began to live in large compounds near the rivers. They built great structures of adobe, though they never developed the refined architecture of the Ancestral Puebloans. Apparently, they put most of their engineering efforts into their canals instead.

The Hohokam culture ended along with those of the other agriculturalists. It is thought that the Pima and perhaps the Tohono O'odham (Papago) Indians may be their descendants.

Mogollon

The Mogollon culture first appeared as a semiagricultural society in south-central New Mexico around 0 B.C. The early (or Ancestral) Mogollon lived in small villages of pit houses in southern New Mexico, southeastern Arizona, and northern Chihuahua and Sonora, Mexico. They eventually spread east into western Texas, developing regional differences between the eastern (Desert) and western (Mountain) groups. The Mountain Mogollon adopted some of the traditions of their Hohokam and Ancestral Puebloan neighbors; the Desert Mogollon were somewhat more isolated.

Furthermore, there were several subcultures within the two main branches. Two of the best-known were the Mimbres of western New Mexico and the Jornada of south-central and southeastern New Mexico and western Texas; sometimes the Mountain Mogollon are referred to as the Mimbres Mogollon, and the Desert Mogollon are called the Jornada Mogollon, probably because so little is known about the other subcultures.

Many experts believe that the Mogollon were the first people in the Southwest to make pottery, around 0 B.C., though others claim that the Hohokam were the first potters. In any case, the Mogollon's pottery skills were among the most advanced of their time. Later, the Mogollon learned other pottery-making techniques from the Ancestral Puebloans and incorporated them into their own unique style. Within a short time, pottery became the primary container for carrying and storing water

LATER MOGOLLON ROCK ART

The region of the Mogollon in southern New Mexico and parts of southeastern Arizona and western Texas is geographically diverse, and this diversity is reflected in the variety of rock art.

Elaborate, stylized animals are common. Snakes are frequently depicted, and some researchers believe they may be related to the snake dance ceremony practiced by modern Hopi people. Another Mogollon image is a goggle-eyed anthropomorph many theorists believe represents the Mogollon version of Tloloc, the Aztec rain god. The "cloud terrace" symbol for rain, another Mogollon motif, might have a depiction of an agricultural structure or of an altar to the rain god. A kilt-wearing variation of the hunchbacked flute player Kokopelli, a typical Puebloan figure, is also found in the Mogollon region.

MOGOLLON RED STYLE (A.D. 500 TO 1300)

Mogollon Red pictographs are scattered throughout the mountains around the Gila and San Francisco River drainages, and sometimes outside of this area as well. They are usually single small designs painted in red on isolated rocks. In addition to the geometric design motifs of the Archaic style, this style has stick-figured human shapes and occasionally animals, fish, birds, and corn.

Visit Site NM-10, Gila Cliff Dwellings.

MOGOLLON RESERVE STYLE (A.D. 1000 TO 1250)

Also called Mountain Mogollon style, Mogollon Reserve is found in far western New Mexico along the upper San Francisco River and in the Tularosa River basin. Mogollon Reserve style shows greater Ancestral Puebloan influence than does Red Mogollon style, especially in images of the flute player. It is believed that after A.D. 1000, the Mogollon of this region began trading vigorously with the Ancestral Puebloans just to their north and began to exhibit

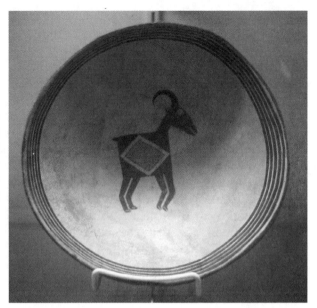

An excellent ex- ample of Mimbres pottery from the Mimbres Museum in Deming, New Mexico

traits of the Ancestral Puebloan culture, building multiroomed pueblos and kivas, while their rock art also took on new design motifs.

Animal tracks, particularly bear tracks, are considered the defining image of this style. Human stick figures and a variety of animal figures, including a long-tailed animal that possibly represents the mountain lion, are also common. Lizards and anthropomorphs are sometimes portrayed with their legs forward or up. Among the geometric motifs is an outlined cross, believed by some scholars to represent the planet Venus.

Visit Site NM-10, Gila Cliff Dwellings.

JORNADA STYLE (A.D. 650 TO 1400)

The Jornada style is a Desert Mogollon style found in the arid basins and ranges of south-central New Mexico. The Jornada style is identifiable by several unique design motifs in both petroglyphs and pictographs. A wide variety of almond-eyed faces or masks are portrayed, and human figures and animals have stylized features such as striped or crosshatched bodies. The legs of quadrupeds are usually bent, presumably to suggest movement. Tadpoles, fish, birds, insects, one-horned snakes, footprints, and animal tracks are also seen.

Perhaps the most interesting Jornada motif is the goggle-eyed figure called Tloloc, after the Mesoamerican rain god. The head is almost always angular rather than round, and the eyes take up at least half of the head. Sometimes Tloloc is represented by nothing more than huge eyes.

At Hueco Tanks, a subcategory of Jornada style, sometimes called Jornada Painted, can be seen. In these polychrome pictographs, masks are a predominant motif.

Visit Site NM-15, Three Rivers Petroglyph Site; Site TX-4, Hueco Tanks State Historical Park.

and food throughout the Southwest, almost completely replacing the traditional basket. Mogollon pottery continued to develop, and designs became more refined. Mimbres pottery in particular, with its distinctive black-on-white designs, is known for its artistry.

As the Mogollon prospered, their villages grew and so did their technology. By about A.D. 900, they were living in larger communities of adobe pueblos in areas with good farmland. Their agriculture practices advanced in sophistication. They dug terraces in hillsides and built stone dams to divert runoff to their crops; some of these dams are still in place today.

The Desert Mogollon were especially identified with the Jornada (or Jornado), who flourished in southern New Mexico and western Texas from about A.D. 700 to 1350. The Jornada remained somewhat more nomadic than the western Mogollon groups, though they did establish pit-house villages and planted a few crops. One group of Jornada established large populations around Hueco Tanks. Later, another group settled an area along the Rio Grande, near present-day Presidio, Texas.

The Mogollon people flourished until about A.D. 1350, when their culture seemingly disappeared. They may have disbanded and/or relocated, but as with all the Prehistoric farming cultures, no one knows for sure. Many believe that the Mogollon were the predecessors of the modern Zuni, Acoma, Laguna, and possibly Hopi cultures.

Prehistoric Nonagricultural Cultures

A number of Indian cultures throughout the Great Basin and other arid regions of the Southwest never developed true agriculture or Puebloan architecture. Many were strictly hunter-gatherers; others lived in small villages and practiced marginal agriculture. Some of these peoples were apparently indigenous, an extension of the regional Archaic cultures, but others are known to have migrated into the Southwest from elsewhere. Most of these cultures are identified by their language groups.

These nomadic peoples usually lived in small bands, but occasionally they organized into larger groups for hunting game and harvesting piñon nuts. They may have done some trading with other cultures as well. In the winter they congregated into large camps, usually near a good water source. Throughout prehistory they relied on game and wild plant foods such as piñon seeds, mesquite beans, yucca, and cactus fruits, along with a variety of seeds and roots. They are thought to have acquired corn as early as 200 B.C., but they never planted regular crops. They may have scattered seeds near springs and returned later to gather whatever had come up.

The Takic speakers of the southern California desert region are believed to have come to the area sometime between 500 and 100 B.C.

They were hunter-gatherers who ranged through the mountains and deserts of southern California. Descendants of the Takic speakers include the Serrano and Cahuilla, among others. During Historic times, other tribes moved into the area as well.

To the east, another group, the Numic speakers, ranged great distances through the arid regions of the Great Basin from about A.D. 1000. They were the ancestors of the Paiute, Ute, and Shoshone. Another Numic-speaking people, the Kawaiisu, ranged through the southern California desert and into the Great Basin, but they were later nearly wiped out by U.S. settlement and the military. Around 1400, the Ute, Shoshone, and Paiute became dominant in what had been Fremont territory. Whether they forced the Fremont out or simply occupied the Fremont's abandoned lands is not known for certain. The Utes and their cousin tribes retained their hunter-gatherer culture, though they did mine salt and grew a little corn.

The Athabascan speakers, forebears of the Navajo and Apache, were late arrivals in the Southwest. Nomadic hunter-gatherers, they migrated into the Colorado Plateau region from western Canada around 1400

ROCK ART OF PREHISTORIC NONAGRICULTURAL INDIANS

COSO RANGE STYLE (A.D. 500 TO 1000)

These Prehistoric Numic petroglyphs show mostly bighorn sheep and geometric patterns. It is thought that Shoshone, Ute, and Paiute shamans and their ancestors traveled from all over the Great Basin to the Coso Range on vision quests, and some researchers believe that the glyphs were made during ceremonies to enter the spirit world.

Visit Site CA-5, Fossil Falls; Site CA-7, Little Petroglyph Canyon.

PECOS RIVER RED MONOCHROME STYLE (A.D. 800 TO 1500)

The Red Monochrome style was used by inhabitants of the lower Pecos River area of western Texas starting around A.D. 800 and continuing until shortly after the arrival of Spanish explorers. As with the Red Linear style, Red Monochrome pictographs may have been part of an ongoing development in the Pecos River style, or it may have been introduced by a different culture.

The Red Monochrome style incorporates red, reddish orange, and yellow colors and depicts solid human and animal figures. Anthropomorphic figures are often shown with their hands up, similar to the Baja California mano and the Barrier Canyon carrot man. Many of the panels in Red Monochrome style are thought to have been made by shamans practicing an ancient mescal ritual.

Visit Site TX-8, Seminole Canyon State Park.

and continued south over the next century or so into Arizona, New Mexico, western Texas, and northern Mexico. The period just before and during the early years of white exploration is sometimes called the Protohistoric period, approximately 1300 to 1600.

The Athabascans were known to be aggressive, and many believe they mounted regular raids on the Puebloan peoples. One group of Athabascans settled in northwestern New Mexico and adopted an agricultural way of life. These became the Navajo. The others, the Apache tribes, remained nomadic through Historic times. The various Apache groups ranged throughout Arizona, New Mexico, western Texas, and surrounding areas.

HISTORIC CULTURES
(A.D. 1500 to present)

After the decline of the Prehistoric farming people around 1500, other Indian groups became dominant in the Southwest. Some of these had clearly moved into the region from elsewhere. Others are thought to be descendants of the Prehistoric farmers.

Historic Pueblo Tribes

Various Puebloan cultures remained after the seeming disappearance of the distinct Prehistoric Puebloan cultures. But between Prehistoric and Historic times, many changes had occurred, and after 1400, Puebloans occupied a smaller territory in the Southwest. The exact causes of the changes that took place remain a mystery, and where the majority of the original Puebloans went is unknown. Many Puebloan traditions, however, still survive in the Southwest.

Today's Pueblo peoples, including the Hopi, Zuni, Acoma, Laguna, and several other tribes, believe they are descendants of the Ancestral Puebloans. Like their ancestors, they live near the rivers in northeastern Arizona and northwestern New Mexico. Continuing their agricultural way of life, they grow crops (mainly corn and cotton) in irrigated fields in the river basins. Many still live in traditional pueblos, from the Spanish word for "villages," in homes made of stone or adobe. They have maintained their heritage as skilled potters and basketmakers; moreover, they have preserved many of their ancient spiritual beliefs, especially among the Hopi and Zuni.

Serrano, Cahuilla, Chemehuevi, and Kumeyaay

The peoples of the southern California desert and surrounding mountains lived in small, seminomadic groups into Historic times. The Serrano and Cahuilla were both Takic speakers and had close cultural ties. The Serrano lived in and around the San Bernardino Mountains and the northern Mojave Desert, while the Cahuilla were native to the San

HISTORIC ROCK ART

HISTORIC PUEBLO STYLES (AFTER 1600)

When the Spanish explorers arrived in the Southwest, some Historic Puebloans, believed to be descendants of the Prehistoric farming peoples, showed a great sophistication in their artwork, including the large multicolored murals painted on kiva walls. Historic Puebloans also frequently painted the walls of their pueblos.

In some Historic Puebloan cultures, the kachina mask is a major design element in their rock art. Much Hopi and Zuni rock art is found in shrines and is associated with spirituality and fertility. Petroglyphs, thought to be clan markers, also apppear in Puebloan territory.

Visit Site CO-1, Anasazi Heritage Center; Site NM-5, Coronado State Monument.

SERRANO, CAHUILLA, AND KUMEYAAY STYLES (AFTER 1600)

In the desert areas of southern California, the Serrano produced mostly abstract geometric petroglyphs, many of which are thought to represent snakes. Some anthropomorphic and zoomorphic images can also be found. The rock art is believed by many to be shamanistic.

Visit Joshua Tree National Park in California (not listed).

The Cahuilla, who also lived in southern California desert regions, made red and black pictographs and petroglyphs believed to be related to either vision quests or puberty rites. Abstract designs include concentric circles, mazes, double diamond shapes, and parallel lines; anthropomorphic figures and handprints are also common.

Visit Andreas Canyon (not listed) and Fish Trap Archaeological Site (not listed), both in California.

Many Kumeyaay abstract pictographs are thought to have been made during puberty rites. Black was used for boys, and red was used, at a different site, for girls.

Visit Site CA-8, Morteros Village and Smuggler Cove.

UTE AND SHOSHONE STYLES (AFTER 1600)

More recent rock art in the Great Basin, northern Utah, and northwestern Colorado are not associated with any Archaic or Puebloan cultures. Rather, they are thought to be Ute, Paiute, or Shoshone images. Predominantly petroglyphs, many are shallowly pecked into the surface of the patina. The images are often anthropomorphic and zoomorphic figures in representational styles. The full-bodied bighorn sheep is the most common design.

(Ute) Visit Site UT-1, Arches National Park; Site UT-3, Bluff Area; Site UT-9, Dry Fork Canyon; Site UT-16, Newspaper Rock State Park; Site UT-17, Nine Mile Canyon; Site UT-23, Sego Canyon.

(Shoshone) Visit Site UT-9, Dry Fork Canyon.

NAVAJO STYLES (AFTER 1700)

Historic Navajo rock art is found in northwestern New Mexico. What is called the Gobernador phase of Navajo history (1700 to 1775) refers to the pre-reservation period in Navajo territory excluding Canyon de Chelly. The rock art style is known as Gobernador Representational, which is similar

in many ways to contemporary Puebloan styles. Painting and carving techniques are often combined, and older images were sometimes rubbed out and painted over.

In this style, supernatural and mythical figures are common, including masked dancers and specific gods. Other designs include birds, corn plants, fertility, and large painted circles, often with feathers, believed to represent either shields or the sun or moon. Handprints are frequently seen as well, and abstract designs are not uncommon.

Star paintings on overhangs and cave ceilings are a distinct feature of Navajo rock art. These are seen in Gobernador style, but also in the later Canyon de Chelly rock art. After the Europeans arrived, Navajo rock art showed fewer religious themes and more depictions of everyday life. Since about 1700, the horse has been a major motif of Navajo rock art.

Visit Site UT-3, Bluff Area.

APACHE STYLE (AFTER 1700)

Generally speaking, the Apache did not produce a great deal of rock art, probably because they were nomadic, but a few Mescalero and Chiricahua Apache sites have been documented in New Mexico and Texas.

Characteristically, the Apache made primarily charcoal drawings. Often, figures were simply drawn onto rock faces using a burnt stick from a fire, but sometimes the charcoal was ground, mixed with a liquid, and painted on the rock. Occasionally other colors were used, the second most common being white.

Horses and riders are common motifs in Apache rock art. Some of these figures represent Spaniards or cowboys. Others represent Indians, often in battle scenes. Other designs include shields, bison, small animals, snakes, and hourglass designs.

Visit Site TX-2, Big Bend National Park.

Juacinto Mountains. The Kumeyaay, a Yuman-speaking people, occupied southeastern California and northeastern Baja. Around 1800 the Chemehuevi, a Numic-speaking people, migrated north from the Great Basin into the Colorado Desert, part of the Kumeyaay's territory.

Mojave, Quechan, Halchidoma, and Cocopa

Along the lower Colorado River, semiagricultural Yuman-speaking peoples lived in small family groups. In the northern areas were the Mojave, in the southern region were the Quechan, and in between them were the Halchidoma. The river delta people of northern Mexico were the Cocopa. Due to their prosperity, they were constantly subjected to raids from nomadic tribes, so they formed coalitions for their common defense.

Ute, Shoshone, and Paiute

Since about A.D. 1000, nomadic Numic speakers, later divided into the Ute, Shoshone, and Paiute tribes, lived in the western Great Basin. Around 1400 they moved into the territory that formerly belonged to the Fremont in the eastern Great Basin and northern Colorado Plateau. They did not adopt the Puebloan traditions of agriculture, pueblo building, or pottery making, but remained mostly hunter-gatherers into Historic times.

The Ute occupied the Colorado Plateau, in eastern Utah and western Colorado, while the Paiute and Shoshone inhabited the Great Basin. The Southern Paiute were in southern Utah, southern Nevada, and northern Arizona; Northern Paiute territory was primarily in western Nevada; and the Shoshone occupied eastern Nevada and western Utah.

Navajo and Apache

Around the time of or shortly after the decline of the Prehistoric Puebloan peoples, the nomadic and aggressive Athabascan-speaking people migrated from western Canada into the region the Puebloans had occupied. The Athabascans were hunter-gatherers when they first arrived in the Southwest, but they gradually established trade relations with the Protohistoric Puebloans. Sometime in the sixteenth or early seventeenth century, a split occurred—one group of Athabascans began to adopt a Puebloan-style way of life, while the rest remained nomadic. The former became known as the Navajo, and the latter were the Apache.

The Navajo occupied most of northwestern New Mexico and part of northern Arizona. After Europeans introduced domestic sheep to the

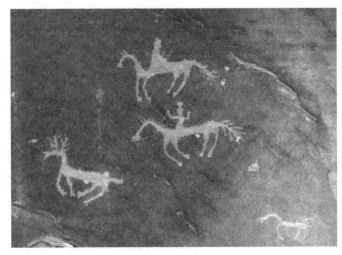

This petroglyph panel from Canyon de Chelly depicts two horsemen pursuing a fleeing deer. The glyphs are presumed to be Navajo.

region in the 1800s, the Navajo became shepherds. They soon gained reknown for their beautiful woolen blankets. They are also famous for their jewelry making, primarily done in turquoise and silver. Today, the Navajo are the largest tribe in the United States, occupying northwestern New Mexico and adjacent areas.

Among the Apache, various subgroups controlled most of New Mexico and western Texas, as well as parts of Arizona and other areas. The horse, acquired in the early 1600s, became an important part of Apache culture, replacing hunting, gathering, and gardening with an emphasis on raiding. The Western Apache ranged west of the Rio Grande, and the Eastern Apache had the areas east. Today most Western Apaches live on one of several reservations in southeastern Arizona. The Mescalero Apache have a reservation in southern New Mexico, and the Jicarilla Apache have one in northern New Mexico.

Comanche and Kiowa

In the early 1700s, invading Comanches forced the Apaches to give up some of their best hunting grounds in western Texas. The Apache retained the southern portions, and the Comanche took over the northern. Between them, the two tribes controlled most of western Texas. In the mid-1800s, the Kiowa people, a Plains tribe who migrated south, began to appear in parts of western Texas.

THE PURPOSE AND MEANING OF ROCK ART

When people see rock art for the first time, their almost universal reaction is to ask, "What does it mean?" But this is not an easy question to answer. The purpose of rock art and the meaning of its images are a mystery, though theories abound. Interpretation is the most controversial, difficult, and intriguing aspect of studying rock art.

Some believe that rock art has great cultural significance and that it can reveal volumes about the people who made it. Others maintain that what we term rock art was no more than the idle doodling of bored hunters waiting for quarry and that nothing of substance can be derived from its study. Many people think that the petroglyph and pictograph panels tell simple stories and portray everyday occurrences. I personally believe that rock art may be all of those things, and perhaps more. Furthermore, any one theory may be applicable within a given region and time span, but no single theory can cover all rock art created over the past 10,000 years.

While we may never be able to "read" rock art as one would decipher a hieroglyph, I think that we can at least discern the basic meaning of much of it. Clearly, in my opinion, rock art is an important link to past cultures, whether we completely understand it or not. I leave it up to the reader to make his or her own interpretations of any rock art sites they visit. As I see it, their interpretations are as valid as those of the so-called experts.

NATIVE AMERICAN VIEWS

When European Americans first saw rock art and asked the local natives what it meant, the Indians universally disavowed any knowledge of the writings of the "Old Ones." Because much rock art is probably closely tied to Indian spiritual beliefs, the natives may have been reluctant to disclose information about it to white people. It was said that whenever

the Indians talked about their ancient rituals and religious practices, the missionaries would beat them.

Native Americans from different regions have different attitudes toward rock art and its meaning. Many tribes consider rock art sacred, while others consider it taboo and avoid discussing it. In some cases, panels have been ritualistically destroyed. Some Indians believe that rock art was not created by men at all, but by spirits. Whether these spirits were autonomous beings who made the images directly or whether they entered human bodies to make them is not certain. Others hold that rock art images were sacred messages left by tribal leaders and shamans. Many Native Americans maintain no particular views about its meaning, and most tribes take no official stance on its interpretation.

Contemporary Native Americans have, however, interpreted a number of rock art panels, usually at the request of a government agency. The famous petroglyph panel at Mesa Verde, Colorado, for example, was interpreted by Hopi members for the National Park Service. The interpreters believed the panel to depict the people's emergence from the earth at the Grand Canyon and their subsequent migrations into the Mesa Verde area. Some of the images represent various spirits and clans, while others represent the Pueblo people in general.

According to interpretations by local Native Americans, panels at Lyman Lake State Park in Arizona are believed to represent the migration routes of their ancestors from Mesa Verde to the Little Colorado River valley. Indians in the Moab, Utah, area said one famous glyph there, known as the "Birthing Panel," represented the birth of a powerful spirit being.

MAJOR THEORIES

The rock art interpretation theories we will discuss here are just that—theories. They may or may not have relevance to the original intent of the images or to what the image makers' descendants believe they mean. None of these theories should be construed as fact, nor do they necessarily reflect specific Native American cultures or beliefs.

Many scholars have studied rock art from various points of view and have come to totally different conclusions about its meaning. There are several major theories and many variations of each one. When theorizing about rock art, we are looking at something that took place over a span of 7,000 years, encompassing a vast geographical area and numerous diverse and evolving cultures. It is reasonable to conclude that there are no simple answers and that no single interpretation theory can be universally applied. Nevertheless, these theories are interesting and may shed some light on the subject as you develop your own interpretations.

Spiritualism

Many major theories about the meaning of rock art center around Indian spiritualism and shamanism. It is widely accepted that early Native Americans had strong spiritual beliefs and that their cultural development was greatly influenced by these beliefs. Moreover, the vast majority of rock art researchers believe that there is at least some spiritual significance to most rock art. Yet we know very little about specific early beliefs. Much of the evidence supporting shamanism theories comes from the ethnographic records of missionaries, which are sketchy and perhaps biased, so modern theories about shamans, their work, and their roles in their culture are largely speculation.

A common creation story among Indians seems to be that long ago, people lived in the spirit underworld. Then, for some reason, there was a division, and the people emerged onto the surface of the earth to live, while the spirits continued to live underground. This is sometimes referred to as the "emergence" story. It was thought that the shaman had special powers to return to the spirit world at will to seek help, wisdom, and guidance from spirit helpers. The use of ceremonial kivas by many prehistoric farming cultures tends to support the idea of the emergence myth and the shaman's connection to the spirit underworld. Kivas were built at least partially underground, with no windows. The entrance was often through a hole in the roof, which may have been the shaman's way of symbolically returning to the underworld. Inside, many kivas had a small tunnel in the center of the floor, believed to represent the point of emergence.

Shamanism theories posit that much rock art is tied to these spiritual beliefs about the shaman's mystic connection. One of these theories maintains that before traveling to the underworld, the shaman made marks on a rock or cave wall as a means of communicating with the spirits. To ask for rain, he drew or carved a rain symbol; for hunting success, he made the image of a game animal. Another theory speculates that the shaman made the images after his trip to the spirit world to record what he saw while there.

One piece of evidence sometimes cited to support the connection between the belief in a spirit world and rock art is the fact that petroglyphs and pictographs are often found in rock shelters and caves. The theory proposes that the early Indians believed that caves were (at least symbolically) entrances to the spirit world. But the idea that caves were ceremonial areas does not take into account that, as archaeological evidence proves, many caves were also used as everyday living spaces.

Many of the theories connecting shamanism and rock art suppose that shamans went into a trance, or altered state of consciousness, in order to enter the spirit world and that rock art was created in this altered state. Supporters of the trance theory point out that archaeologists have found

The rock shelter at Andreas Canyon in California. Petroglyphs appear on the rock slabs that form the sides of the shelter. This site has been closed to the public because of vandalism.

hallucinogenic substances, such as jimsonweed and peyote, from over 4,000 years ago in rock shelters, and there are historical accounts of Indians using peyote as well. Other plants thought to have been used in shaman ceremonies were tobacco, marijuana, and hallucinogenic mushrooms. Fermented plant juice may also have been used as an aid to enter the spirit world. If rock art images were, in fact, made in a state of hallucination, no one but the image maker could possibly understand their meaning.

Another theory related to spirituality is the vision quest theory. It is thought that in certain cultures many, if not all, people went on a vision quest—usually at puberty—to seek a spirit helper to guide them through life. A spirit helper was usually a spirit animal with supernatural powers that could ensure such things as hunting success for men and easy childbirth for women. Some theorists maintain that only shamans chose powerful predatory animals like bears, wolves, or mountain lions as spirit helpers because they were believed to be too powerful for the average person to control.

According to the vision quest theory, young men and women undergoing puberty rituals made images of their spirit animal on a rock. The girls almost universally acquired a rattlesnake spirit helper, as it was the

animal believed to guard the entrance to the underworld and hence the vagina. Rattlesnakes were depicted realistically or by wiggly lines. A string of connected diamonds probably represented the diamondback rattlesnake. Boys presumably chose various animals.

Another theory related to mysticism, developed in the late 1950s, concluded that most rock art was a form of "hunting magic." The hunting-magic theory is based on the assumption that the most important thing to the people at the time was the acquisition of food through successful hunting, gathering, and farming. Therefore, most rock art is meant to elicit supernatural support for these activities.

There are several versions of the hunting-magic theory. One of the most popular believes that the shaman drew hunting scenes or game animals on the rocks prior to a hunt to ensure success. Another theory suggests that a hunter would draw a picture of the primary animal he was hunting on a rock near his ambush spot, either to ask the spirits to make the animal appear at that location or to mystically draw the animal to the site. A third version postulates that the images are made after the hunt to give thanks to the spirits or to symbolically share the food with them.

This Mogollon glyph at Three Rivers, New Mexico, of a bighorn sheep pierced by arrows could be an example of "hunting magic."

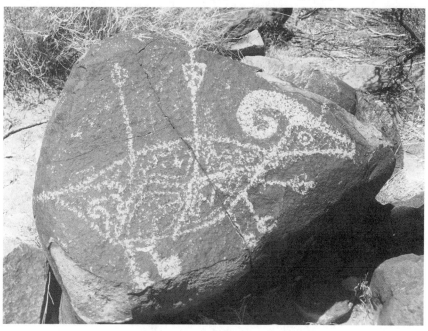

Storytelling

Some theories about the meaning of rock art have less to do with mysticism and more to do with human communication. Some rock art panels appear to tell elaborate stories, which the theorists say were simply the image makers' way of recording events that had occurred in their lifetime, or possibly stories of the past. This theory is supported by cave paintings in Baja California, which seem to depict scenes of great battles, showing men pierced with arrows. Detailed hunting scenes are also common in rock art, showing hunters with weapons, dogs chasing game animals, and animals being herded into pens.

One of the storytelling theories claims to be able to accurately interpret virtually all rock art stories based on a universal sign language used by modern Indians. The interpretation method involves a very complicated system of symbols. The theorist states, however, that difficulties may occur in attempting to read rock art without some knowledge of the culture of the people who made it. Yet we know very little about most of these cultures. In my opinion, no single system can interpret rock art created by so many different cultures, over such a broad geographic area, and spanning thousands of years. The style used in Historic panels, for instance, is very different from styles used in Prehistoric times, and I see no way to correlate the findings from any one panel to any other, even those found in the immediate area.

Astronomy

Numerous drawings of stars, the sun, and other astronomical bodies indicate a keen interest in the heavens. The question of the meaning of these celestial images also inspires many theories. It is not unlikely that celestial bodies and events were viewed as having religious significance. Whether for spiritual or historical reasons, many astronomical events were apparently recorded on stone. Some glyphs are thought to depict the appearances of comets, eclipses, and meteor showers. One particular glyph motif, found at over twenty sites in the Southwest, almost certainly depicts the supernova that created the Crab Nebula in A.D. 1054. Several of these glyphs show a crescent moon and a particularly prominent star, all in the same relative positions. Astronomers who have studied the supernova claim that the images depict the relative positions of the moon and the supernova as they would have appeared in the sky that day. This spectacular event, they believe, could only have been seen in a few locations around the world, including parts of China and the American Southwest.

Some astronomical rock markings apparently had a practical purpose, serving as celestial or solar calendars, probably to mark planting and harvesting times in farming cultures. Using the light cast by the rising or setting sun, the calendars marked the summer and winter solstices, the vernal and autumnal equinoxes, and other annual benchmarks.

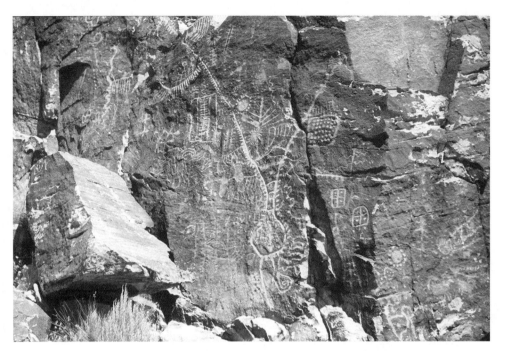

This intricate petroglyph at Parawan Gap, Utah, is believed to be a solar calendar.

Maps and Directionals

Another view that advances the idea of rock art serving practical needs is the theory that many rock art symbols were directional markers and that the panels were often maps. Nomadic cultures may have used directional glyphs to find good water, hunting, and camping spots. Some of these theorists have come up with specific ways to interpret these directional markers and maps.

Naturally, some researchers refute this theory, pointing out that the people were intimately familiar with their territories and didn't need directions to find their way around. Furthermore, they say, the Indians would most likely want to keep the locations of important places secret from strangers, competitors, and enemies. This sounds very plausible, but I know personally that map glyphs do exist. I have seen one petroglyph, on a large flat stone near the edge of Summer Lake in southern Oregon, that I can state with certainty was a map.

This glyph was very old and patinated, but it had been pecked very deeply and could be seen clearly in the early morning. It was a map of the entire valley, showing an outline of the lake that closely followed

the current shoreline at high water. Each of the major springs that feed the lake were also distinctly marked, shown as circles in the same areas that springs exist today. One area, indicated with a series of large concentric circles, is the spot where the hot springs are found.

The proprietor of the resort at the hot springs told me that many years ago her children collected buckets of arrowheads and other artifacts around the springs. This confirmed, at least to me, that the hot springs had been a major Indian camping site. This information was also a key to interpreting the map. The relative importance of each spot could be judged by the number of concentric circles there. It is sad that archaeologists never investigated the site before it was bulldozed and built over.

Territorial Markings

Another major theory applied to at least some rock art is the idea that some images represent clan or territory markings. This theory is based on the fact that in certain areas a specific design motif is very common but is rarely seen elsewhere. The theory supposes that each tribe or clan marked its territory with a unique symbol as a sort of No Trespassing sign. Clan symbols were often animals, real or imaginary, stylized with a particular design.

Nomadic people often traveled over great distances, repeating seasonal routes from year to year. Unable to defend their far-flung borders from other groups, they may have established boundary markers on the rocks at various points in their territory. They also probably marked their winter camp areas to warn intruders that the spot was spoken for. I have seen such camping spots with abundant glyphs on practically every large rock in the area. If some glyphs were meant as clan or boundary markers, then it must be assumed that each group understood the meaning of the other groups' symbols. Some of the marks might have only subtle differences to identify separate but related clans.

Some contemporary Indian cultures still use clan symbols. For example, Hopis have numerous clans, all with distinct symbols, such as Bow, Snake, Mountain Sheep, Bear, Cloud, Bluebird, Badger, Eagle, Spider, Butterfly, Corn, Lizard, and many others. These clan symbols can be seen in rock art as well as in pottery designs.

Art

The final rock art interpretation theory I will present could be called "art for art's sake." It has been suggested that rock art is art in the usual, European sense. In other words, the image makers' intentions were artistic rather than mystical or practical. The proponents of the art theory point to the Native American people's artistic expression in their pottery, costumes, and blankets.

A Simple Approach

My own theory is simple. I think that no single theory can explain all rock art. Different image makers had different motives, intentions, and purposes according to their cultures and possibly their personal inclinations. With this in mind, I believe that most rock art relates to one of two things: human activity or spirituality (including mysticism). The two areas may overlap, such as hunting scenes, which could represent the activity itself but could also be a form of hunting magic. In any case, I encourage you to formulate your own theories, which in my opinion are as valid as anyone else's.

SYMBOLS

The subject matter of most rock art panels is pretty basic: animals and humans, sometimes interacting; spirit creatures; celestial bodies; geometric shapes; and sometimes plants. Portrayals of human activities are common, especially hunting. Other rock art images may be symbols. These symbols may have had different meanings and purposes according to culture and context.

Anthropomorphs

Human images (anthropomorphs) are the most common, though they sometimes appear to be doing nothing but standing there. A human figure might have represented the self, a certain person, a generic human, all of mankind, or even something else. Variations of the human figure could have meant "male," "female," "friend," "enemy," or perhaps even a spirit or the supreme being. If the human figure is in close proximity to a symbol, such as a dot, cupped line, two solid dots, or two small circles, it might mean, respectively: "man standing here," "man drinking water," "blind man," or "man watching." Thus a human figure standing over a circle and next to two small circles and a cupped line might mean "I came here looking for water." Of course, this is just a guess.

Some rock art shows human figures with their hands raised above their heads, which some researchers believe portrays people praying to their gods. Many anthropomorphic images have unusually shaped heads or the heads of animals and could easily be spirit figures. Other anthropomorphic figures are adorned with elaborate costumes and headdresses. These may portray shamans engaged in religious ceremonies or rituals. One theory claims that people and animals portrayed in an upside-down position represent death.

Sexual Images

Many rock art panels depict explicit sexual situations, including intercourse, male and female genitalia, pregnancy, and childbirth.

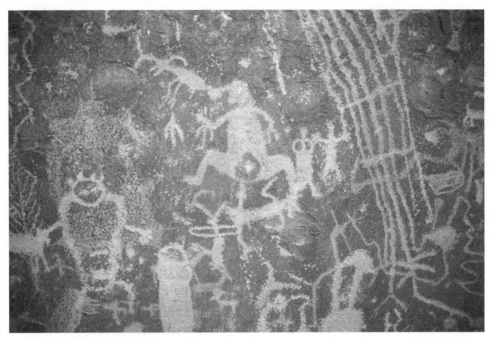

The central two figures in this petroglyph panel at Rochester Creek, Utah, appear to be engaged in sexual activity.

Anthropomorphic figures with obvious genitals are common. Women shown with breasts protruding from each side of their torso are frequently seen in Baja cave paintings. An interesting panel in Arizona's Petrified National Forest shows two large anthropomorphs with obvious genitalia standing side by side. One has a large penis and testicles; the other, two pendulous labia. But most anthropomorphs with genitalia depict penises, often exaggerated ones, leading many researchers to conclude that only men drew rock art. One theory suggests that much rock art was made by bored adolescent boys watching for game animals, evidenced by the fact that so much of it is clearly sexual in nature.

The bisected oval pattern is nearly universally accepted as a vulva symbol representing the female sex and/or fertility. It was usually portrayed disembodied, but it occasionally appears on an anthropomorphic figure. The vulva symbol is common throughout western America, from Alaska to Baja. It is often seen in multiples, especially in softer types of rock. I have seen small outcrops of tuff completely covered with vulva symbols. Many believe that the vulva was a fertility symbol

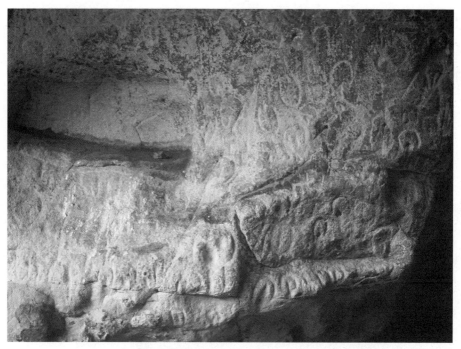

A group of vulva glyphs in San Borjitas Cave in central Baja California, Mexico.

that extended beyond human reproduction to mean successful crops, or even more generally to mean prosperity or success. Another theory suggests that it represented the entrance to the spirit underworld.

Men and Gods

The "flute player" figure was a common image among prehistoric farming peoples of the Southwest. The Ancestral Puebloan usually portrayed him with a hunched back or carrying a backpack. The humpbacked flute player is widely referred to as "Kokopelli," a name derived from a Hopi kachina character. One theory maintains that Kokopelli was a clan marker for the Kokopelli tribe. The Fremont had a similar flute player but without a hump or pack and sometimes accompanied by a dog.

The flute player is often shown with a large erect phallus, which is the basis for two popular theories about the figure's meaning. One is that he is a fertility symbol and his image was drawn to ensure abundant crops. In one version of the theory, Kokopelli's backpack is thought to contain seeds of corn. The second theory is that the flute player represents courtship, playing music to woo young ladies. In his pack,

Kokopelli carries gifts for the maiden he is trying to seduce, or perhaps valuables with which to buy her from her family. According to some theorists, Kokopelli represents a trader with a pack full of merchandise. The flute announces his arrival in the village. This does not explain the phallus, however.

Another anthropomorphic symbol seen in the Southwest is thought to represent a rain god. The Jornada Mogollon people frequently drew images of a spirit creature believed to be their version of Tloloc, the

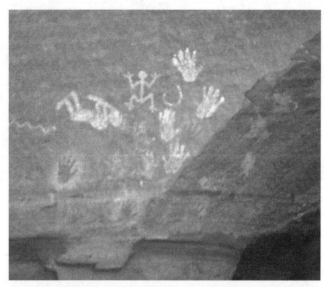

A reclining Kokopelli image from Canyon de Chelly, Arizona

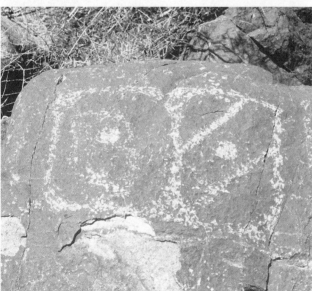

An example of a symbol that may represent the rain god Tloloc, found at the Three Rivers site in New Mexico

Mesoamerican rain god. Tloloc is easily identified by his huge eyes and is often referred to as the "goggle-eyed rain god." Some researchers believe that the Hohokam "pipette" figure is another, highly stylized version of Tloloc. Some kachina figures also bear similarities to Tloloc.

Tloloc was represented in highly stylized or abstract designs as well as in naturalistic styles. Occasionally, only the eyes were drawn. It is thought that the Tloloc image migrated up the Rio Grande through trade with Mesoamerican and Central American cultures.

Animals, Plants, and Nature

After anthropomorphic figures, the second most common motif in rock art is animals (zoomorphs). It makes sense to assume that animals that appear frequently must have some significance, probably because they were sources of food. In Alaska, whales, bears, and fish are frequently drawn. In Baja California, sea turtles, whales, and billfish are common.

However, at least one researcher believes that animal images do not necessarily represent food sources. He points out that along the Columbia River, where salmon was the biggest food staple, there are very few

Petroglyphs in Baja California often depict fish and other sea-dwelling creatures such as turtles, whales, and dolphins. This panel is at Arroyo del Pollo.

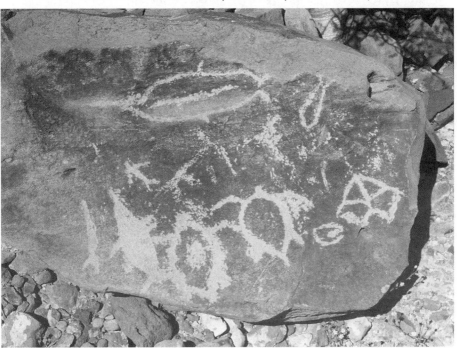

pictures of fish. The same researcher also notes that bighorn sheep can be found in drawings almost everywhere in the West, including places where sheep were probably only a minor food source. Moreover, bighorn sheep may not even have been native to all the places in which its image appears. Because of this, the bighorn symbol by itself is the subject of several theories.

The bighorn sheep is one of the most common zoomorphic figures in southwestern rock art. Among the various theories put forth about the meaning of the bighorn image are that it represents a spirit helper, a rain god, game animals in general, or some other thing. Perhaps it simply represents a bighorn sheep. The bighorn may have been a sacred animal in some Indian religions, and whatever it symbolized may remain elusive forever.

The theory that the bighorn represented rain is a popular one. The hypothesis is that Indians believed that every time a bighorn died, it would rain, and thus killing a bighorn would induce rain. A variation on this is that rain shamans took the bighorn as their spirit helper, possibly because the sheep always knew where to find water. It is further speculated that before a rain ceremony was held, a picture of a bighorn was drawn on a rock to increase the power of the ritual.

Taking a completely different tack, another expert suggests that bighorns didn't represent sheep at all, nor any actual animal. Rather, they were a means of communicating information about a location. According to this theory, the attitude of the sheep is critical in conveying certain

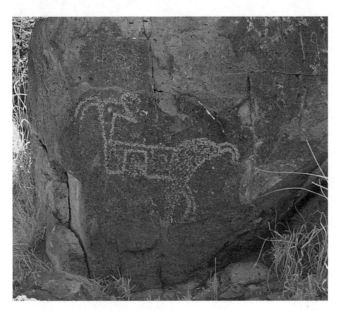

A stylized bighorn sheep glyph at Three Rivers, New Mexico. The pattern on the sheep's body might symbolize the rain god Tloloc.

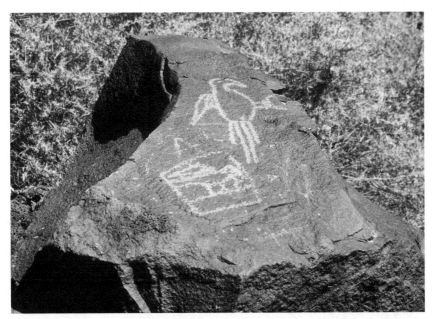

Parrot images are found throughout the Southwest. Among the highest concentrations are at Petroglyph National Monument in New Mexico.

meanings. Which way the animal faced indicated direction. Whether it was standing, walking, or running was significant in determining the urgency of the message. The length and shape of the horn indicated the distance and the difficulty of the journey.

Another animal image found in the Southwest that researchers place great emphasis on is the parrot. There was only one parrot species that was native to the region, the thick-billed parrot of southern Arizona. Yet parrot images are often seen in rock art in both Arizona and New Mexico, and on the southern Colorado Plateau as well. The thick-billed parrot is fairly drab in appearance and therefore unlikely to have such prominence. It is believed that the images represent the brightly colored macaw, which must have been traded from southern Mexico. There is evidence to support this: green parrot feathers have been found in prehistoric pueblo ruins. The macaw was probably prized for its bright, colorful feathers, and it is likely that the feathers were a status symbol worn only by shamans and chiefs, or used in ceremonial dress.

Waterbirds such as herons, cranes, and ducks might signify water or rain. Snakes may represent rivers. Other rain-related images are lightning bolts and clouds. The kiva murals at Coronado State Monument all seem to have a water-related theme—lightning bolts, cups, ducks, and other water symbols are numerous.

Plants are occasionally seen in rock art. Usually represented are domestic crops such as corn, squash, and beans, but a few native food plants like yucca pods also appear sometimes. Corn is the most frequent plant found in rock art, and the people who made these drawings were most likely farmers. The squash blossom is an occasional motif in Puebloan pottery and blankets as well as rock art. Jimsonweed, a hallucinogenic plant believed to have been used to induce trances, is also sometimes depicted in rock art.

Geometric Shapes and Designs

The geometric designs so often seen in rock art were probably symbols, but what they stood for is, unsurprisingly, a matter of great debate. Some think that the symbols were a way to give directions to an important spot, such as a water source or a cache of food or weapons. In this theory, each of the design elements—dots, wavy lines, spirals, etc.—had specific directional meanings. For example, a line of dots on a rock along a trail pointed to another rock with further directions on it. A spiral meant to go up or down, depending on the direction of its rotation. Lines with complicated twists and turns, often called *meanders*, showed that the route to the place of interest was circuitous. A cross or X might have meant "cross over," and a curved line might have indicated "go around."

According to another theory, geometric symbols were used for storytelling and other general communications. For instance, two dots connected by a short horizontal line meant "talking," and two dots not connected meant "looking." A short vertical line simply meant "man."

A theory about geometric rock art symbols suggested by Native Americans is that the lines and meanders show the routes of their ancestors' migrations. Spirals are a symbol of migration in general and/or the original place of human emergence. Panels of this nature can be found throughout the Four Corners region, including Lyman Lake State Park in Arizona and Mesa Verde National Park in Colorado. The contemporary American Indians who live in the area believe that these two panels tell about the prehistoric migrations of the Ancient Ones from the place of emergence in the Grand Canyon.

An unusual design found at the Three Rivers site in New Mexico is the dotted circle pattern. It is the most common motif at this site, yet it is rare anywhere else, except for a few sites in Mexico. It may have been used as a clan marker. Many of the dotted circle glyphs have various designs inside the circle. Among the several I've seen were crosses, bird tracks, and clovers.

One researcher has suggested that the dotted circle might be a symbol for the Mesoamerican fertility deity Quetzalcoatl, the plumed serpent. A naturalistically depicted plumed serpent motif found at several Mogollon rock art sites is thought to be Quetzalcoatl or the equivalent

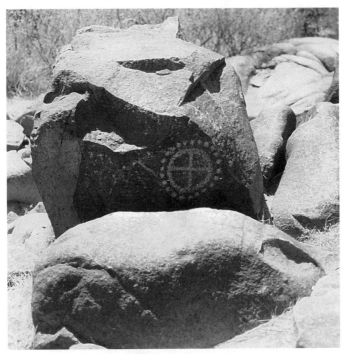

Typical dotted circle glyph at Three Rivers, New Mexico

of the Hopi water serpent Palulukon. The serpent is usually shown with only one plume, which arcs forward. Sometimes a single horn or a pair of horns replaces the plume.

A Final Thought

As with general rock art interpretation theories, theories about the meaning of any specific symbol are educated guesses at best. My advice is to take all theories with a grain of salt. Perhaps the most important thing about pondering the meaning of rock art is to discover what it means to you.

4

ROCK ART PRESERVATION

Rock art is continually under attack from the elements and from man. Means of protecting it are varied and controversial, and people within the rock art community often disagree on appropriate methods of protecting rock art. There are a great many people with an interest in rock art for one reason or another. At the top of the hierarchy are the professionals who are paid to control vandalism and manage rock art sites. This group includes federal, state, and local land managers and archaeologists. There are also numerous archaeology and anthropology professors, many of whom do field research on rock art through the financial support of their institutions and private and government grants. College students are seldom paid, but they generally receive course credit for their field studies. Other professionals include conservators, who make their living repairing damage to rock art, as well as various consultants and grounds workers.

There is another small group of people who derive income either directly or indirectly from rock art. This group includes artists, photographers, and people who manufacture or sell items with rock art images on them. I know of one fellow who sells rubber stamps of rock art images. Sadly, there are also unscrupulous people who deal in black market artifacts, including rock art stolen from public lands.

A group who deserves great praise and recognition but is seldom recognized publicly is the volunteer corps of rock art enthusiasts who donate uncountable hours to rock art preservation and conservation. These are the people who, in my opinion, are the truest guardians of rock art, for they have no vested interest (and probably do most of the work). Many of these volunteers are site stewards who monitor and maintain sites assigned to them by officials.

Last but not least are the people who enjoy visiting, photographing, and/or researching rock art sites as a hobby. I wrote this book mainly for them.

UNDERSTANDING THE PROBLEMS

The problems with rock art conservation are numerous and complex, and there seems to be no consensus about the best strategy for addressing them. Each agency follows its own plans and procedures, and there is no apparent coordination of efforts among the agencies. Internal disagreements among officials, archaeologists, and other rock art advocates often impedes progress.

In my opinion, any approach to the protection of rock art should be based on common sense. It is undoubtedly impossible to protect all rock art from all threats, so we can logically assume that at least some sites will be damaged or destroyed despite our best efforts. Furthermore, funds available for rock art protection are very limited. Therefore, it seems apparent that a criteria must be devised for deciding where to focus protection efforts. To do this, we must determine the urgency of the needs and the practical considerations of providing effective solutions for each individual site or area. The amount of public visitation, the accessibility of the location, the current condition of the site, the scientific and historic significance of the site, and the nature and degree of current and potential threats must all be taken into account and balanced against whatever funds and personnel may be available to implement specific plans. In many cases, volunteers can be recruited and trained and/or supervised to do much of the work.

Forces of Nature

Among the most common threats to rock art today are natural erosion and weathering, stresses from human impact such as development, and vandalism. Wind and water erosion has undoubtedly damaged or destroyed countless rock art images over the past 10,000 years, especially pictographs. Wind-borne sand and debris chip away at rock art, and precipitaion, floods, and runoff water also take their toll. On some cliffs, water leaches chemicals from the rock and deposits stains over the rock art below. Sunlight also fades pictographs.

Moisture in the underlying rock can freeze and cause thin sections of the surface stone to flake away or break off, a process called "spalling" or "exfoliation." Entire sections of cliffs in the form of boulders frequently break away and tumble down the talus slope, and those sections occasionally have rock art on them. This happened recently at Grapevine Canyon near Laughlin, Nevada.

Little can be done to protect rock art from the processes of nature. Attempts have been made to coat pictographs with various clear coatings, but these have not proven to be entirely effective or permanent solutions. At some sites where the rock art is in a wash or gully, small barriers have been built to divert the water around the panels. A few

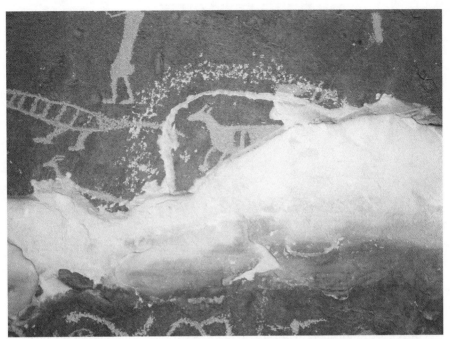

Here a section of the Rochester Panel in Utah has separated from the base rock and fallen away due to a natural process called spalling.

sites have had shelters built over them. Perhaps the only way to protect sites from the weather would be to build some kind of a shield around each of them—an impractical solution, to say the least. It is probably inevitable that all rock art exposed to natural forces will eventually succumb to them.

Human Impact

The damage done to rock art by humans is an altogether different issue from natural deterioration, and a great deal can be done to curb it. First we must accept the fact that any and all human contact with rock art is potentially destructive. That is not to say that the damage is always malicious, of course. Even the everyday wear and tear of human visitation to sites can incrementally disturb them. Yet by raising awareness, we can make sure we tread as lightly as possible.

A tremendous amount of rock art has been destroyed by modern man in the name of progress. The building of roads, railroads, and towns has blasted and bulldozed away much irreplaceable rock art. Dams have submerged hundreds of archaeological sites underwater.

The builders of this rock wall at the Signal Hill site in Arizona inadvertently used a stone that had petroglyphs on it. Note the black stone at the bottom.

Erosion is often severely aggravated by logging, plowing, overgrazing, and construction. Ironically, there have even been instances of damage done to rock art in the building of protection for it. In erecting the wall of a ramada near the Signal Hill petroglyph site in Saguaro National Monument, Arizona, builders (presumably unintentionally!) used a stone that had portions of petroglyphs on it.

While little or nothing can be done now to undo the damage, we have begun to learn from our past mistakes. Today, commercial and residential construction on public land is more thoughtfully planned, and each new development site has to be evaluated for environmental and archaeological impact before ground is broken. While finding rock art at a building site does not necessarily mean that the project will be stopped, it does generally mean that pertinent data is to be recorded and artifacts are to be removed and preserved. Examples of salvaged archaeological collections in the Southwest include the Lost City Museum in Overton, Nevada, and the extraordinary Anasazi Heritage Center near Dolores, Colorado.

Unfortunately, strict adherence to protection regulations is not always observed. In fact, some conservationists have suggested that many compliance efforts are little more than a perfunctory gesture meant to appease environmentalists and Native Americans. Sometimes, rock art sites endangered by "progress" are saved only when an advocacy group speaks out. Even then, the site is usually not preserved but simply examined and salvaged before the construction proceeds. I believe this is, in most cases, an inadequate solution.

Vandalism and Looting

Vandalism and looting at rock art sites has been a huge problem for the last 200 years. During the "Indian Wars," soldiers and cowboys liked to destroy anything connected with Indians, and using rock art for target practice was common. Today, vandalism continues to be a serious problem. People still shoot at rock art with guns, carve their names into panels, and deface images with paint, chalk, and charcoal. Sometimes "taggers," generally teenage boys, spray paint graffiti on rock art, especially in urban areas.

Despite the outcries over vandalism expressed by archaeologists and others, only a fraction of the thousands of rock art sites in the Southwest have received any kind of protection against it. It is often assumed that easily accessible sites are more vulnerable, but this is not necessarily true. I have seen many sites that are difficult to find but have been badly vandalized, yet other sites that are visible from a paved road show little or no evidence of vandalism.

In addition to being vandalized, petroglyphs and pictographs are occasionally stolen. Panels have been chiseled off the rocks at several sites, and in some cases, thieves have made off with entire boulders. An exquisite rock art panel was taken from Inscription Canyon

California's Fish Trap site has been closed because of vandalism.

in southeastern California in 2000. Corrupt artifact dealers routinely plunder archaeological sites, often with the aid of a backhoe, from both public and private lands.

Some looters are simply ignorant, picking up a "souvenir" without realizing that it is both unethical and illegal. Others may unintentionally dig up rock art and other artifacts while excavating rocks and boulders for building or landscaping. Whether intentional or not, these practices rob the public of the precious legacy of past cultures.

PRESERVATION AND PROTECTION STRATEGIES

Laws and Enforcement

Numerous federal and state laws have been passed to protect cultural resources, including rock art, but in order for laws to be effective, they must be enforced. One mandate that must be included in any site protection plan is to investigate acts of vandalism and looting, and to apprehend and prosecute the offenders.

Sadly, too few funds are allocated for enforcement. Though rock art on public land is protected under various laws, many public sites are understaffed and rely on visitors to watch for vandals and report them. Sites on private property are protected only by trespass laws, which are up to the property owner to enforce. While I would certainly support passing more and better laws, even more urgent is getting adequate funding to enforce the ones we already have.

Federal laws currently in place include:

1. The Antiquities Act of 1906, which requires a permit for any archaeological excavation and provides for penalties of violators.

2. The Historic Sites Act of 1935 declares a national policy to preserve historic sites and objects of historic significance for the public.

3. The National Historic Preservation Act of 1966 provides funds and guidelines for the preservation of archaeological sites on public land.

4. The Archaeological Resource Protection Act of 1979 establishes a permit requirement for the excavation of archaeological sites and removal of artifacts from public or Indian lands. It also prohibits the sale, purchase, or transport of illegally obtained artifacts.

Documentation

Though not a law, a federal mandate was issued by a former Secretary of the Interior to find and document rock art sites. Unfortunately, however, Congress has not so far seen fit to appropriate funds for the work.

Locating and documenting as many sites as possible is one of the first steps necessary in protecting them.

In order to document a site, detailed data about the site must be collected, including location, elevation, descriptions of types and styles of images, and other information. Photographs of all images should be included. This data is then turned over to the authority in charge of the site location. Once a site is documented, it should be evaluated to determine if it is a reasonable candidate for protection and what forms of protection are practical. If in your travels you find a site you believe may be undocumented, by all means take notes and photographs and contact the officials who oversee archaeological sites in that area. (See the Resources list in the back of this book.)

Development of Sites for Public Access

In the past, it has been the practice of archaeologists to keep the location of rock art sites a dark secret from the public in an effort to protect them from vandals and looters. However, it has become apparent that this strategy is no longer effective. As access into remote areas becomes easier, Bureau of Land Management officials cannot effectively prevent public access to sites on public lands. In fact, many in the rock art community now promote the opposite approach and believe that the best way to protect sites is to encourage public visitation. But increased visitation must go hand in hand with increased public education and awareness. Furthermore, as more visitors bring more pressure upon these sometimes fragile treasures, measures need to be taken to ease the impact. Fences, paths, signage, visitor registration boxes, and other improvements at public sites are among the methods in place to address these issues.

Sites in national and state parks and monuments receive partial protection simply by being within official park boundaries. Not only is this a psychological deterrent, but most parks are also routinely patrolled, and there are usually visitors around to spot and report vandals and thieves.

At many public sites, officials have built fences and paths to help keep the impact of public visitation to a minimum. In some cases, entire sites have been enclosed in eight-foot-high chain-link fences; elsewhere, three- to four-foot wood or iron rail fences have been installed in front of the main panels or along the footpath. Even unobtrusive barriers at sensitive locations, such as a line of painted rocks or a low wooden rail, can be very effective. Along the trails, signs are usually posted asking visitors to stay on the established pathways. Signs warning people of rattlesnakes, poison ivy, and other dangers are a good way to enhance the message.

The posting of signs at rock art sites is a very important method of protecting them. In addition to signs marking designated pathways, interpretive signs increase awareness and knowledge about Indian rock art and how to preserve it. Signs also give the site an "official" presence and impart a feeling of importance to the rock art.

This site at Homolovi Ruins State Park in Arizona has been fenced off and signed to protect it.

This sign at Parowan Gap in Utah warns of rattlesnakes.

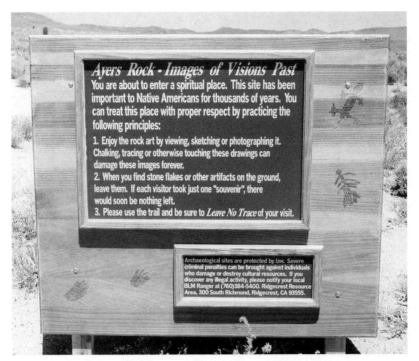

This sign at the trailhead to Ayers Rock in California reminds visitors of the sacred nature of rock art sites.

The U.S. Army Corps of Engineers conducted an exhaustive study of the issue of signing archaeological sites in 1989. The study concluded that in order for a signing program to be most effective, a number of factors must be considered. Sites that are easily accessible, highly visible, or have a history of looting or vandalism should be a priority for signage. On-site signing is usually preferable for highly visible and easily accessible sites; roads or trails may be signed in more remote areas. Signs should also be placed in nearby camping areas. All signs should carry a "warning" message as well as interpretive information.

At several sites in places frequented by hunters, signs have provided an unintended form of diversion. Hunters who used to shoot at rock art have begun to shoot at the signs instead, leaving the rock art unharmed.

Intentional diversion methods also seem to be effective, such as creating a "graffiti rock" where people can sign their names and presumably satisfy their urge to make their own marks on rocks. At El Morro National Monument in New Mexico, a large rock near the entrance to

A government sign damaged by hunters

the visitor center has a sign inviting visitors to scratch their names in the soft stone. This rock is covered with names, dates, and place-names, while the nearby rock art remains unmolested.

At vandalized sites, graffiti is often removed from the panels, but sometimes it is left in place as an example of the destruction it causes. A sign explaining the problem and a number to call to report vandals may be posted to underscore the message. This approach has proven effective in reducing the amount of vandalism and graffiti at many sites.

Visitor registration boxes have also proven highly successful in several locations, including Los Padres National Forest in California and Coconino National Forest in Arizona. Registration boxes act as an initial intervention device—if visitors register their names at the trailhead, they are unlikely to vandalize the site. In addition to registering visitors, these boxes often are used to distribute brochures with information about the site and about rules for visitors.

Physical improvements such as parking areas, marked trails, trashcans, restrooms, picnic tables, and ramadas not only make rock art sites more comfortable for visitors but also make them appear more official, eliciting more respect. Buckhorn Wash in Utah, for example, had been severely damaged by vandals when it was decided to restore the site

and improve it for public visitation. A BLM official told me that since the project was completed, vandalism at this site has been greatly reduced. Many rock art sites have been stabilized in this way, though they represent only a fraction of the thousands of rock art sites in the Southwest.

According to the Corps of Engineers study, protection programs should incorporate several different methods, including law enforcement, site monitoring, fences, signs, public education, visitor registration boxes, site improvements, and other measures. In addition, cooperation among all federal and state agencies is paramount in order to maximize a protection program's effectiveness.

Restoration

I understand that the term "restoration" is not actually valid when applied to rock art because there is no way to totally restore it to its original condition after it has been vandalized. Nevertheless, a number of severely vandalized sites on public land have been successfully repaired by professional conservators. The process often involves removing spray paint with special chemicals, filling in bullet holes, and "touching up" damaged glyphs with specially mixed pigments. The rock art in South Mountain Park, on the very edge of metropolitan Phoenix, has been severely damaged by taggers, but a number of the panels have been restored by professional conservators.

Buckhorn Wash in Utah was the first restored site I had the pleasure to visit. In addition to the remarkable restoration work involved, the site was further improved by the addition of a parking area, trash cans, interpretive signs, and fenced paths. The result is an excellent site for public viewing with a marked decrease in vandalism.

A well-developed site in Bloomington, Utah

The restoration project at Courthouse Wash in Utah's Arches National Park uncovered evidence that the site had been "vandalized" by previous Indian cultures. When the modern graffiti was being removed, some of the underlying paint came with it, only to reveal a third layer of painted images under them.

Volunteer Stewardship

There are numerous successful volunteer site steward programs throughout the Southwest. In addition to monitoring the sites for vandalism, stewards document and photograph the sites, keep them free of trash and debris, distribute informational materials to visitors, and help add improvements to the sites, among other things. Many of these programs are run by the national and state parks, which provide training and supervision for the volunteers. A number of nonprofit rock art organizations also run stewardship and similar programs, conducting trash removal projects, monitoring endangered sites, and performing other conservation duties.

Los Padres National Forest in California has one of the best and most effective stewardship programs in the country, conducted by U.S. Forest Service archaeologists. Los Padres contains many Chumash rock art sites that had suffered varying degrees of vandalism in the past. In an effort to stop the destruction, the Forest Service archaeologists initiated an aggressive site steward program called "Partners in Preservation." The results have been excellent. While the problem has not been totally solved, it has been drastically reduced.

Another very effective program is the Arizona Site Stewards Program, administered by the State Historic Preservation Office, which is a division of the Arizona State Parks Board. This statewide program trains volunteers to monitor sites and record any evidence of damage. Rangers investigate all reports of vandalism or looting. Other states also have site steward programs.

Citizen Awareness and Action

There are a number of things you can do to help protect rock art sites. One is to observe the rules of rock art etiquette when visiting sites. (See chapter 1.) "Leave no trace" should be your motto. Specifically this means do not litter, stay on the trails, and do not touch or otherwise disturb the site. These sites are sacred places to many Indian people. Comport yourself appropriately and leave only your footprints behind.

Furthermore, we rock art lovers can play a vital role in protecting sites from vandals and looters. The sad reality is that many sites are seriously undersupervised by officials, so protecting sites falls largely on conscientious citizens. So many of these sites are in peril, and the destruction will continue unless we remain vigilant and, when necessary,

take action. Sites on public lands are everyone's responsibility. If you witness vandalism or looting, report it immediately. If you feel a site is being mismanaged or needs additional protection, express your opinion to the responsible agency. Better yet, volunteer to help.

If you have the inclination, join a regional historical or archaeological organization. You may even decide to contact government officials in support of additional laws and funding for rock art preservation. At whatever level of participation, we must all take an active role in helping to protect this valuable part of our human heritage.

PART II

THE SITES

The more than 100 sites listed here are those I feel are the most appropriate and easiest for the general public to visit. Some of them are huge and contain many large panels, while others may have just a couple of small petroglyphs. Though many of these sites are a little off the beaten track, most can be reached in good weather in a regular car, though a few back roads do require a high-clearance vehicle such as an SUV or pickup. To view some of the sites, you will need to take a modest hike, but others can be viewed without ever leaving the pavement.

I investigated well over 150 public rock art sites throughout the Southwest. My information came from sources readily available to the public, including government agencies such as the National Park Service, U.S. Forest Service, Bureau of Land Management, state parks divisions, regional visitor information services, and municipal chambers of commerce. Yet specific information about some of them was very hard to come by. There were a number of sites I was asked not to list at all, and I haven't. Some agencies asked me not to give specific directions to their sites but instead to direct readers to the visitor center for information, which I have done. Lacking official guidance on many sites, I used my own judgment to determine which sites were suitable and which were too fragile or endangered for inclusion in this book. Beyond that, I have faith that the people who buy this guide are responsible citizens and will be respectful when visiting these sites.

Besides rock art, there are numerous other Indian artifacts to see throughout the Southwest, such as pueblo ruins, pit-house depressions, fire pits, metates and mortars, pottery, and remnants of tools and weapons. Many good museums have displays of tools, weapons, pottery, basketry, and even clothing. Some have reproductions of villages and camps.

I have listed the sites by state, and within each state, alphabetically by name. Each site has a heading with a site number, the name of the site, a contact number and/or Web site, a note about whether or not fees are required, a map locator number, and directions to the site. I

found it too impractical to include information on the times a site is open for viewing. Many sites with restricted access have hours that vary seasonally; others require a guided tour to view, sometimes requiring a reservation, and tour hours vary as well. Because of the complexity of listing all this, and because the information is so much subject to change, I decided that it would be most helpful simply to direct readers to call ahead. When a site is not associated with a park or other restricted-access facility, there are no hours of operation, but it's always best to explore sites in the daylight, so you can see where you're going and find what you're looking for.

The phone numbers, fees, and other information given in the following chapters are subject to change at any time. In addition, sites are sometimes closed to the public for a variety of reasons without notice. At the time of publication, the information was as accurate as possible.

Map locators: For most sites, I included locator numbers for that state's DeLorme Atlas & Gazetteer. I also listed USGS map locators when available. In Nevada, I listed the locators for the NV DOT maps, as they are more detailed than USGS maps and show the rock art sites. The Nevada chapter has information on how to order a NV DOT map.

Contact information: Even though I've listed a contact number for each site, the agencies vary greatly in how much information they give about rock art sites under their jurisdiction. Further information can sometimes be obtained from rock art organizations, private tour agencies, and various Web sites. (See also the Resources listing in this book.)

Directions: Even with written directions, many sites are very difficult to find without a map. On the other hand, many sites require explicit directions to guide you beyond the parking lot, so I have provided them in most of the listings. In addition, at improved sites, specific directions and local maps can usually be obtained at the visitor center or entrance booth.

Many of the rock art sites listed in this book are in national, state, and municipal parks, each with its own appeal and special attractions. Most public parks have picnic areas, and many offer campsites and other recreational facilities for families. Don't miss the opportunity to enjoy the wonderful sights and experiences these special places afford.

Arizona Rock Art Sites

1. Canyon de Chelly
 National Monument
2. Chevelon Canyon/Rock Art
 Canyon Ranch
3. Deer Valley Rock Art Center
4. Grand Canyon National Park
5. Homolovi Ruins State Park
6. Inscription Rock at Davis Dam
7. Keyhole Sink
8. Laws Spring
9. Little Black Mountain
10. Lyman Lake State Park
11. Painted Rocks Campground
12. Palatki Ruins
13. Petrified Forest National Park
14. Picture Rocks Retreat
15. Saguaro National Park
16. South Mountain Park
17. Springerville/K5 Ranch
18. V-Bar-V Ranch
19. White Tank Mountain
 Regional Park
20. X Diamond Ranch

5

ARIZONA

Many rock art sites in Arizona are on National Park Service land, and some have been developed for public visitation. For example, Petrified Forest National Park has a small rock art display at the visitor center and two petroglyph sites on public view. Saguaro National Park in southeastern Arizona has two improved sites and another one nearby.

Two of Arizona's public parks with extensive rock art are Homolovi Ruins State Park and Lyman Lake State Park. The sites in both these parks have been stabilized and are closely monitored. The Deer Valley Rock Art Center northwest of Phoenix is devoted entirely to rock art research and offers an excellent opportunity to see, study, and photograph rock art.

The public land in the national forests also contains a great deal of rock art. Palatki Ruins is probably the best improved site on national forest land in Arizona. Laws Spring and Keyhole Sink are two others that are open to the public, but they have minimal improvements.

Of all the southwestern states, Arizona has had the most diverse and interesting native cultural development. Arizona has been the home of several distinct Prehistoric and Historic Puebloan and non-Puebloan cultures. The Hohokam was the largest culture of Prehistoric Arizona, and no traces of their civilization have been found outside the state. Two other, smaller Puebloan cultures exclusive to Arizona were the Sinagua of the Verde River valley and the Salado of the Tonto Basin. In addition, Ancestral Puebloan rock art can be seen in northern Arizona and the Four Corners area, and there are Mogollon ruins in the southeastern part of the state.

Among the non-Puebloans, Yuman cultures, known as the Patayan, have occupied the lower Colorado River area along the western border of Arizona for about 1,500 years. The Cohonina, a subculture of the Patayan, occupied northern Arizona's Coconino Plateau and the south

rim of the Grand Canyon from around A.D. 750 to 1100. The Cohonina were nonagricultural and lived in pit houses.

During the fourteenth and fifteenth centuries, nomadic Athabascan-speaking people, migrating south from Canada, began to appear in Arizona, first in the north and spreading south. They were the ancestors of the Apache and Navajo.

SITE PRESERVATION

Arizona has one of the best site stewardship programs in the country, administered by the State Historic Preservation Office (SHPO), part of the Arizona State Parks Division. The SHPO trains volunteers who monitor hundreds of sites around the state. These stewards report vandalism to land managers. The Bureau of Land Management in Arizona has also been effective in protecting and improving many rock art sites.

The Phoenix Parks and Recreation Department has done a remarkable job of preserving the vast number of urban rock art sites found at South Mountain Park. The Pueblo Grande Museum has an ongoing public education program to teach the public about the fragility and value of these treasures. Phoenix had adopted a comprehensive preservation management plan to battle one of the most severe threats to the rock art at South Mountain: graffiti. Graffiti removal is a priority, as graffiti seems to attract more graffiti. The city has installed a number of interpretive signs, constructed improved trails at several popular sites, and restored sites damaged by vandalism. Some areas of the park have been closed to vehicular traffic, and park rangers regularly monitor most of the sites. State site stewards also safeguard a number of the more critical areas in the park.

To report vandalism in Arizona, call Arizona Game & Fish, (800) VAN-DALS (826-3257). For other useful numbers, see the Resources listing at the end of this book.

ARIZONA SITES

Site AZ-1
CANYON DE CHELLY NATIONAL MONUMENT

Map locators: DeLorme 35 A4
Information: Canyon de Chelly National Monument, (928) 674-5500; Web site, www.nps.gov/cach/
Fees: No entrance fee. Fees for permit and guide required for almost all rock art.
Directions: From I-40 at Chambers, take US 191 north to Chinle. Follow the signs to the site.

People have been living in Canyon de Chelly (de SHAY) for over 2,500 years. Many Navajo families still live and farm here, and they consider it a sacred place. The Ancestral Puebloans (Anasazi) were the first permanent inhabitants. They began occupying the canyon around 400 A.D. and continued to flourish here for a thousand years.

The Ancestral Puebloans left many petroglyphs and pictographs behind. Thus Canyon de Chelly has some excellent rock art. Much of it is associated with the many pueblo ruins in the canyon, but there are several lone rock art sites scattered about as well. There are many interesting images here, including Kokopelli (the humpbacked flute player), bighorn sheep,

Ruins of Ancestral Puebloan cliff dwellings at Canyon de Chelly. You can see petroglyphs high on the wall.

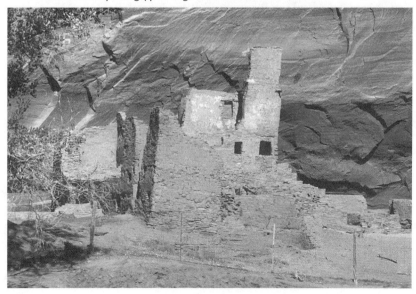

anthropomorphic figures, handprints, and many abstract designs. Another common motif is the turkey, which the Ancestral Puebloans domesticated more than a thousand years ago.

About 700 years ago, the ancestors of the Navajo people first migrated into this region from northern Canada. Within a century the Ancestral Puebloans had disappeared, and the Navajo evolved as a Puebloan culture. They added their own rock art, often showing images of horses and riders with hats; these are either Spanish explorers or cowboys, obviously non-Indians.

Site AZ-2
CHEVELON CANYON/ROCK ART CANYON RANCH

Map locators: DeLorme 43 C6
Information: Rock Art Canyon Ranch (privately owned), (928) 288-3260 (free brochure); call for access, as the gate is locked to control vandalism.
Fees: Suggested donation for entry.
Directions: The ranch is about 25 road miles southeast of Winslow. Call for directions.

The Chevelon Canyon site is on Rock Art Canyon Ranch, which is private property, so you have to call ahead. The site contains some of the best Prehistoric Puebloan petroglyphs in the region. In addition, Archaic petroglyphs here are believed to date back over 4,000 years.

This is a great spot to spend an afternoon in. Visitors can see hundreds of petroglyphs on the varnished sandstone walls along the base of the canyon. Images include anthropomorphs with headdresses and patterned bodies and zoomorphs with antlers. You can drive to the top of the canyon and climb down the short distance to the bottom.

Call for a free brochure, which outlines some of the many activities and things to see at the ranch. Contributions are used to make improvements to the site.

Coconino National Forest. See V-Bar-V Ranch.

Davis Dam. See Inscription Rock at Davis Dam.

Site AZ-3
DEER VALLEY ROCK ART CENTER

Map locators: DeLorme 57 A5
Information: Deer Valley Rock Art Center, (623) 582-8007; Web site, www.asu.edu/clas/anthropology/dvrac/; Bureau of Land Management, Phoenix, (623) 580-5500
Fees: Entrance fee. Tours available.

Deer Valley Rock Art Center, northwest of Phoenix, is a great place for the rock art enthusiast, as it is devoted entirely to the study of rock art. The gift shop stocks dozens of books and rock art–related items, and the center has numerous exhibits and interpretive displays.

The best feature of the center is the quarter-mile-long Hedgpeth Hills Petroglyph Trail, which features over 1,500 petroglyphs concentrated along the lower slopes of the Hedgpeth Hills. The level trail follows the base of the hill, where you will see hundreds of glyphs on numerous panels along the way.

The petroglyphs are believed to have been made by Archaic, Hohokam, and Patayan peoples. Images include animals, humans, and abstract shapes such as spirals and parallel lines. The trail guide that is available at the center shows each significant place along the trail.

Site AZ-4
GRAND CANYON NATIONAL PARK

Map locators: DeLorme 31 A6
Information: South Rim Visitor's Center, Grand Canyon National Park, (928) 638-7888; Web site, www.nps.gov/grca/grandcanyon/south-rim/index.htm/
Fees: Entrance fee. Tours also available.
Directions: From Flagstaff, take US 180 north about 80 miles to park entrance. From Williams, take AZ 64 north about 60 miles to park entrance. Directions to the site on Bright Angel Trail are described below. Tours are available for additional sites.

The original inhabitants of the Grand Canyon are believed to be the Pinto Basin Desert Culture, who lived here at least 4,000 years ago. There is no evidence that they left any rock art in the area, but their followers, the Ancestral Puebloan, and later the Hopi, did. Another group who left petroglyphs, a subculture of the Yuman-speaking Patayan known as the Cohonina culture, occupied the south rim of the Grand Canyon from around A.D. 750 to 1100.

There are numerous rock art sites in the Grand Canyon, but most of them are accessible only by raft along the Colorado River or by long hikes from the canyon rim. One site can be seen from the Bright Angel Trail, a trail used by mule trains as well as pedestrians. About ¼ mile down the trail from the rim is a rock arch. Just past the arch, look up on the canyon wall to your left, about 75 yards above you, to see a group of red pictographs on the rock face. The pictographs, primarily small images of animals, can best be seen with binoculars. (See color plate 2.)

Site AZ-5

HOMOLOVI RUINS STATE PARK

Map locators: DeLorme 43 B6
Information: Homolovi Ruins State Park, (928) 289-4106; Web site,
www.pr.state.az.us/parks/parkhtml/homolovi.html
Fees: Entrance fee. Camping available.
Directions: From I-40, take exit 257 and follow the signs to the visitor
center. Directions to sites are available at the center.

Along the Little Colorado River, a few miles east of Winslow, Homolovi Ruins
State Park consists of four clusters of Prehistoric Puebloan ruins and several
rock art sites. Hopi Indians reside in the area now. They are thought to
be the descendants of the Ancestral Puebloan culture, which disappeared
about A.D. 1400.

Homolovi is on a shallow floodplain basin of the Little Colorado, which
floods frequently in wet years. It is believed that the Ancestral Puebloan
moved here from the Four Corners area during a prolonged drought, when
the area flooded only once a year in early spring, making it ideal for farm-
ing cotton. In the late fourteenth century, almost 2,500 people lived here in
at least five villages. All the ruins here are on high ground, where they can't
flood out during the spring runoff. Numerous artifacts including spindles
and looms have been found here, attesting to a strong textile industry. You
can also find bedrock metates here.

An unusual feature of the ruins is the presence of rectangular kivas. The
Ancestral Puebloan traditionally built round kivas, and the Mogollon usu-
ally built square ones. It is believed that the architecture at Homolovi devel-
oped over a period of time, from round pit houses to square or rectangular
ones, and that this style of architecture carried over to the pueblos and
kivas, which were built later.

Petroglyphs can be seen in two of the ruins (Homolovi IV and IV West).
Among the images are zoomorphs, such as a canine figure, and anthropo-
morphs, including flute players and masked figures thought to be kachinas,
or supernatural beings.

Honanki Ruins. See Palatki Ruins.

Site AZ-6

INSCRIPTION ROCK AT DAVIS DAM

Map locators: DeLorme 36 A1; USGS AZ-0395 (Davis Dam)
Information: Davis Camp, Mojave County Parks, (928) 754-7250
Fees: Entrance fee.
Directions: From Bullhead City, Davis Dam is very prominent and easy to
find. Take AZ 95 north to the Davis Camp entrance, on the Arizona side of
the Colorado River. Directions to Inscription Rock are described below.

Near the south end of Davis Dam in Bullhead City, along the paved road
leading to the dam's maintenance buildings, is an ample area to park off

the road within a stone's throw of some of the petroglyphs. You must pay an entrance fee at the park gate to get access. Past the gate a short distance is a fork. Take the right one, which leads to the dam. At the gate to maintenance buildings is a rocky point on the right, where you can see several petroglyph boulders from the pavement.

The site has not been improved, and there are no trails. Rather than go scrambling up the hill, please stay at the bottom and use binoculars. Use a telephoto lens to take pictures; you will have no trouble getting good photos this way without disturbing the area.

K5 Ranch. See Springerville.

Kaibab National Forest. See Keyhole Sink; Laws Spring.

Site AZ-7
KEYHOLE SINK

Map locators: DeLorme 41 A6; USGS AZ-2518 (Sitgreaves Mountain)
Information: Williams and Forest Service Visitor Center, Kaibab National Forest, (928) 635-1418; Web site, www.fs.fed.us/r3/kai/recreation/sites_wc_keyhole.html
Fees: None.
Directions: From Williams, take I-40 east to the Pitman Valley exit. Take Historic Route 66 east about 2 miles to the Oak Hill Snowplay area. Park in the parking lot there and look for the trailhead on the north side of the road. The site is an easy 1-mile walk through the pine forest.

The Kaibab National Forest near Williams has numerous archaeological sites, including the rock art at Keyhole Sink, a scenic little box canyon. The walls of the canyon are carved with 1,000-year-old petroglyphs (probably Sinaguan) depicting animals and hunting scenes. With a spring at the base of the cliff and several hiding places, the area was obviously a good ambush spot for wild game.

There are two distinct petroglyph panels on the cliff face. One is a hunting scene showing a herd of deer entering the canyon, possibly an example of a hunting-magic glyph. The other panel is a group of geometric designs, anthropomorphic and possibly zoomorphic figures. The panels are pretty faded, so you must look closely to make out some of the images.

Kings Canyon. See Saguaro National Park.

Site AZ-8
LAWS SPRING

Map locators: DeLorme 31 D6; USGS AZ-2536 (Squaw Mountain)
Information: Williams and Forest Service Visitor Center, Kaibab National Forest, (928) 635-1418

Fees: None.

Directions: From Williams, take I-40 east to AZ 64. Go north about 5 miles to Spring Valley Road (FR 141) and turn right. Go about 7 miles to FR 730 and turn left (north). Continue north about 2³/₁₀ miles to a fork in the road. Take the left fork (FR 115) for about 2 miles to FR 2030. Follow this road to the Laws Spring trailhead. From the trailhead, it is about a ¼-mile hike to the springs.

Another public rock art site in the Kaibab National Forest is at Laws Spring, southwest of Squaw Mountain, about 12 miles north of Keyhole Sink. To get to this site, you have to take dirt Forest Service roads; a high-clearance vehicle is advised, and it is best not to travel in or after bad weather.

This petroglyph site was used as early as 4,000 years ago. Most of the glyphs were made by people of the Prehistoric Cohonina culture between A.D. 700 and 1000. Images include abstract anthropomorphs, spirals, and geometric shapes. You can also see initials carved by nineteenth-century emigrants who traveled along the historic wagon trail that passed near the spring.

Site AZ-9
LITTLE BLACK MOUNTAIN

Map locators: DeLorme 21 A3; USGS AZ-0807 (Lizard Point)
Information: Bureau of Land Management, St. George, UT,
(435) 688-3246
Fees: None.
Directions: From I-15 in Utah, take exit 6 to Riverside Drive in St. George. Go south to the Arizona border sign. The turnoff to Little Black Mountain is about ½ mile farther down the road, on your left. Follow this road for about 4½ miles to the site. This road is not regularly maintained, so conditions can vary. During wet periods, four-wheel-drive vehicles may be necessary.

Near the Utah border, south of St. George, is the Little Black Mountain Petroglyph Site. Over 500 glyphs can be seen along the base of the sandstone cliff, both on the cliff face itself and on nearby boulders. There are several cultures represented by the rock art here, including various branches of Prehistoric Puebloans. Zoomorphs such as turtles, lizards, sheep, and bear paws, as well as anthropomorphs, may be seen here. Some glyphs are believed to be Virgin River Puebloan, so you might want to compare them to those found at Valley of Fire in Nevada.

This site has been fenced to protect it from off-road vehicles, and it has been improved with graveled trails, interpretive signs, and a toilet. Watch yourself, as there are known to be rattlesnakes, scorpions, and poisonous spiders in the area.

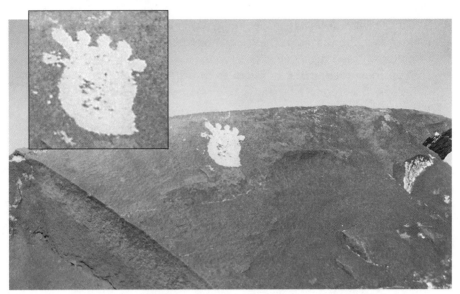

An unusual petroglyph found at Little Black Mountain is this human footprint with six toes.

Site AZ-10
LYMAN LAKE STATE PARK

Map locators: DeLorme 53 A5; USGS AZ-0832 (Lyman Lake)
Information: Lyman Lake State Park, (928) 337-4441; Web site,
www.pr.state.az.us/Parks/parkhtml/lyman.html
Fees: Entrance fee. To see Ultimate Petroglyph Rock, ranger-guided tours
(via boat) available seasonally for additional fee. Camping available.
Directions: From St. Johns, take US 180/191 south to the park entrance.
Ask for map and directions at the visitor center.

Located along the upper Little Colorado River, between Springerville and St. Johns, Lyman Lake State Park has both ranger-guided and self-guided tours to its prominent petroglyph sites. The easy self-guided tour is along the ¼-mile-long Peninsula Trail, accessible from the campground. There is day-use parking at the trailhead. Across the lake is a second sight, called Ultimate Petroglyph Rock. It can be reached by boat and a ½-mile hike or by a several-mile hike around the lake. More glyphs are scattered among the boulders on the east side of the lake.

Archaeologists have extensively studied the glyphs in this area. The scientists also consulted with native Hopi people about the rock art's meaning. The earliest glyphs, apparently made by Paleo-Indian or early Archaic cultures, could be more than 8,000 years old. These are mostly rectilinear and curvilinear abstract designs deeply pecked into the rock.

Other glyphs, probably made during the Basketmaker period, could be more than 1,500 years old. These are also rather abstract and often consist of patterns called meanders. The Hopi believe some of these are maps, showing how their ancestors migrated into this country from the north. Others are believed to be clan markers. Images of curvy lines are thought to be snakes or water gods.

Later glyphs show people growing corn, giving birth, and hunting, clearly an indication that they were thriving here. These were probably made by the Ancestral Puebloans. There is one distinct glyph of a flute player, different from the common Puebloan image of Kokopelli in that he does not have a hump on his back, but that he is a man is very evident. Another interesting glyph is that of a cranelike bird. It is very stylized but similar to waterbird images found in the Petrified Forest and Beaver Creek areas. This may be a clan marker of the Crane clan.

Nearby, at Rattlesnake Point, is a pueblo ruin with several excavated rooms. Lyman Lake is also a great place to camp, picnic, and fish in the spring, summer, and early fall.

Newspaper Rock. See Petrified Forest National Park.

Site AZ-11
PAINTED ROCKS CAMPGROUND

Map locators: DeLorme 56 D1
Information: Bureau of Land Management, Phoenix, (623) 580-5500; Web site, phoenix.az.blm.gov/paint.htm
Fees: Day use and camping fees.
Directions: From Gila Bend, take I-8 about 12½ miles west to Painted Rocks Road (exit 102). Go 10⁷⁄₁₀ miles north on this paved road to an intersection at a curve in the road with a large sign to the site and campground, about ½ mile farther.

Painted Rocks Campground is adjacent to a renowned rock art site with over 750 petroglyphs on an isolated outcrop of boulders, including anthropomorphs, zoomorphs, and geometric shapes. There are also numerous traces of ancient canals nearby, left here by the Hohokam culture. The site is well marked and has been improved by the Bureau of Land Management. In fact, it is an excellent example of a site developed for public visitation. There is a large fenced parking lot, ramadas for shade, and restrooms. There are also basic camping and picnic areas here, but no water. The signs are mostly about how to conduct yourself at the site and do little interpreting.

The site itself is also quite impressive. It occupies a small rock outcrop in the middle of a flat desert. Some small boulders are completely covered in glyphs, and there are more on the larger rocks at the southern end.

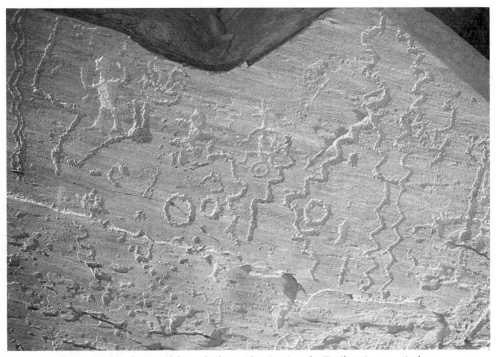

A petroglyph panel found along the Peninsula Trail at Lyman Lake

Hohokam Gila Petroglyph–style panels at Painted Rocks

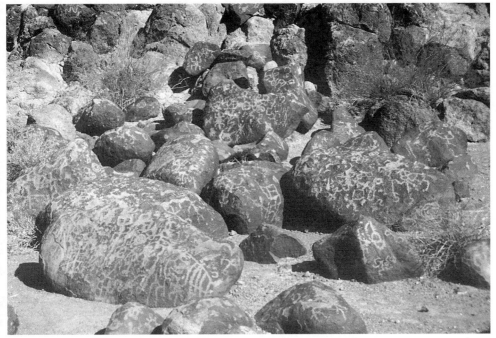

Site AZ-12
PALATKI RUINS

Map locators: DeLorme 42 C1
Information: Palatki Ruins Visitor Center, (928) 282-3854; Sedona Ranger
Station, (928) 282-4119
Fees: Entrance fee.
Directions: The Sedona Ranger District Station is at 250 Brewer Road in
Sedona. Brewer Road is the first left south of the intersection of AZ Alt. 89
and AZ 179; there is a sign for the ranger station. The visitor center is nearby.
To get to the sites, take AZ Alt. 89 west about 5 miles. The turnoff onto front-
age road 525 is between mileposts 365 and 364, on the right. Follow the signs
to the sites. This is a rough and dusty dirt road, but it should be passable in
dry weather.

The Sedona region has been occupied for over 8,000 years. The most no-
table culture to live here were the Sinagua people, from about A.D. 1150
to 1300. The Palatki and Honanki Ruins, near Sedona, were left behind by
the Sinagua.

Palatki contains the ruins of two small cliff dwellings. On the rock face
above the eastern pueblo are two shieldlike pictograph figures that many
believe to be clan symbols. The Red Cliffs area, about ½ mile to the west,
has several alcoves with rock art, spanning perhaps more than 6,000 years.
Fragile red, white, and black pictographs can be seen on the walls, drawn
there by the Sinagua and later cultures who moved into the area. (See color
plate 3.)

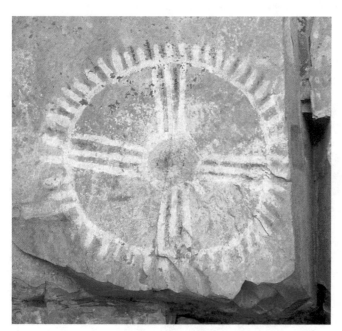

*A Sinagua
pictograph at
the Red Cliffs
site at Palatki
Ruins*

Palatki has other pictographs, believed to be made during the Archaic period of 3,000 to 5,000 years ago, long before the pueblos were built. The Archaic pictographs are primarily geometric figures such as rakes, squiggles, and dot patterns. The petroglyphs believed to be the oldest might predate the Archaic red pictographs.

There are a couple of panels of "pits," in a style similar to the Great Basin Archaic pit-and-groove style, which is believed by many to be the oldest form of rock art. In addition, there are many panels of deeply grooved narrow lines in the rock, which are a mystery. These lines are also believed to be very old because later glyphs were painted or drawn on top of them. Another rare form of rock art found here is a type of pictograph made with a relatively thick layer of mud or clay in the form of a distinct figure, such as a circle or quadruped. It is not known how old these glyphs are.

The Sinagua people left their marks on the rocks also, mostly in the form of white pictographs. More recent drawings done in charcoal are believed to have been left by either the Yavapai or the Apache people. An unusual glyph here is a double square-wave form with a serpent's head, possibly a Sinaguan version of the Hohokam pipette symbol. Several reddish figures found here represent another unusual motif, similar to Barrier Canyon–style carrot men and ghost figures found commonly in Utah and northwestern Colorado. These are believed to have been made over 2,000 years ago.

There is a small visitor center and bookstore, run jointly by the Friends of the Forest and the Arizona Natural History Association, a short distance from the Sedona Ranger District Station. You should allow at least one or two hours to appreciate the site, so call ahead for visitor center hours. The entrance gate is closed about half an hour before the site itself closes. If there has been rain or snow recently, I recommend you contact the Sedona Ranger Station to learn the condition of the roads to Palatki—if the roads are unpassable, the site will be closed.

Site AZ-13
PETRIFIED FOREST NATIONAL PARK

Map locators: DeLorme 44 B3
Information: Petrified Forest National Park, (928) 524-6228; Web site, nps.gov/pefo/
Fees: Entrance fee.
Directions: From Holbrook, take I-40 east to exit 311, Petrified Forest National Park. Follow the signs to the Puerco Ruins and Newspaper Rock.

There are two popular rock art sites in Petrified Forest National Park, Puerco Ruins and Newspaper Rock. Get a brochure and map at the visitor center. While you're there, be sure to look at the displays, including one of rock art. The glyphs here are thought to be Prehistoric Puebloan, and possibly some Archaic. Some think they represent a record of the past or perhaps are ancient calendars.

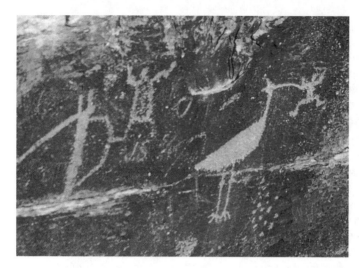

Stork petro-
glyph at the
Puerco Ruins,
Petrified Forest
National Park

The Puerco site is only a short walk from the parking lot at the Puerco Ruins, down a well-marked trail. The glyphs are on rock faces below the ruins. Among the abundance of rock art are some quite interesting images, including masks, animals, and long-beaked birds.

Newspaper Rock is south of Puerco and well below road level. The site is not accessible because of the steep climb necessary to reach it. The Park Service installed a telescope at the overlook, and it provides a fair view of the images on the rock face far below.

Site AZ-14
PICTURE ROCKS RETREAT

Map locators: DeLorme 66 C3
Information: Picture Rocks Retreat, (520) 744-3400
Fees: None, but check in at office.
Directions: The simplest way, from Tucson, is to take I-10 west to exit 246, Cortaro Road; turn southwest and follow it to Ina Road. Turn right (west) to Wade Road. Turn left (south); Wade becomes Picture Rocks Road and leads to Picture Rocks Retreat.

On private property near the northeastern edge of Saguaro National Park, the Picture Rocks site is on a large rock outcrop in a wash behind the Picture Rocks Retreat office. Permission to visit can be obtained from the office. There is a gravel parking area at the trailhead. The glyphs extend for about 20 yards up the wash. Visitors are asked not to climb on the rocks, both for their own safety and for the protection of the sacred Hohokam art. The images are primarily Hohokam human and animal forms, including a line of hand-holding humans and a hunting scene.

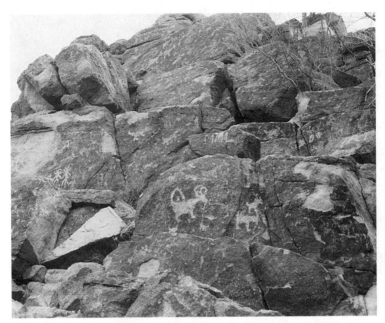

Glyphs at Picture Rocks Retreat

Puerco Ruins. See Petrified Forest National Park.

Rock Art Canyon Ranch. See Chevelon Canyon.

Site AZ-15
SAGUARO NATIONAL PARK

Map locators: DeLorme 66 D3
Information: West Park Visitor Center, Saguaro National Park,
(520) 733-5158
Fees: None.
Directions: From Tucson, take AZ 86 to Kinney Road. Follow Kinney to the Arizona-Sonora Desert Museum. The trailhead into Kings Canyon is across from the museum; directions to the two Kings Canyon sites are described below. To get to the Signal Hill site, follow Kinney Road until it turns into Golden Gate Road. Keep going to the Signal Hill (Bajada Loop) trailhead and picnic area. The trail to the Signal Hill site is about ¼ mile long; there are several good interpretive signs.

The two public rock art areas in the Saguaro National Park (West District), just west of Tucson, are Kings Canyon and Signal Hill. Most of the earlier glyphs here were made by late Archaic cultures and later ones by either the Hohokam or the Salado people.

Kings Canyon has two sites, representing over 300 designs in all. The first is an easy 1-mile hike from the trailhead near the museum. The petroglyphs

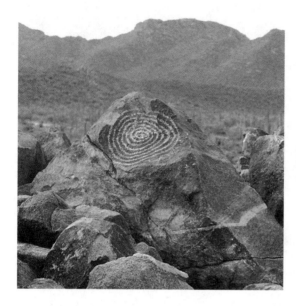

This glyph at the Signal Hill site in the Saguaro National Park is believed to be a solar marker.

are near a small dry creekbed that cuts through the canyon. Just past the creekbed on your right is a large outcrop of bedrock with a flat surface. There are two indentations in this rock that were probably used as mortars, but they may be filled with sand and hard to spot.

The second site is about a mile farther up. Continue along the wash, climbing up three dry falls. At the top of the third one are the petroglyphs, on the boulders and canyon walls. Here are typical Hohokam-style human and animal figures and spirals. The heavily patinated geometric designs including grids, rakes, and zigzags, are probably Archaic.

The Signal Hill site, with over 200 designs, is on a rugged volcanic hill that commands a good view of the surrounding desert. Rattlesnakes inhabit the rocks along the trail. A pipe fence protects the glyphs and interpretive signs. There are a few quadruped glyphs here, but most of the petroglyphs are geometric shapes. At least one is a celestial marker, a prominent spiral that catches the light of the rising sun at the summer solstice.

Signal Hill. See Saguaro National Park .

Site AZ-16
SOUTH MOUNTAIN PARK

Map locators: DeLorme 57 B5
Information: South Mountain Park, (602) 495-0222; Web site, www.phoenix. gov//parks/hikesoth.html; Environmental Education Center, (602) 534-6324; Pueblo Grande Museum and Archaeological Park (toll-free), (887) 706-4408; Boy Scout station, (602) 276-8656

Fees: No entrance fee to park; interpretive hikes at Environmental Educational Center may have additional fee. Rock art tours can be arranged through the Pueblo Grande Museum in Phoenix; admission fee for museum. Additional tours available locally.

Directions: The park is on southernmost edge of Phoenix. The main entrance is at south end of Central Avenue, just past Dobbins Road. Trails to various sites are marked.

South Mountain Park in Phoenix is the nation's largest city park, with over two million visitors each year. Eleven miles across, the park has abundant Hohokam rock art. Of the approximately 8,000 petroglyphs in the park, most are around 800 years old. Anthropomorphic stick figures are the most common, but geometric designs and a variety of other images also abound.

Some of the easiest sites to find are at Inscription Rock, along the Desert Classic Trail near the Pima Canyon parking lot. There is another prominent panel about a mile down Pima Canyon, where the Pima Wash Trail meets the National Trail. The panel is on the north side of the trail.

Even easier to reach is Box Canyon, near the Holbert Trail. At the paved parking lot just south of the main park entrance, to the right along the base of the hill, are several panels you can see from the pavement. There is more rock art just inside the entrance to Box Canyon, on your left and above your head. You can also see panels all along the north side of the canyon, some on large boulders at the bottom and some on the cliff faces near the top.

Entrance to Box Canyon. Look for petroglyphs on your way in.

Go to the Boy Scout station at 20th Street and Dobbins Road for access to the Hieroglyphic (Geronimo) Trail. This trail has some excellent rock art, but you must obtain permission and directions.

For further information on Phoenix-area rock art and archaeology, visit the Pueblo Grande Museum in southeastern Phoenix. The museum is dedicated to the study and preservation of Hohokam culture. On the grounds are the ruins of a 1,500-year-old Hohokam village.

Site AZ-17
SPRINGERVILLE/K5 RANCH

Map locators: N/A
Information: K5 Ranch/Reeds Motel, (800) 814-6451; Web site, www.k5reeds.com
Fees: Guide required; register at Reeds Motel in Springerville.
Directions: Reeds Motel is at 514 E. Main in Springerville.

Springerville is near where the Ancestral Puebloan and Mogollon cultures overlapped along the upper Little Colorado River. At Springerville and upstream, ruins indicate Mogollon peoples were prevalent, and downstream the Ancestral Puebloan were dominant. There are numerous pristine rock art sites along the river in the Springerville area, but most of them are on private property and accessible only by guided tour.

One of the major rock art tours in the area is offered at the K5 Ranch. Guides both on foot and horseback can take visitors to some of the most spectacular rock art sites in the region. These tours can even be customized to your needs. Small groups only.

Site AZ-18
V-BAR-V RANCH

Map locators: DeLorme 42 D1; USGS AZ-0242 (Casner Butte)
Information: Sedona Ranger Station, (928) 282-4119; Web site, aztec.asu.edu/aznha/vbarv/vbarv.html
Fees: Parking pass required; obtain at ranger station.
Directions: From Sedona, take AZ 179 south to Forest Road 618. Go 2⁸⁄₁₀ miles on this narrow paved road past the Forest Service campground to Beaver Creek. Across the bridge, the entrance to the ranch is immediately to the right. From the parking area, the site is down a short trail, beneath the many trees along Beaver Creek.

The Sinagua people occupied the Verde Valley region of Arizona along the Verde River from 600 to 1,400 years ago. In the Coconino National Forest, south of Sedona, is the V-Bar-V petroglyph site along Beaver Creek, a major tributary of the Verde River. There are thirteen panels here, containing 1,032 individual petroglyphs.

In many cases, the glyphs are actually touching or connected by meandering lines. All are in the characteristic Sinagua Beaver Creek style, found exclusively in the eastern Verde Valley. An interesting point about this site is that there are no glyphs of the earlier Archaic or later Yavapai or Apache styles here, as there are in other Sinaguan rock art sites.

There are other sites nearby, but most of them are difficult to find. One site is on the left side of the road as you are heading back to the highway, just across the Red Tank Draw bridge. This is not an improved site, but it is well known and frequently visited by locals.

Site AZ-19
WHITE TANK MOUNTAIN REGIONAL PARK

Map locators: DeLorme 56 A3
Information: White Tank Mountain Regional Park, (623) 935-2505; Web site, www.maricopa.gov/parks/white_tank/; Pueblo Grande Museum and Archaeological Park, (602) 495-0901; Web site, www.ci.phoenix.az.us/parks/pueblo.html
Fees: Entrance fee. Guided hikes may require additional fee.
Directions: From Phoenix, take AZ 101 north to Olive Avenue, then go west to the park entrance. Follow signs to the trailhead.

White Tank Mountain Park, a county park just west of Phoenix, has some of the best examples of Hohokam rock art to be found anywhere. According to a brochure, most of the rock art here is Hohokam, but some glyphs are believed to have been made by Archaic cultures and some possibly by Paleo-Indians of 8,000 years ago.

Waterfall (Box) Canyon, a popular destination for local hikers, is a great place to look for Hohokam petroglyphs. The trail is user-friendly and suitable for young and old alike. It has many good sites along its easy 1-mile length, and at its end, you might be further rewarded with a wade in the cool water usually found here. If you are lucky enough to be here on a day after it has rained, you might even get to see the 75-foot-high waterfall at the trail's end. The largest group of glyphs is at "Petroglyph Plaza," about halfway along the trail. There is another site near the entrance to Box Canyon.

The Goat Camp Trail has another rock art panel. Within about ten minutes' walk from the trailhead are some petroglyphs on a large black boulder just north of the trail. They consist of abstract geometric figures. One resembles a sunburst, and others are just wavy lines. Another trail with petroglyphs is the Black Rock Loop Trail, which is about two miles long, round-trip. The first part of this trail is wheelchair accessible. There are several panels on a black rocky outcrop about ¼ mile in.

Site AZ-20
X DIAMOND RANCH

Map locators: DeLorme 53 C5; USGS AZ-0599 (Greer)
Information: X Diamond Ranch, (928) 333-2286; Web site, www.xdiamondranch.com
Fees: No entrance fee. Guide recommended; no set fee but tip or donation appreciated. Register at ranch.
Directions: From Springerville, take AZ 260 west to County Road 4124 (South Fork Road), near milepost 391, and continue to the ranch headquarters. There are a few signs along the way, but they are not very prominent.

Another place with a great deal of upper Little Colorado River rock art is on X Diamond Ranch property west of Springerville. There are a number of Mogollon ruins in this area, with rock art nearby. You must check in at the ranch to see the sites, and a guide is recommended.

There is also a small petroglyph site along the South Fork Road on the way in to the X Diamond Ranch, approximately 1⁴⁄₁₀ miles from AZ 260 on South Fork Road. It is about 8 feet off the pavement and highly visible, so you can see it without leaving the comfort of your car.

A well-known petroglyph site at X Diamond Ranch

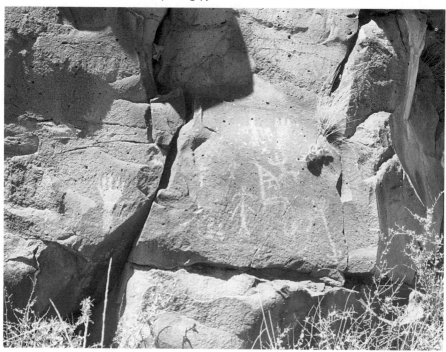

6

Inland Southern California

There are petroglyphs, pictographs, and even geoglyphs in southern California, but petroglyphs are by far the most numerous. In the desert areas, Indians produced mostly petroglyphs; those in the wetter regions to the west made pictographs. Designs range from abstract geometric patterns to elaborate scenes of humans and animals. The diversity in styles is attributable to the many different cultures that have inhabited this region over the past 8,000 years.

Site Preservation

Southern California seems to have a greater vandalism problem than most areas, probably because of the high population density. There have been many instances of graffiti, and at one BLM site a petroglyph was stolen. Burdened with this problem, California's Bureau of Land Management has undertaken an unusual approach to rock art preservation. It is now publicizing many well-known and heavily visited sites throughout the state, listing descriptions, maps, and directions on its Web site and offering information on site etiquette and preservation. Russ Kaldenberg, California BLM state archaeologist, believes that keeping rock art sites secret is no longer an effective way to protect them. In his view, the presence of responsible visitors, especially to certain remote sites, will act as the best deterrent to vandals.

Nevertheless, many sites simply have to be shut down, at least temporarily. Due to frequent closures, I have omitted many of the sites I would have liked to have included, such as the Indian Canyons at Agua Caliente, Bishop Petroglyph Loop, Fish Trap Archaeological Site, and others. Death Valley National Park has rock art sites, but they aren't well publicized, and I did not list the park here. I also omitted the site at Barker Dam, in northwestern Joshua Tree National Park, because the panels there were all but destroyed some years ago when a movie crew painted over the petroglyphs to make them more visible. I have been

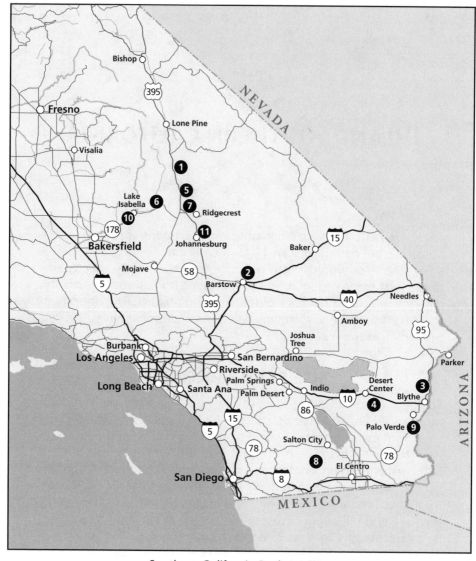

Southern California Rock Art Sites

1. Ayers Rock
2. Barstow Area
3. Blythe Intaglios
4. Corn Springs
5. Fossil Falls
6. Kern Nos. 317 and 878

7. Little Petroglyph Canyon
8. Morteros Village and
 Smuggler Cove
9. Palo Verde Petroglyphs
10. Slippery Rock
11. Steam Well

advised by my legal counsel not to name the large and powerful motion picture company believed responsible for this desecration, but the site is sometimes referred to as the "Disney Panel." (See color plate 4.) To arrest the trend of vandalism and restore public access to these remarkable places, I encourage everyone to support the various rock art preservation organizations in their efforts to protect and manage endangered sites.

Most of the sites the BLM lists are generally well known, near good roads and easily accessible. Each of these sites has had, or is scheduled to have, improvements such as signs, fences, paths, registration boxes, and marked parking areas. Some also have restrooms and trash cans. Furthermore, the BLM has trained a number of stewards to monitor the sites regularly. In addition to the Web site (http://ceres.ca.gov/ceres/calweb/blm.html), the California BLM, in a joint effort with the State Historic Preservation Office (SHPO), has produced an excellent brochure called "Rock Art of Native California." You can purchase it from most California BLM offices for a nominal fee.

Making the public a partner in helping preserve these precious and sacred places exerts significant social pressure on would-be vandals and looters. While this program has not totally stopped vandalism, it has reduced the severity of the problem markedly, at least at some sites. It seems to work better than the keep-it-a-secret policy of the past. In one official's opinion, paraphrased, when we include the public in caring for rock art sites, most people rise to the challenge and accept the responsibility. Another official, BLM archaeologist Sarah (Sally) Cunkelman, noted, "Ultimately these sites belong to the public, and protection of them is up to the American people."

Report vandalism to any California BLM office (see Resources).

INLAND SOUTHERN CALIFORNIA SITES

Anza-Borrego Desert State Park. See Morteros Village.

Site CA-1
AYERS ROCK

Map locators: DeLorme 40 D1; USGS CA-0403 (Cactus Peak)
Information: Bureau of Land Management, Ridgecrest, (760) 384-5400
Fees: None.
Directions: From Ridgecrest, take US 395 north to Coso Junction. Take Gill Station Road east about 3⁸⁄10 miles, then turn left (north) onto a small dirt road and go a little over 4 miles to a (sometimes) locked gate. A small, narrow dirt road leads uphill to the left. Follow it about ½ mile, past the Pictographs sign, to the parking area. There is a marked ¼-mile trail to the site.

Believed by some researchers to have been made by a Coso Shoshone rainmaker shaman, the pictographs at Ayers Rock may be about 200 years old or less. Its age is indicated by the image of a horse and rider, originally painted in red, purple, orange, and black. Besides the horse and rider, there are images of bighorn sheep, two large shamans or mythical beings with headdresses, elk or deer, and another small animal. The site has been badly vandalized within the last few years. This is an endangered site.

Site CA-2
BARSTOW AREA

Map locators: See below
Information: Bureau of Land Management, Barstow, (760) 252-6000
Fees: Generally none; tours available locally.
Directions: Described below.

There are so many rock art sites in the Barstow area, I have lumped them into one heading. This area hosts around 10,000 documented petroglyphs, pictographs, and geoglyphs, petroglyphs being by far the most common. One site, Buzzard Rock, is right in town. Perhaps the best-known area for rock art is Inscription Canyon. Other sites may be found in the Rodman Mountains. The Mojave River Valley Museum in Barstow also has exhibits and programs about rock art.

Archaeologists have found evidence of at least 10,000 years of human habitation in the Barstow area, first by Archaic cultures and more recently by the Shoshone, Southern Paiute, Kawaiisu, and Serrano. Many of the petroglyphs in this area were done in Great Basin curvilinear and rectilinear styles, dated as early as A.D. 1000. Others, including those depicting atlatls, are even older. Glyphs portraying visions and supernatural beings are likely shamanistic. The most common animals shown are bighorn sheep and rattlesnakes, both considered shaman spirit guides.

Unfortunately, this region has sustained quite a bit of damage to its rock art from vandalism and carelessness. Still, much remains in good condition, and the sites are well worth visiting.

Inscription Canyon and Black Canyon
Map locator: DeLorme 67 C6

Note: At the time of this writing, legal issues had arisen regarding access to the Black Mountain area, so please check with the Barstow BLM before you go.

The Black Mountain area contains some of the most spectacular rock art sites in the Mojave Desert, including Inscription Canyon and Black Canyon. Probably made by the Southern Paiute or Kawaiisu, many of the glyphs in Inscription Canyon may represent visions of shamans. The bighorn sheep, a common zoomorph, was a spirit helper of rain shamans. Some of the anthropomorphs have complex geometric patterns, thought to be signs of power. Serrano white pictographs of zoomorphs and geometric forms may also be seen here.

At Black Canyon, petroglyphs pepper both sides of the steep basalt cliffs. Like the images at Inscription Canyon, many of them were likely made by shamans on vision quests. Some glyphs combine human and animal forms, possibly representing supernatural transformation.

The Black Mountain area is about 30 miles northwest of Barstow. A four-wheel-drive vehicle is recommended, especially in wet weather. To get there from Barstow, take Irwin Road north and east to Copper City Road, on the left. Take Copper City Road about 15 miles north, where it splits off to the left (west) and a few miles farther becomes Black Canyon Road (BLM route EF373). Stay on this road about 10 more miles. Inscription Canyon is on the left, where a dirt road takes you along the base. The petroglyphs appear along both walls of the north-south canyon and can be seen from the road. For Black Canyon, continue west/southwest on Black Canyon Road from Inscription Canyon about 6 miles. Turn left on BLM route C283 and follow the canyon wash to a sign on your right marking the petroglyphs.

Rodman Mountains
Map locator: DeLorme 82 C3

The Rodman Mountains, about 30 miles southeast of Barstow, were occupied by the Serrano (Vanyume) Indians. Of the two major rock art sites in the area, Surprise Tank and Howe's Tank, only the location of Surprise Tank is publicized. Both tanks were important watering holes along the trade route between the Colorado River and the Pacific Coast.

Surprise Tank is a narrow streambed carving the lava rock for about a hundred yards. Some of the petroglyphs here date back over 11,000 years; others are much more recent. Zigzag patterns, representing rattlesnake spirit helpers, are common. Other images include bighorn sheep, handprints, and humans.

To reach Surprise Tank, take I-40 east from Barstow to Daggert. Continue east on the south frontage road, which becomes Camp Rock Road, about 25 miles. There, Camp Rock Road turns sharply right and heads to the Lucerne Valley. Straight ahead is a dirt road, Cinder Cone Road (BLM road OJ228). Take Cinder Cone Road about 6½ miles to BLM road OJ223, on the right (east). Follow this road (along which are also a possible intaglio and a possible Native American rock alignment, both of which are fenced) about 1⁸⁄₁₀ miles to a flat area where you can park. Surprise Tank is directly ahead. Walk along the wash to the site.

Black Canyon/Black Mountain. See Barstow Area.

Site CA-3
BLYTHE INTAGLIOS

Map locators: DeLorme III B6; USGS CA-0165 (Big Maria Mountain SE)
Information: Bureau of Land Management, Yuma, AZ, (928) 317-3200; Web site, www.az.blm.gov/yfo/intaglios.html
Fees: None.
Directions: From I-10 at Blythe, take US 95 north about 15 miles. At the sign, take the dirt road west to the two sites.

The giant prehistoric earth figures north of Blythe are very easy to find and visit, which makes them probably the most famous geoglyphs in North America. There are six giant figures here in three locations. Most likely made by the Patayan, or Ancestral Yuman, the intaglios are thought to be at least 450 years old, and some may be more than 2,000 years old. The two most accessible, which some experts have dated at 1,100 years old, are protected by chain-link fences. One is a human shape, the other an

Intaglio of Hatakulya, the mountain lion, as seen from the ground

animal. It is believed that the humanlike figure may represent Mastamho, the creator, or his evil twin, Kaatar. The other is possibly the spirit helper Hatakulya, the mountain lion.

Buzzard Rock. See Barstow Area.

Site CA-4
CORN SPRINGS

> **Map locators:** DeLorme 109 C7; USGS CA-3573 (Corn Spring)
> **Information:** Bureau of Land Management, Palm Springs, (760) 251-4800
> **Fees:** None for entry. Camping available.
> **Directions:** From Desert Center, take I-10 about 9 miles east to the Corn Springs exit. Follow the frontage road about ½ mile, then take the gravel road south for about 7 miles.

Corn Springs is a desert oasis, complete with palm trees, in the Chuckwalla Mountains of the Colorado Desert, east of Desert Springs. Just before the BLM campground at Corn Springs are many petroglyphs on the rocks adjacent to the road. Some are marked with signs. The glyphs continue on around this rock outcrop, but you have to get out of your car to see many of them. Be careful where you stop, as the ground is sandy. Among the glyphs scattered around the area, some of the best are on the south side of the wash.

Most, if not all, of the glyphs at Corn Springs are geometric patterns. Some incorporate natural features of the rock into the pattern—one glyph uses a long, thin vein of quartz as a baseline for a series of semicircles along its entire length. Several different groups probably made the various panels over the past few thousand years. The Chemehuevi people moved into this

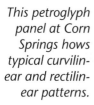

This petroglyph panel at Corn Springs hows typical curvilinear and rectilinear patterns.

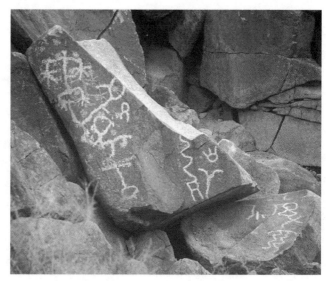

part of southern California about A.D. 1100. This spring was also an important water hole along a route connecting the Yuman-speaking people of the Colorado River with the Desert Cahuilla people of the Coachella Valley. Besides the rock art, evidence of a small temporary village has been found here, probably a resting place for traveling bands.

Coso Range. See Fossil Falls; Little Petroglyph Canyon.

Site CA-5
FOSSIL FALLS

Map locators: DeLorme 51 A7; USGS CA-1351 (Little Lake)
Information: Bureau of Land Management, Ridgecrest, (760) 384-5400
Fees: None.
Directions: From Ridgecrest, take Cinder Road to the BLM Fossil Falls road, on the right. Take the right fork to the falls parking area. A ¼-mile trail leads to the top of the falls.

This Coso Range rock art site is called Fossil Falls, but there are no fossils here. The name comes from the geographic remnant of the falls of an ice age river. Archaeological evidence shows that this area has been heavily used since the end of the last ice age, about 8,000 years ago.

Coso Range rock art is thought to have been made by Prehistoric Numic-speaking cultures. Most of it is dated at A.D. 500 to 1000. There are petroglyphs among the boulders in two small rock alcoves just below the top of the falls, but the site is difficult to spot. It is necessary to scramble among the upper boulders to find the small and faint glyphs. The images here are typical of Coso Range petroglyphs, mostly bighorn sheep and geometric patterns.

A petroglyph at Fossil Falls

Inscription Canyon. See Barstow Area.

Site CA-6
KERN NOS. 317 AND 878

Map locators: DeLorme 51 B6; USGS CA-3573 (Lamont Peak)
Information: Bureau of Land Management, Bakersfield, (760) 384-5400
Fees: None.
Directions: From US 395 at Ridgecrest, take CA 178 west. Between mile-posts 70 and 71, take Chimney Peak (Lamont Meadows) Road north about 2¼ miles to a large rock outcrop on the left. Continue about ¼ mile to a fence and a cattle guard. Look for a very large boulder about 250 yards west of the road, across the wash and slightly up the hill. Walk across the open flat and across the creek bottom to the Kern No. 317 site. For Kern No. 878, continue north, slightly uphill, to a small rock overhang surrounded by boulders. A small BLM sign marks it.

Between Canebrake and Walker Pass in the South Fork Kern River Valley, along the usually dry Canebrake Creek, are two rock art sites worth visiting. The first, Kern No. 317, contains several red geometric pictograph designs. One image here is similar to a sunburst in a circle, and others are long lines with tally marks along their entire length. There are only a few images here, indicating that the site may have been used by only one shaman or other individual, possibly on a dream quest.

Like No. 317, Kern No. 878 consists of red pictographs. These include two stick-figure anthropomorphs, a spoked-wheel design, and other geometric designs. You will also find several bedrock mortars here.

Little Blair Valley. See Morteros Village and Smuggler Cove.

Site CA-7
LITTLE PETROGLYPH CANYON

Map locators: DeLorme 52 D4
Information: Maturango Museum, Ridgecrest, (760) 375-6900; Web site, www.maturango.org
Fees: Fee for guided tour required; register at museum. (Tours are seasonal.)
Directions: Ridgecrest is at CA 178 and US 395. Follow the signs to the museum, at 100 E. Las Flores Ave. (corner of Las Flores and China Lake Blvd.).

The Coso Range in eastern California holds some of the highest concentrations of rock art in the West, but most of the best sites are on the China Lake Naval Weapons Range, which is closed to the public. Fortunately, guided public tours to the best rock art site, in Little Petroglyph Canyon, can be arranged through the Maturango Museum in Ridgecrest in the spring and fall. It is about a three-mile hike from the parking lot to the end of the canyon and back, along a sandy and rocky wash through the bottom of the canyon. The trip takes most of a day.

Little Petroglyph (Lower Renegade) Canyon has over 6,000 images, which have been chipped into the rocks over the past 12,000 years. It is unknown who made the oldest ones, but those dated after A.D. 500 were probably made by prehistoric and protohistoric Numic speakers (Paiute, Shoshone, Ute). Numerous anthropomorphic, zoomorphic, and geometric figures line its walls. Bighorn sheep, atlatls, humans, spirit beings, snakes, and many rectilinear and curvilinear designs also adorn the rock.

A curious thing about this area is that all the bighorn glyphs seem to be of mature male sheep, no females or young. This indicates to some researchers that the images were used in rainmaking ceremonies and ceremonies used to enter the spirit world. Shoshone, Ute, and Paiute shamans traveled from all over the Great Basin to the Coso Range for vision quests and other spiritual rituals.

Mojave Desert. See Barstow Area.

Site CA-8
MORTEROS VILLAGE AND SMUGGLER COVE (LITTLE BLAIR VALLEY)

Map locators: DeLorme 115 D5 and D6; USGS CA-2677 (Whale Peak) and CA-0712 (Earthquake Valley)
Information: Anza-Borrego Desert State Park, (760) 767-5311
Fees: None.
Directions: From Salton City, take CA 86 south to CA 78. Go west to road S-2, then south past Shelter Valley to the Anza-Borrego Desert State Park boundary. Continue about 1½ miles to Blair Valley Road, a dirt road on your left marked with a historical marker for the Butterfield Stage Route. A bulletin board has a map showing the way to the pictographs and to the Morteros Village site. The parking area is about 4 miles southeast, marked by a large sign. The trail leads southwest about 200 yards and skirts the edge of a small gully strewn with boulders. The pictographs, not marked, are on a large boulder a few yards west of the trail, on your right as you look up the gully.
For Smuggler Cove, continue down the road about 1½ miles to another parking area, marked with a sign saying Pictographs. The trail leads 1 mile east to the site. The pictographs are on a large boulder at the end of the trail.

The Anza-Borrego Desert State Park includes some of the most interesting desert landscape in the Southwest. It has mountains over 8,000 feet high as well as desert areas below sea level. The park covers 600,000 acres of eastern San Diego County in the Colorado Desert, west of the Salton Sea, all the way to the Mexican border. Both the Smuggler Cove and the Morteros Village sites are near the center of the park.

When Spanish explorers first entered the area over 200 years ago, they found Kumeyaay and Cahuilla people living here. Two rock art sites in this area are believed to be Kumeyaay puberty sites, one for boys and one for girls. Both are thought to be between 300 and 750 years old.

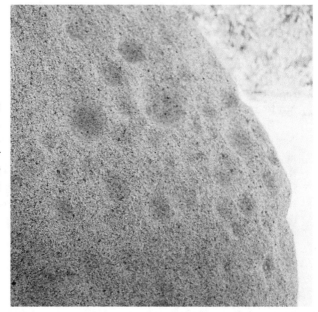

These rock depressions, called cupules, were used for grinding. These are at Morteros Village.

The girls' site is at Smuggler Cove in Little Blair Valley. The two dozen or so red pictographs painted by girls are primarily zigzags and diamond chains believed to represent rattlesnakes, powerful spirit-helper images. The nearby boys' site is on a large boulder at Morteros Village, an ancient Kumeyaay village site. Typically, the boys used black pigments to paint a picture of the spirit helper they acquired during their puberty-rite ceremonies.

The Morteros pictograph panel is near the ground in a small depression on the back side of a large boulder that is next to a smaller boulder with cupules, or small mortars. The cupules may have been used to grind the charcoal from which the paint was made. While the pictographs themselves are not spectacular, the site is interesting to visit for the other relics of human habitation found there. The village is estimated to be 800 years old, and the pictographs are believed to be from 300 to possibly 750 years old.

Site CA-9
PALO VERDE PETROGLYPHS

Map locators: DeLorme 119 B5
Information: Bureau of Land Management, Palm Springs, (760) 251-4800
Fees: None.
Directions: From Palo Verde, take CA 78 south to just past milepost 74. Take the gravel road on the left, Quarry Road, south to the site, which is on the flat area at the base of the rise, on the north (left) side. Two sets of barriers block vehicles from entering the two main access points. Just beyond the barriers are blue Archaeological Resource signs marking the sites.

While there are several intaglios, or geoglyphs, along the lower Colorado River, there are few petroglyphs or pictographs. The only petroglyph site in this area open to the public is about 7 miles south of Palo Verde, about 100 yards east of the pavement on CA 78, reached by a short dirt road. The site sits along an ancient path used for centuries by local desert cultures traveling to and from the Colorado River.

There are reportedly numerous images of ancient quadrupeds, anthropomorphs, and snakes adorning the walls of this shallow box canyon, but all I was able to find were a few geometric designs deeply etched into the relatively soft sandstone. The glyphs I found were on boulders along the eastern edge of the basin. Many images have faded into oblivion, and natural erosion has taken a toll on many others. There has also been some vandalism at this site.

Rodman Mountains. See Barstow Area.

Site CA-10
SLIPPERY ROCK

Map locators: DeLorme 50 C3; USGS CA-1260 (Lake Isabella North)
Information: Bureau of Land Management, Bakersfield, (760) 384-5400
Fees: None.
Directions: From Bakersfield, take CA 178 east to CA 155 (Isabella Dam Road). Go north a mile or two to a dirt road on the left with signs for the Keysville South Boat Ramp and the Forest Service Visitor Center. Take this road, past the boat ramp sign, to the end of the road. By the river is a brown Danger sign. The petroglyph boulder is to the left (downstream) of the sign.

The petroglyph boulder at Slippery Rock

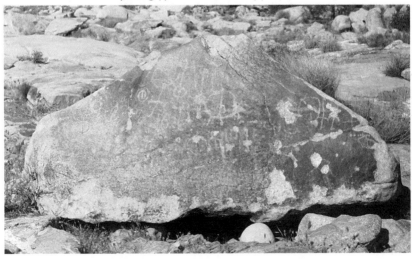

Just below the Lake Isabella Dam, on the south side of the Kern River, is the Slippery Rock petroglyph site. There is a good panel of petroglyphs here, mostly geometric patterns, on a single boulder. There is also one or more possible atlatl images on the panel. It is believed that the bow and arrow replaced the atlatl in this region about 1,500 years ago, which could help date this glyph. The glyphs were probably made by the Tubatulabal people, an ancient, isolated band who first moved into the Lake Isabella area about 5,000 years ago.

Smuggler Cove. See Morteros Village.

Site CA-11
STEAM WELL

Map locators: DeLorme 66 A3; USGS CA-1210 (Klinker Mountain)
Information: Bureau of Land Management, Ridgecrest, (760) 384-5400
Fees: None.
Directions: From Johannesburg, take US 395 southeast to Trona Road. Go north about 1¼ miles to Steamwells Road, a dirt road on the right, and turn right (east). A few yards in, the road is marked as RM1444. Follow it a little over 4 miles to a blocked-off dirt road on the left with a BLM sign for Steam Well. Park here and hike north for about ⁴⁄₁₀ mile to another road on your left. Take this trail about ²⁄₁₀ mile to the site.

Off US 395, east of Johannesburg, is the Steam Well site. The natural spring here has probably been visited by humans for thousands of years. The rock art in this region is thought to have been made by Southern Paiute or Kawaiisu people. The site has been fenced to protect it, and it is marked with a sign. The petroglyphs, on rock faces at the spring, are primarily geometric patterns and designs.

Surprise Tank. See Barstow Area.

Colorado Rock Art Sites

1. Anasazi Heritage Center
2. Canyon Pintado National Historic District
3. Colorado National Monument
4. Escalante Canyon
5. Hicklin Springs
6. Hovenweep National Monument/ Holly Group
7. Irish Canyon
8. Mesa Verde National Park
9. Penitente Canyon
10. Rangely Area
11. Sand Canyon
12. Sandrocks Trail
13. Ute Mountain Tribal Park
14. Vogel Canyon
15. Yellowjacket Rock Shelter

7

Colorado

There are a number of excellent rock art sites in Colorado. The state has its fair share of Archaic rock art, as well as that from the Ancestral Puebloan period, and even some contemporary rock art sites. It is not uncommon to find examples of two or three styles of rock art on the same panel. Most of the petroglyphs and ruins in southwestern Colorado are Ancestral Puebloan. In the northwestern part of the state, particularly in Canyon Pintado, visitors can see Fremont pictographs and petroglyphs. The rock art of southeastern Colorado was made by the predecessors of the Plains Indian cultures, rather than Ancestral Puebloan or Fremont, so its style differs from the rock art of any other region in the state.

The development of rock art sites in Colorado varies as much as the styles do. Canyon Pintado, near Rangely, is one of the best-developed public rock art areas in the nation. On the other hand, most of the other rock art sites in the Rangely area have not been improved and have no facilities; several are in very primitive areas. There are quite a few sites in state and national parks and monuments. Some of these are open to the public, but the locations are not always publicized. Other Colorado sites have simply been closed to the public. As in my listings for other states, I have omitted several places I would like to have included, such as Bridgeport and McDonald Creek. I did list Colorado National Monument, but without directions to the sites; due to heavy vandalism, the National Park Service asks that visitors speak with park officials for information.

SITE PRESERVATION

One of the most ambitious plans to protect rock art for the enjoyment and appreciation of future generations of Americans is being conducted by the Bureau of Land Management at Canyon Pintado in the Rangely area. In addition to working to stabilize and improve most of

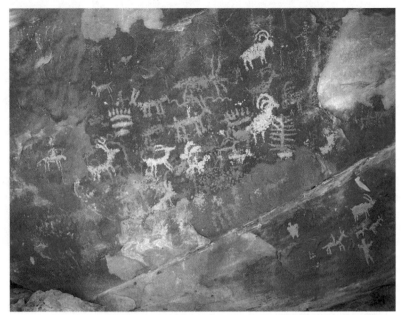

Due to vandalism, this site on Deer Creek, near Bridgeport, is closed to the public. Note the variety of zoomorphic images on this panel.

the canyon's numerous rock art sites and its few ruins, two orientation centers, one near each end of the canyon, have been constructed with restrooms, parking lots, ramadas, and information kiosks. At each major site within the canyon will be parking areas, information signs, and marked, maintained trails.

Elsewhere, the Colorado Interagency Archaeological Education and Antivandalism Task Force has been established "to combat destruction of cultural resources through coordinated efforts and pooled resources." This task force comprises a number of archaeological societies and federal and state agencies in Colorado. One of their primary goals is public education, including teacher workshops.

To report vandalism, call any BLM office, the Colorado BLM State Office at (303) 239-3600 (ask for the law enforcement office), or the Colorado State Archaeology Office at (303) 866-3395.

COLORADO SITES

Site CO-1
ANASAZI HERITAGE CENTER

Map locators: DeLorme 85 A4
Information: Anasazi Heritage Center, (970) 882-5600; Web site,
www.co.blm.gov/ahc/index.htm
Fees: Suggested donation for entry.
Directions: From Cortez, take US 666 north about 10 miles to CO 184; go
east about 7 miles. The center is 3 miles west of Dolores, at 27501 CO 184.

The Anasazi Heritage Center is not a rock art site per se, but it is an excellent resource for information on local Indian culture. Officials there offer the following description: "The Anasazi Heritage Center is a museum for interpreting the history and culture of the Canyons of the Ancients National Monument, Trail of the Ancients, and the Four Corners Region. The center's hands-on Discovery Area, education programs, permanent exhibits, and films explore archaeology, local history, and Pueblo, Ute, and Navajo lifeways." The museum houses over three million artifacts.

While the center offers background on Native American history, it has little information on specific sites in southwestern Colorado. According to the staff at the center, there are no rock art sites in their area accessible by road or trail. They do recommend other sites, such as those at Mesa Verde National Park and Ute Mountain Tribal Park.

The center was created, in part, to support a large archaeological operation to preserve whatever Ancestral Puebloan cultural artifacts could be salvaged from the nearby McPhee Reservoir. A piece of an eleventh-century kiva mural rescued from the Lowry Pueblo ruins is also on display here, along with a full-sized photograph of the original mural. When excavated, the mural was mostly intact, but exposure to air and humidity quickly started to deteriorate it. The Bureau of Land Management removed the remainder of the mural from the ruins site and housed it at the center to preserve what they could. The mural was done in a large white-on-black stair-step pattern similar to a pottery design of the same period. For those wishing to visit the Lowry Pueblo, directions can be obtained at the center.

Battle Rock. See Sand Canyon.

Site CO-2
CANYON PINTADO NATIONAL
HISTORIC DISTRICT

Map locators: See below.
Information: Canyon Pintado National Historic District, (970) 878-3800;
Web site, www.co.blm.gov/wrra/c pintado1.htm; Town of Rangely, (970) 675-
8476; Web site, www.rangely.com/pintado.html
Fees: None.

Directions: From Rangely, take CO 139 south into Canyon Pintado. Eight sites are marked along the highway. Brochures are available in Rangely. Directions to individual sites are described below.

Most of the lower 20 miles of the Douglas Creek Valley is called Canyon Pintado (Spanish for "Painted Canyon"), after the many pictographs on the rocks here. The variety and number of glyphs in this area have drawn rock art enthusiasts for years.

Some of the rock art is in the Archaic style, and some may even be from the Paleo-Indian period, which leads researchers to believe that people have lived in the canyon for over 10,000 years. In addition to the very old drawings, other periods are represented, including Historic Ute rock art. Most of the rock art is from the Fremont period, of about A.D. 600 to about A.D. 1300. Among the styles of rock art found here are Classic Vernal Fremont anthropomorphic shapes, Archaic Barrier Canyon–style carrot men, and even a drawing of Kokopelli, which shows a close affiliation with the Ancestral Puebloans (Anasazi) from the south.

Within the canyon are eight public, interpreted archaeological sites, starting a few miles south of the town of Rangely. The following describes the main sites with rock art, going from north to south. Canyon Pintado's south orientation center is just south of the Waving Hands site. For other sites in the Rangely area, see site CO-10.

East Fourmile Draw
Map locator: DeLorme 32 A2

East Fourmile Draw is a rather extensive rock art area with at least three major sites and an orientation center. The turnoff is east of the highway at milepost 61.3.

About 700 yards up the draw, the Sun Dagger site, the farthest one from the parking area, has some exquisite polychrome pictographs, which act as solar markers.

State Bridge
Map locator: DeLorme 32 A3

At milepost 59.7, a dirt road leads east to the parking area and a well-marked trail to this site. On the south and west faces of a cliff is Classic Fremont style rock art such as anthropomorphic figures with trapezoidal bodies.

Cow Canyon
Map locator: DeLorme 32 A3

To get to the site, turn east at milepost 57.8, Philadelphia Creek, and go ²/₁₀ mile to a road on the right (south). Take this road ⁸/₁₀ mile to Cow Canyon and turn east. The gravel parking area is about ¹/₁₀ mile in. There are several signs along the way, making the site easy to find, but the roads are dirt, so do not travel them during wet weather.

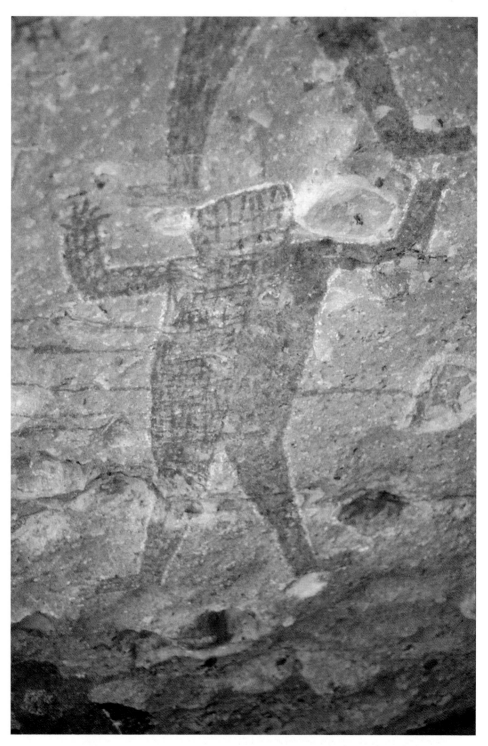

Color plate 1: *"Los Monos" image at Cueva San Borjitas in Baja California, Mexico*

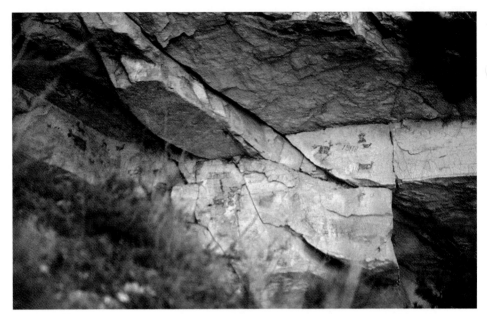

Color plate 2: *These small red pictographs of animals can be seen at the south rim of the Grand Canyon, high above the Bright Angel Trail.*

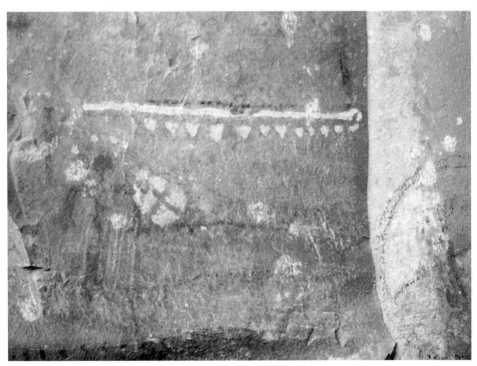

Color plate 3: *This pictograph panel at the Palatki Ruins in Arizona shows vivid white images and faint red images.*

Color plate 4: *Vivid images at Barker Dam in California. Unfortunately, these are not the original pictographs—they were painted over by a motion picture crew to make them stand out.*

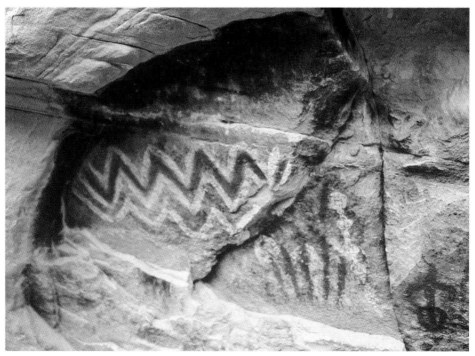

Color plate 5: *This small portion of a pictograph panel in southern Nevada's Brownstone Canyon is quite striking. Because the site requires a rigorous hike or horseback ride, it is not listed in this book.*

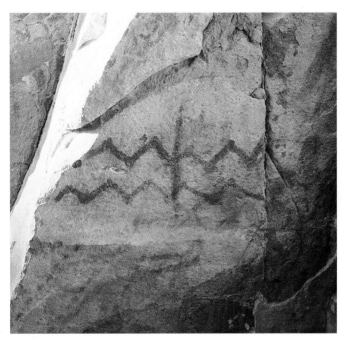

Color plate 6:
A red Mogollon pictograph panel at Gila Cliff in New Mexico. The two large zigzags in the center are obvious, but you can also see other, fainter images all around them.

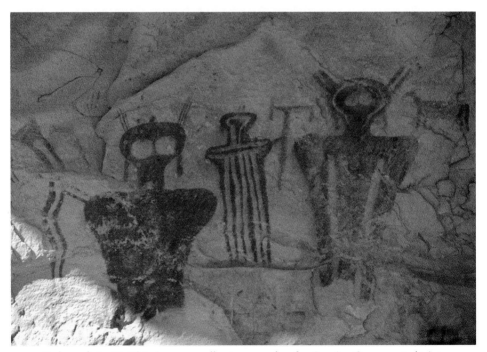

Color plate 7: *This is an excellent example of a Barrier Canyon style image, found at Sego Canyon in Utah. Particularly interesting are the heads of these anthropomorphs.*

Color plate 8: *This painting on the ceiling of San Borjitas Cave in Baja is typical of the Monos motif. Notice the use of red and black pigments and the multiple spears piercing the bodies.*

Color plate 9: *An excellent example of a polychrome pictograph at the Montevideo site in Baja. The colors include orange, yellow, black, and blue.*

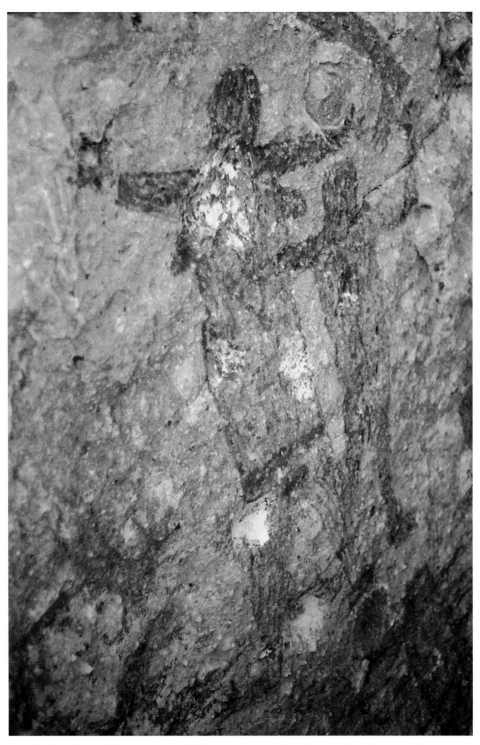

Color plate 10: *Females with breasts protruding from under the armpits are common in Baja rock art and occasionally seen in the southwestern U.S.*

Color plate 11: *The maker of this red deer pictograph at Candalaria in east-central Baja used a natural hole in the rock for the deer's eye. This technique is called incorporation.*

Color plate 12: *This pictograph is one of two panels found under a rock overhang near the village of San Lucas in Baja. If you look closely, you can see a red deer rearing up on its hind legs and a black animal overlapping and facing it.*

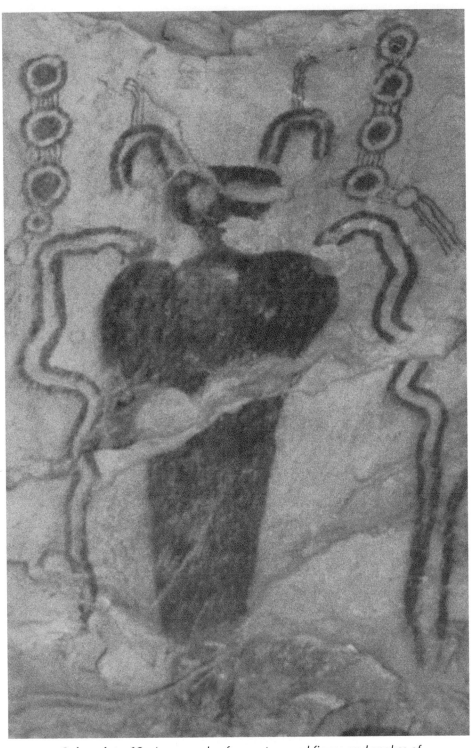

Color plate 13: *An example of an antennaed figure and snakes of the Barrier Canyon style. This pictograph is in Sego Canyon, Utah.*

The panels, less than a hundred yards from the parking area, face the road. They are marked with an interpretive sign and protected by a wooden fence. On the east side of the road is Historic Ute rock art depicting horses and men with shields and lances, as well as an image of a flintlock pistol.

White Birds

Map locator: DeLorme 32 B3

The White Birds site, at milepost 56.5, on the west side of the road, has some great polychrome pictographs. Colors include white, red, and orange. The slope up to the site is rather steep.

Kokopelli

Map locator: DeLorme 32 B3

At milepost 56, past Little Bull Draw on the west side of the road, is a pictograph of the humped-back flute player, Kokopelli, though you need a little imagination to see him. There is a parking area and picnic table on the east side of the road. The presence of Kokopelli at a Fremont site indicates the Fremont's close affiliation with their Ancestral Puebloan neighbors to the south.

Waving Hands

Map locator: DeLorme 32 B3

The Waving Hands site, at mile 53.5, on the west side of the road, has two distinct panels. One is a red Fremont pictograph panel, and the other is a white Ute panel. The latter is just around the corner to the north, under a rock overhang.

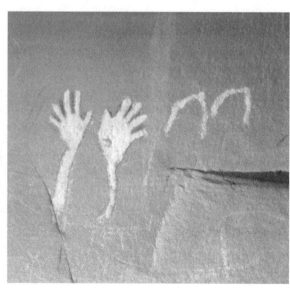

The Waving Hands pictograph site in Canyon Pintado shows the use of white pigment. This Ute panel is probably only a few hundred years old.

Castle Rock Pueblo. See Sand Canyon.

Site CO-3
COLORADO NATIONAL MONUMENT

Map locators: DeLorme 42 D3; USGS CO-0394 (Colorado National Monument)
Information: Colorado National Monument, (970) 858-3617; Web site, www.nps.gov/colm/
Fees: Entrance fee.
Directions: From Grand Junction, take I-70 west to the Horizon Drive exit for east entrance; take I-70 to exit 19 for west entrance. Since these sites have no physical protection, they are not publicized; see park officials for directions.

Since the several easily accessible rock art panels at Colorado National Monument have not been stabilized, signed, or protected, they have sustained considerable damage at the hands of vandals. Rock art can be found at Monument Mesa, East Entrance Canyon, White Rocks, and Monument Creek. Probably the best-known and most accessible petroglyph site is at the Hardy Shelter in upper No Thoroughfare Canyon, a rock shelter near the Devil's Kitchen Trail. There are a number of glyphs on the top of a large boulder in front of the rock shelter.

Many of the petroglyph panels at Colorado National Monument are in the typical Ancestral Puebloan style. After the Ancestral Puebloans disappeared from the area about A.D. 1250, Utes became the dominant residents.

Comanche National Grasslands. See Vogel Canyon.

Site CO-4
ESCALANTE CANYON

Map locators: DeLorme 55 C6; USGS CO-0754 (Good Point)
Information: Bureau of Land Management, Montrose, (970) 240-5300
Fees: None.
Directions: From Grande Junction, take US 50 south and follow the signs to Escalante Canyon. From the bridge across the Gunnison River, go several miles to the turnoff on the left, Dry Fork Road (a sign says Dry Mesa). This is a primitive road that runs through Escalante Creek, so be cautious. Continue about 1 ½ miles, staying to the right and following the creek bottom. The site, on the west side of the road, is behind a tall chain-link fence.

Along the Dry Fork of Escalante Creek in the southwestern corner of Delta County, south of the Gunnison River, is a Historic Ute petroglyph site containing several images of horses and riders. This interesting site shows several different techniques used to carve the glyphs into the rock.

One scene shows a number of mounted warriors wearing elaborate war-bonnets trailing long feathered tails. The warriors appear to be attacking a

shielded figure in the center of the panel. The images are sharply defined, carved precisely into the rock. The site faces east, so morning is the best time to take pictures.

Site CO-5
HICKLIN SPRINGS

Map locators: DeLorme 99 D5
Information: John Martin Reservoir State Park, (719) 336-3476
Fees: None.
Directions: From Las Animas, take CO 101 south about 5½ miles to Road BB. Go east about 8 miles to Road 19. Turn left (north) and go about 1 mile, until the road turns into Road CC. Ahead is a primitive dirt road leading north. A high-clearance vehicle is recommended. The road is hazardous during wet weather. Take this road for about 1 mile to a closed gate. Go through the gate (be sure to close it behind you). The site is a little farther down the road on the left.

The Hicklin Springs site is a little harder to reach than most sites in this book, but it's well worth the trip. If you don't have a high-clearance vehicle, it is a mile-plus hike to reach it. There is a profusion of rock art in this area, with many varied images both clustered and scattered around on the rock faces. The glyphs are easy to recognize. There is poison ivy growing around some of the best panels, so be cautious.

Among the interesting glyphs here are several dot matrix patterns. The pits, which are pecked into the stone, are clearly a tally of something, or maybe a calendar. Another glyph shows a number of tally marks of horizontal and vertical grooves, which some scientists claim are similar to Ogam writing, a form of ancient Celtic writing used in Ireland around 1000 B.C. A more famous example of this style of writing in America is at Inscribed Cave near Hines Lake in central Colorado. This site has caused a great deal of controversy among scientists about the origin of the writings.

Site CO-6
HOVENWEEP NATIONAL MONUMENT/ HOLLY GROUP

Map locators: DeLorme (Colorado) 84 A1; USGS UT-2095 (Ruin Point)
Information: Hovenweep National Monument, (970) 562-4282; Web site, www.nps.gov/hove/
Fees: Entrance fee.
Directions: From Cortez, take US 160 south 4 miles to County Road G (Airport Roadway); go west about 40 miles. The main entrance to Hovenweep National Monument is in Utah. Park officials have closed the petroglyph site to visitation, but it can be seen clearly from a viewpoint just above. From the parking lot, take the short trail to the Great House ruin, then follow the

left fork along the canyon rim to a jut with a large juniper tree. From the far side of the tree, you can look down and see the petroglyphs.

Hovenweep is a Ute Indian word for "Deserted Valley," but it was not always so. Archaeologists have found evidence of Paleo-Indians here dating back to 11,000 years ago. Much later, Hovenweep became the home of a sub-culture of the Ancestral Puebloans.

From about the first century A.D., Archaic hunter-gatherers began to plant a few scattered crops in the area, eventually establishing small villages of pit houses. The community evolved to a highly sophisticated Puebloan culture, which thrived until about A.D. 1300. At one time, the area had a population of as many as 2,500. It is generally believed that the people abandoned Hovenweep at the end of the 12th century, migrating into the Grand Canyon and other parts farther south.

Most of the structures that remain today were built after A.D. 1200. They are very diverse, including pueblos, kivas, towers, and granaries. The Ancestral Puebloans who constructed them were very skilled architects and builders. They were also very accomplished farmers, evidenced by the agricultural terraces, ditches, and dams used to control runoff rainwater.

The distinctive towers of Hovenweep have intrigued researchers for decades. Were they watchtowers, observatories, storage silos, churches, or maybe government halls? Throughout the area are round, square, and D-shaped towers. Some of the remains are twenty feet tall; the height of the original towers is unknown.

Within a collection of pueblos called the Holly Group is a petroglyph panel available for public viewing. It is a dramatic example of how the Ancestral Puebloans used the sun's position to determine optimum planting and harvesting times each year. Under a rock ledge are several petroglyph markings strategically placed for a dagger of sunlight to fall on them at the summer solstice and the fall and spring equinoxes. To the east of the glyph panel are two large boulders that form a slit through which the rising sun throws a beam of light onto a rock face at sunrise. The position of the light changes slightly each day. On the rock are a spiral, a partial spiral, and a three-ring concentric circle. These markers were also used to determine the solstices and equinoxes.

Site CO-7
IRISH CANYON

Map locators: DeLorme 12 B3
Information: Bureau of Land Management, Craig, (970) 826-5000
Fees: None.
Directions: From Craig, take US 40 west to CO 318. Continue west to Moffit County Road 10N, marked by a sign for Rock Springs. From there, the site is about 4½ miles north.

The main panel at Irish Canyon has an interpretive sign and is well protected by a fenced viewing platform.

Irish Canyon is a remote and scenic canyon in northwestern Colorado. The southern entrance is only fifty yards wide, with high, steep walls. Just outside the entrance is an improved Fremont rock art site that has a parking area, paved trail, toilet, and picnic area, but no drinking water. The trail is wheelchair accessible, but it is fairly steep. Interpretive signs tell more about the artwork of the Fremont culture.

Ismay Trading Post. See Yellowjacket Rock Shelter.

John Martin Reservoir State Park. See Hicklin Springs.

Mellen Hill. See Rangely Area.

Site CO-8
MESA VERDE NATIONAL PARK

Map locators: DeLorme 85 B5; USGS CO-1532 (Point Lookout)
Information: Mesa Verde National Park, (970) 529-4465; Web site, www.nps.gov/meve/; Mesa Verde County Visitor Information, (800) 253-1616
Fees: Entrance fee.
Directions: From Cortez, take US 160 about 10 miles east to the Mesa Verde National Park entrance. Take the Petroglyph Point Trail to the main site.

Mesa Verde National Park was the first national park established to preserve the works of ancient peoples. The cultural remains at Mesa Verde reflect

more than 700 years of prehistory. From about A.D. 600 to 1300, people lived and flourished in pueblo communities throughout this area. The sheltered villages, usually called cliff dwellings, represent the last 75 to 100 years of inhabitation at Mesa Verde. The ruins in Mesa Verde are some of the most significant and best preserved anywhere.

Petroglyph Point Trail, 2⁸⁄₁₀ miles round-trip, leads to the best-known and largest petroglyph site in Mesa Verde. Petroglyph Point has a panel with more than 100 glyphs, including anthropomorphs, lizards, spirals, and handprints.

Site CO-9
PENITENTE CANYON

Map locators: DeLorme 79 B7; USGS CO-1946 (Twin Mountains SE)
Information: Rio Grande National Forest, Monte Vista, (719) 852-6233
Fees: None.
Directions: From Saguache, take US 285 south to Route G (milepost 69). Turn right and go west 6³⁄₁₀ miles to the first fork in the road. Take the left fork, County Road 38A, a good gravel road, ⁸⁄₁₀ mile to the sign for the Penitente Canyon Trail entrance road, a dirt road on the right. Take it 1²⁄₁₀ miles to the Penitente Canyon parking area. The pictographs are at the south edge of the parking area behind some brush.

About twenty miles south of Saguache in the San Luis Valley of south-central Colorado is Penitente Canyon, an area well known for its fabulous rock climbing. Less well known is the rock art there. The parking lot at the trailhead has a toilet, a garbage can, and an information kiosk telling about the local rock art, but no drinking water.

Evidence of man in Penitente Canyon dates back to early Prehistoric times. Later, the Ute tribe had a summer camp at La Garita, the Spanish raised sheep in the area, and the Anglos started farms, each in turn leaving their distinctive marks upon the land. It is believed that the canyon has been a spiritual place for thousands of years, as attested to by the paintings left on its walls by primitive artists. Later, it was even a place of worship for a small sect of Catholic men, who painted a Madonna here.

Site CO-10
RANGELY AREA

Map locators: DeLorme 22 D2; USGS CO-1589 (Rangely)
Information: Rangely Chamber of Commerce, (970) 675-5290
Fees: None.
Directions: Described below.

In addition to Canyon Pintado, there are numerous other rock art sites in the Rangely area. I have listed only the two easiest to find. You can get explicit directions to the others from the Rangely Chamber of Commerce.

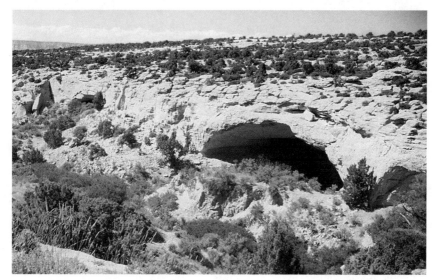

The Mellen Hill caves, near Rangely, as seen from the low ridge along Highway 64.

The Mellen Hill sites are northwest of Rangely off CO 64. At milepost 7.3, turn onto the short dirt road there and park in the turnout. There is a trailhead marker on the low ridge there, and farther down the trail is a BLM archaeological sign near the sites. Both Fremont and Ute rock art can be seen in a shallow canyon along the north side of the highway, on ledges near the entrances of some caves, and on a small overhang on the north wall at the top of the canyon. The triangular anthropomorph with headdress is Fremont.

To reach the Reservoir site, take CO 64 east from Rangely, turn off at milepost 26.9, and go through the gate. There is a sign here that says Reservoir Site. Take the first left fork in the dirt loop road and go along the reservoir for a little less than ½ mile, where you will find yourself above a draw between you and the highway. There is a small BLM archaeological sign near the glyphs, which are on the south face of the draw, about 200 yards west of the highway. Here you will see anthropomorphic and abstract figures.

Site CO-11
SAND CANYON

Map locators: DeLorme 84 B2; USGS CO-0120 (Battle Rock)
Information: Bureau of Land Management, Canyons of the Ancients National Monument, (920) 882-4811; Web site, www.co.blm.gov/canm/
Fees: Entrance fee.
Directions: From Cortez, take US 666 south to McElmo Canyon Road (aka G Road or Airport Road) and go west about 11 miles to Sand Canyon.

Sand Canyon extends north from McElmo Creek, an area that has probably been occupied intermittently for the past 8,000 years. Paleo-Indians, Archaic hunter-gatherers, Ancestral Puebloans, and later Ute and Navajo cultures were among the occupants of McElmo Canyon. Over the years, many of these people have left images on the rocks here. Much of the rock art in this area is on private property and is not accessible without permission. Some sites are on public property, but they are not considered open to the public. Nevertheless, McElmo Canyon is well known to local residents, and a great deal of archaeological research has been conducted here. The area is also a popular hiking and horseback riding spot.

I was unable to obtain information about the rock art from any official sources, but through some local agencies, ranchers, and business owners, I have assembled the following information on Sand Canyon and the rock art site at Castle Rock.

Castle Rock Pueblo is an ancient Ancestral Puebloan village. In the area are scattered rock art panels, but only one panel at the pueblo, Battle Rock, is open to the public. It is hard to find, as it is not on a prominent rock face and the glyphs are not obvious without close inspection. Most of the other rock art in the area is on private property, which is generally fenced and posted.

This site, the McElmo Rock Shelter, is on a blind curve in the road, so I was asked not to specify its location.

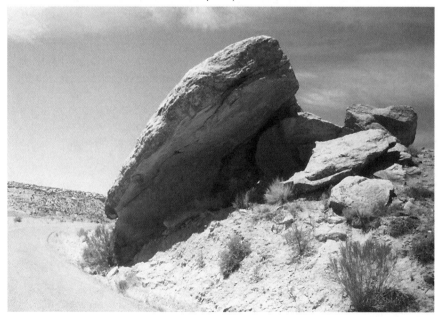

128

Some locals maintain that the panel at Battle Rock depicts the battle for which the place was named. The true location of the battle is disputed. One legend claims that about A.D. 1250, a battle took place between the Ancestral Puebloan inhabitants of the Castle Rock Pueblo and their ancient enemies, the Athabascans. Shattered bones found in a kiva attest to ritual killings, possibly of enemies. The Puebloans abandoned the site soon after the battle took place. I have been informed that there is no archaeological proof that there were any Athabascans in this region at that time. I guess that is why the story is called legend and not history. In another version of the battle story, a band of Utes attacked a Navajo village here, and the residents retreated to Battle Rock for safety. The battle did not go well for the Navajo, and the women, rather than be taken captive, threw their children and then themselves onto the rocks below.

Archaeologists have determined that when the Castle Rock Pueblo was abandoned by the Ancestral Puebloans, shortly after A.D. 1250, the kivas were burned. Kivas, being sacred ceremonial places, would not have been systematically burned without reason. Some believe they were burned as a way to close them when the people abandoned the area. Another theory states they could have been burned by the triumphant enemies of the Puebloans as an act of desecration. Another interesting fact is that when the Ancestral Puebloans went away, they left almost all their possessions behind. This might indicate a rapid retreat after a major defeat, or that they anticipated a long and difficult journey.

Site CO-12
SANDROCKS TRAIL

Map locators: DeLorme 15 D5
Information: Museum of Northwest Colorado, (970) 824-6360; Craig Chamber of Commerce, (970) 824-5689
Fees: None.
Directions: The trail is on the north side of Craig, but finding the access is a bit confusing, as the official trailhead is no longer marked. The best access I've found is from the end of Alta Court, a cul-de-sac near the western end of the trail. There used to be a sign, destroyed by vandals, marking the official trail behind the house. Alta Court is off Alta Vista Drive, between Ninth Street and Finley Avenue.

The Sandrocks Trail in northern Craig contains Ancestral Puebloan rock art as well as more recent Shoshone or Ute-style images. You will find shield figures, hand- and footprints, paw prints, animals, geometric designs, and horses and riders carved into the sandstone.

The level trail is easy to walk, and there are numbered signs along the way indicating points of interest, including petroglyphs and native plants. Petroglyphs are found at trail markers #4 (shield figures and zoomorphs), #5 (paw prints and handprints), #6 (horse and rider), #8 (shield figures and plants), #9 (paw prints), #10 (horse figures and lightning), and #11 (rectilinear figures).

The trail markers were installed by the local High Country Cactus Kickers 4-H Club in 1987 and 1988 in cooperation with the Craig city council and others, but the site was heavily vandalized with spray paint soon after. The same 4-H group was successful at removing much of the graffiti but ran out of funding before the project could be completed, and it appears that no maintenance of the trail has been provided since 1988. It's a shame the city has allowed the trail to deteriorate to its present state.

Site CO-13
UTE MOUNTAIN TRIBAL PARK

Map locators: DeLorme 84 D3; USGS CO-1868 (Tanner Mesa)
Information: Ute Mountain Tribal Park, (800) 847-5485 or (970) 565-3751 x330; Web site, www.utemountainute.com/tribalpark.htm
Fees: Fee for guided tour; register for full-day tour at visitor center; call to arrange half-day tour.
Directions: From Cortez, take US 160/666 south 15 miles to the Ute Mountain Visitor Center and Museum. Visitors may tour the park in their own vehicles only if accompanied by an official Ute guide. Some tours require almost 100 miles of driving. Bus tours also available. Half-day tours are a short walk from the road.

Historic Ute, Basketmaker, and Ancestral Puebloan rock art can be found at the Ute Mountain Tribal Park, not far from Mesa Verde National Park. Both pictographs and petroglyphs are abundant here. The park also contains many pueblo ruins.

There is an excellent early Puebloan (late Basketmaker) panel at Kiva Point. There are over 200 individual images here, including anthropomorphic and zoomorphic figures and numerous rows of dots. The park also has the only known petroglyph of a cow, obviously a Historic Ute image.

Site CO-14
VOGEL CANYON

Map locators: DeLorme 100 A3
Information: Comanche National Grasslands, (719) 384-2181
Fees: None.
Directions: From La Junta, take CO 109 south about 13 miles to the sign to Vogel Canyon, County Road 802. Turn west and go about 1½ miles to Forest Service Road 505A, then turn south for another 1½ miles to the parking lot. A good marked trail leads ½ mile to the canyon; the site is a little farther down, along the canyon wall to the left.

Many of the canyons south of La Junta, in southeastern Colorado, have petroglyphs, but most of them are on private property. One notable exception is Vogel Canyon, in the Comanche National Grasslands. The Vogel Canyon site is well worth visiting. It has four hiking trails and a picnic area with a parking lot, three covered picnic tables, grills, and a toilet.

The development of the canyon's recreation area and the restoration of its 400- to 2,500-year-old petroglyphs is a heartening success story.

This area has been badly vandalized in the past. Local teenagers used to come here for beer parties, and the place was littered with broken beer bottles. Vandals had spray painted many of the panels, scratched initials into the sandstone, and pockmarked the cliffs with bullet holes. The site was in danger of being totally destroyed. The Forest Service, together with several local entities, implemented a plan to try to save it. They blocked off the road into the canyon and built a parking area within a short hike to the site. To further develop the site for public visitation, new trails with masonry barriers at sensitive spots were constructed, a restorer was hired to repair much of the damage to the petroglyphs and eradicate as much of the graffiti as possible, and interpretive signs were installed. Vogel Canyon is now one of the best public rock art sites in the Southwest, and the vandalism has been greatly reduced.

Site CO-15
YELLOWJACKET ROCK SHELTER

Map locators: DeLorme (Colorado) 84 B1; USGS UT-1613 (Wickiup Canyon)
Information: N/A
Fees: None.
Directions: From the parking lot at Ismay Trading Post on McElmo Canyon Road, the site is at the end of a well-traveled dirt road and a short footpath.

Near the Ismay Trading Post by the Utah state line is a well-known site frequently visited by people in the Four Corners area. I had heard about the site, but I could get no exact information. One BLM official suggested that the site may be on private property. I decided the only hope I had of unraveling this mystery was to visit the site personally. An interesting story resulted from my visit.

The Ismay Trading Post is an isolated establishment almost entirely supported by the residents of the nearby Indian reservation and a few local ranchers. I would characterize its construction as somewhere between ramshackle and dilapidated. Upon entering the dimly lit store, I spied an old man sitting on a stool next to the counter, reading a magazine, and two young Native Americans who looked at me like I had just emerged from a UFO.

I asked the old, unshaven gentleman if he was the proprietor, and he answered with an unintelligible grunt, which I took for an affirmative. I introduced myself and asked if he knew the way to the rock art site. Without looking up from his magazine, he asked me why I wanted to know. I explained that I was writing a book on the Indian rock art of the region and wished to visit the site if permissible. He thought for a moment, then replied that if someone as ignorant as I could write a book about something

The Yellowjacket Rock Shelter site can be seen from the Ismay Trading Post parking lot.

he knew nothing about, then he might as well keep the information to himself and get rich writing his own book.

I quickly pointed out that most writers don't get rich, and that if this was the only site he knew about, his would be a very short book. He muttered something else I couldn't quite make out, and finally responded that while he may not be a writer, he was the best danged storekeeper in the region, and why didn't I buy something? Without pointing out that he was the only storekeeper in the region, I purchased a cold soft drink. After taking my change, I asked him whether he was going to help me or not. He replied that I shouldn't really need any help, 'cause any fool could just walk out into his parking lot and see the site from there.

I thanked him, walked out into the parking lot with my beverage, and found that, sure enough, the rock art was in plain sight for any fool to see.

The area is not fenced or marked with any signs, so I still don't know if it is on private or public property. In any event, access does not seem to be restricted. The well-worn path indicates to me that the site is visited regularly.

8

Nevada

Nevada's most dominant geographical feature is the Great Basin Desert, which covers approximately 75 percent of the state. The climate of the Great Basin has had a major influence on the way of life of the area's inhabitants since humans first came to Nevada, possibly more than 10,000 years ago. Around A.D. 400, while nonagricultural Numic-speaking (Ute) cultures ranged through the Great Basin, the Virgin River Puebloans built pueblos and farmed in southern Nevada. Possibly a subculture of the Ancestral Puebloans of the Colorado Plateau, the Virgin River Puebloans were displaced by Numic speakers around 1300. Over thousands of years, the early inhabitants of Nevada left a great legacy for us in their rock art and artifacts, but within fifty years of the first contact with white explorers, the original Indian way of life was destroyed.

SITE PRESERVATION

While Nevada has an abundance of rock art, and many sites are clearly shown on maps, not a great deal has been done to protect most of them. Only a few sites in Nevada have been improved or developed for visitation. The improved sites include Hickison Summit, Grimes Point, and some of the sites in Valley of Fire State Park. These have good parking areas, trash cans, restrooms, trails, and interpretive signs. One Nevada site, Grapevine Canyon near Laughlin, is highly publicized by the Laughlin visitor center, but it has no interpretive signs, barriers, or other protection, and there has been some vandalism here. I have listed sites with relatively easy access, whether they have been developed or not.

For current information on preservation efforts in the state, contact the Nevada Rock Art Association. They also give tours. Their Web site is www.nevadarockart.org/.

To report vandalism, call any local BLM office or the Nevada BLM State Office, (775) 328-6586.

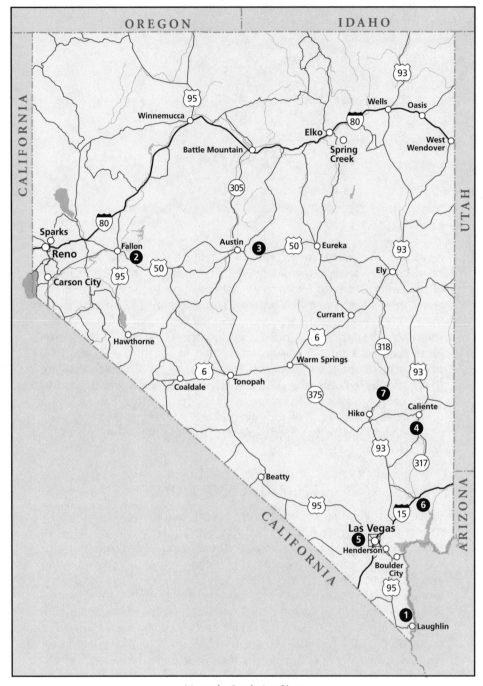

Nevada Rock Art Sites

1. Grapevine Canyon
2. Grimes Point
3. Hickison Petroglyph Recreation Area
4. Rainbow Canyon/Etna Cave
5. Red Rock Canyon National Conservation Area
6. Valley of Fire State Park
7. White River Narrows Archaeological District

NEVADA SITES

Note: For Nevada sites, I have used NV DOT maps for locations. They are more detailed than USGS maps and show the rock art sites. To request an NV DOT map catalog, contact the Nevada Department of Transportation, Map Section Room 206, 1263 S. Stewart, Carson City, NV 89706; (775) 888-7627; Web site, www.nevadadot.com/traveler/maps/request/.

Atlatl Rock. See Valley of Fire State Park.

Etna Cave. See Rainbow Canyon.

Site NV-1
GRAPEVINE CANYON

> **Map locators:** DeLorme 72 F4; NV DOT Quad. 14-2, R65E-T31S
> **Information:** Lake Mead National Recreation Area, (702) 293-8990; Laughlin Visitor Center, (800) 452-8445. A brochure with a map of the rock art can be obtained from either agency.
> **Fees:** None.
> **Directions:** From Laughlin, take NV 163 east. About 7 miles past Davis Dam, turn north onto the road to Christmas Tree Pass (milepost 13). About 2 miles up, on the left, is the parking lot for Grapevine Canyon. From there it's about ½ mile up the wash on a marked trail to the site.

Grapevine Canyon, seven miles west of Laughlin, has a large parking area with trash cans at the trailhead, but there are no interpretive signs or other improvements at any of the panels. Still, it is an excellent site for rock art lovers.

Paleo-Indian hunters from at least 10,000 years ago frequented this area. Attracting humans and animals to this spot was a year-round spring about ¼ mile up the canyon. Cattails and bamboo grow at the spring, as well as a huge grapevine that blocks the entire canyon. To get past it, you must walk through a small tunnel cut through the brush.

From the rocks that form the narrow mouth of the canyon, there is rock art practically everywhere you look, but little or none is visible near the base of the canyon. Reportedly, the rock art does extend many feet below the current level of the canyon floor, and it also extends to the uppermost rocks at the very top of the canyon on both sides.

Many of the panels containing rectilinear and curvilinear designs also have numerous zoomorphic and anthropomorphic images. Most of the petroglyphs are thought to be of Patayan, or Ancestral Yuman, origin. Shortly after you enter the canyon, about halfway up the steep slope on the left is a striking panel that shows a line of bighorns running. Others who have visited the site agree that this panel is not soon forgotten.

Another interesting panel is farther up the canyon on the opposite side, but it can be seen only from the opposite hillside or from immediately

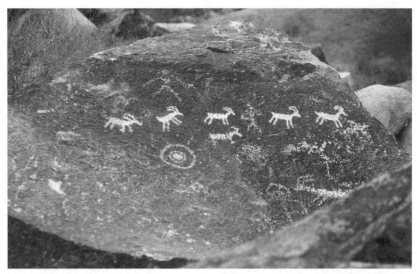

This panel of running bighorn sheep is one of many at Grapevine Canyon.

above it, as it faces upward. It appears to be a very stylized thunderbird image.

There is another site on the north side of the wash just outside the mouth of Grapevine Canyon. Many of the glyphs here seem older and of a different style than those in the canyon itself.

Site NV-2
GRIMES POINT

> **Map locators:** DeLorme 43 C10; NV DOT Quad. 6-10, R30E-T18N
> **Information:** Bureau of Land Management, Fallon, (775) 885-6000; Churchill County Museum, (775) 423-3677
> **Fees:** None.
> **Directions:** From Fallon, take US 50 east about 12 miles to the Grimes Point National Recreation Trail parking lot. The trail has interpretive signs at each site.

About 12 miles east of Fallon on US 50, the "Loneliest Road in America," lies the Grimes Point Archaeological Area. The Grimes Point Trail is a self-guided tour through Nevada's best-developed rock art site. Here you will find a paved parking area, toilets, and picnic tables. A superb free pamphlet explains the significance and possible meaning of many of the images found here. There is also an excellent walking path with numerous interpretive signs at significant spots along the way. This is one of very few sites that are wheelchair accessible.

136

A typical Great Basin Archaic petroglyph at Grimes Point. This site has excellent signs and other improvements.

About 10,000 years ago, Grimes Point was under the waters of the gigantic Lake Lahontan, which covered much of northwestern Nevada. As the ice age ended and the weather warmed, the lake level began to drop and humans moved in, around 9,000 years ago. Over the millennia, many cultures have inhabited this part of Nevada, a fact shown by the several different styles of petroglyphs at Grimes Point, along with evidence found in nearby Hidden Cave.

Many think that Grimes Point was once a good hunting site, and a number of the glyphs here may relate to hunting magic. The rocks along the shore of Lake Lahontan made good hiding places for hunters trying to lure in waterfowl. Other experts think some of the images are related to astrological events.

Site NV-3
HICKISON PETROGLYPH RECREATION AREA

Map locators: DeLorme 46 C2; NV DOT Quad. 6-6, R46E-T18N
Information: Bureau of Land Management, Battle Mountain,
(775) 635-4000
Fees: None.

Directions: From Austin, take US 50 about 25 miles east to the well-marked entrance to the Hickison Summit campground. The site is about a mile from the turnoff. A clearly marked loop trail from the parking area leads to the petroglyph sites.

Hickison Petroglyph Recreation Area is a public rock art site. The petroglyphs are next to the picnic area, in a shallow sandstone draw on the north side of US 50. A brochure and trail guide is available at the trailhead, and each of the panels along the trail are marked with numbered signs. The Hickison campground, maintained by the BLM, is a free facility with campsites, toilets, grills, trash cans, and picnic tables. There is no water, electricity, or dump station here, however.

For thousands of years, people came to the Hickison Summit area to hunt. It is known that people lived around lakes in the nearby valleys more than 10,000 years ago. The area was a major migratory route for deer and probably other large game animals, where Prehistoric people hunted antelope, bighorn sheep, and deer. Many think that the petroglyphs here are connected with hunting activities or hunting magic.

Most of the petroglyphs here are thought to have been made between 500 and 1,000 years ago, but some think a few may date back several thousand years. The images include a number of rectilinear and curvilinear designs as well as numerous stylized zoomorphic designs, probably representing deer or other quadrupeds. There are also several glyphs that resemble the

On this panel at Hickison, some of the deeper, horizontal grooves appear to have been carved over older, vertical lines, indicating that two different cultures may have inhabited this area over time.

138

common vulva symbol and probably represent fertility. Some of the glyphs found here were scratched into the rock surface, while others were pecked. This could indicate that they were made by two different cultures.

Mouse Tank and Petroglyph Trail. See Valley of Fire State Park.

Petroglyph Canyon. See Valley of Fire State Park.

Site NV-4
RAINBOW CANYON/ETNA CAVE

Map locators: DeLorme 63 F7; NV DOT Quad. 9-2, R66E-T5S
Information: Bureau of Land Management, Ely, (775) 289-1800
Fees: None.
Directions: From Caliente, take NV 317 south for about 20 miles, until it ends and becomes Meadow Valley Road. Continue south about 5 more miles, until you reach a low train trestle that straddles a sandy wash. Park there, walk under the trestle, and follow the wash south through a narrow tunnel. The pictographs are a little more than 100 yards beyond the tunnel, on the cliff face to your left.

Rainbow Canyon is probably the most beautiful canyon in southern Nevada. There is abundant water here, which has attracted humans and animals for thousands of years. Archaeological evidence shows that man has lived in Rainbow Valley for more than 5,000 years. Etna Cave (Tunnel Wash) is one of several good sites in the canyon.

Etna Cave has been an archaeological dig for about seventy years, after the discovery of a Prehistoric Indian campsite, dated at about 3000 B.C. Along the wash that leads to the cave site is a large panel of red pictographs. Some are thought to be 1,000 years old.

Site NV-5
RED ROCK CANYON
NATIONAL CONSERVATION AREA

Map locators: DeLorme 70 D1; NV DOT Quad. 12-3, R58E-T21S
Information: Red Rock Canyon Visitor Center, (702) 515-5320; Web site, www.redrockcanyon.blm.gov
Fees: Entrance fee. Camping also available.
Directions: From Las Vegas, take NV 159 (Charleston Blvd.) west several miles to Red Rock Canyon. Directions to individual sites are described below.

Red Rock Canyon National Conservation Area, west of Las Vegas, has several interesting rock art sites, but only two, Willow Spring and Red Spring, are open to the public. More than 300 archaeological sites have been recorded at Red Rock, including rock circles, campsites, rock shelters, roasting pits, and rock art. Roasting pits were used widely here, and there are numerous

remains. Among the artifacts found in the canyon area are projectile points, pottery, and tools.

The Red Rock area has over forty springs, many of which are year-round water sources, and numerous natural rock catch-basins, or *tinajas*. This water has attracted humans and animals for thousands of years. While there is no direct evidence of human occupation by Paleo-Indians, the area has been occupied by at least six different cultures, possibly spanning a period of more than 10,000 years. Various Archaic cultures are believed to have visited Red Rock Canyon from about 1500 B.C. to A.D. 1. Early Paiute, Ancestral Puebloan, Patayan, and other peoples—probably hunting and gathering parties—often came to Red Rock, leaving behind pieces of pottery.

The Virgin River Puebloan people are believed to have settled in southern Nevada around A.D. 500 and stayed to around A.D. 1200. Near the end of the Puebloan reign, about 1,000 years ago, some of them may have moved into the Red Rock area. Possibly the main settlements near the rivers had become overcrowded and were no longer able to support the population. After the disappearance of the Puebloans, the Ute Indians regularly came to Red Rock Canyon on foraging and hunting trips, but they never established permanent camps.

Willow Spring

No image represents humanity better than handprints. Handprint images are found on every continent of the world, some dating back over 20,000 years. At Willow Spring in Red Rock Canyon, a series of five red handprints were prominently painted on a large rock for all passersby to see. Since handprints are such a universal image, it is impossible to tell what culture made them. However, considering their relatively exposed location and the fact that they are painted, they are likely to be less than 1,000 years old, which would mean that they were probably made by Utes or Paiutes.

Some experts maintain that these handprint pictographs mark a spot of great supernatural significance, possibly a place where a shaman could place his hands and magically enter into the spirit world—a portal of sorts. Other rock art panels can be found along the wash nearby.

Willow Spring, marked on all maps of Red Rock Canyon, is a popular picnic area with toilets, picnic tables, and trash cans. It is located off the Scenic Loop, about 5 miles past the visitor center, near the park entrance. The turnoff is on your right. As you enter the picnic area, the handprint panel is on your right, about 30 yards from the road. Park and take the path that leads to the pictographs and a large roasting-pit site. The site is protected by a rail fence and has an interpretive sign. There are also a few petroglyphs near here, along the Lost Creek Discovery Trail, an easy ¾-mile walk.

Red Spring

Red Spring is another great rock art site to visit. Its many petroglyphs are very accessible and easy to find. The glyphs probably span several thousand years and represent several cultures, based on the varied degree of

repatination of the glyphs compared to that of the natural rock. Some of the glyphs are heavily varnished, indicating great age, while others are fairly bright and probably no more than a few hundred years old.

Curvilinear and rectilinear patterns are very prominent here, with wavy lines, circles, triangles, and grids. There are very few zoomorphic or anthropomorphic images. One panel here, high up on a cliff face, has the same blanket design as that found at Valley of Fire. It is moderately repatinated, indicating an age of at least several hundred years.

The Red Spring picnic area is well marked on Red Rock Canyon maps. Take West Charleston Blvd. (NV 159) west from Las Vegas. Look for the Calico Basin turnoff on the right, about 2 miles before the Scenic Loop. Follow this side road to the end of the pavement, about 2 miles. A little farther down, on your left, is the entrance to the Red Spring picnic area, where you will find a parking area, a few picnic tables, toilets, and Red Spring itself. To get to the petroglyphs, walk across the little wooden bridge over the spring and follow the trail to your right. About 75 yards in, you will start to see glyphs on the heavily patinated boulders along the foot of the hill. Many of the glyphs are on rocks near the base of the hill, but there are also some up the hillside on boulders and cliff faces.

Site NV-6
VALLEY OF FIRE STATE PARK

Map locators: DeLorme 71 A7; NV DOT Quad. 12-1 and 12-2, R67E-T17S
Information: Valley of Fire Visitor Center, (702) 397-2088; Web site, parks. nv.gov/vf.htm
Fees: Entrance fee.
Directions: From Las Vegas, take I-15 north to NV 169 and follow the signs to Valley of Fire State Park, West Entrance. Directions to individual sites are described below.

Valley of Fire State Park in southern Nevada, northeast of Las Vegas, has a long history of human occupation and contains some of Nevada's best rock art sites. Besides the well-known Atlatl Rock and Petroglyph Canyon, there are many others, some of which can be spotted without even leaving your vehicle. I will describe five of the park's best sites for rock art viewing.

Some experts believe that man may have been visiting the Valley of Fire area for as long as 11,000 years. Four thousand years ago, the climate was much wetter and cooler here, and the inhabitants of that period lived in a time of great abundance. Game was plentiful, especially bighorn sheep. Many scientists think that the majority of the surviving rock art was created during this period. Since the predominant rock in the area is sandstone, a fairly soft rock, older images may not have endured thousands of years of weathering.

One way scientists use to date the petroglyphs in this region is by the subject matter. The prominent image of the atlatl, which came into widespread use as early as 6,000 years ago, shows that the glyphs are at least 1,500

years old, because the bow and arrow replaced the atlatl around A.D. 500. Another clue to the age of some panels are the many representations of agricultural plants, primarily corn, depicted frequently in this area. These images would date to the Ancestral Puebloan era, about 700 to 1,700 years ago.

Among the images depicted in Valley of Fire are animals, plants, and people, as well as geometric designs in the curvilinear and rectilinear styles. While such variation sometimes represents drawings of different cultures over a great span of time, in this case the appearance of the weathering and patination looks fairly consistent on most of the figures, regardless of style.

Atlatl Rock

About 4 miles down the road from the park's west entrance is a paved side road on the left leading to Atlatl Rock. There is a parking lot near the base of Atlatl Rock, along with a covered picnic area and restrooms. The site is at the top of two flights of stairs; the main panel is protected by a steel rail and a sheet of plastic.

This unique and fascinating rock art site has one of the best images of an atlatl ever found. The atlatl, used for throwing light spears, was a stick with leather finger loops attached near one end.

The main panel at Atlatl Rock, Valley of Fire State Park. The long horizontal line with a circle at one end, at the top of the photo, is thought to be an atlatl.

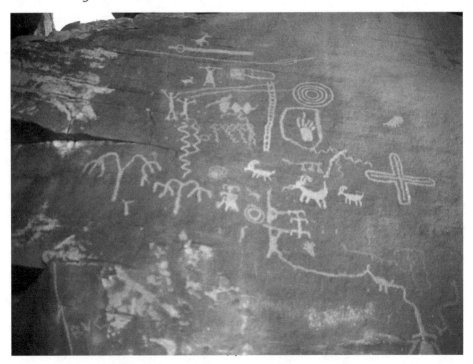

An unusual figure at this site is a half-man, half-bighorn image—basically a two-legged bighorn or a man with a sheep's head. Some experts believe this figure represents a spirit or supernatural being, perhaps something visualized in a drug-induced trance. Others think it might represent a shaman dressed in a bighorn mask and headdress for a hunting ritual.

Other images at Atlatl Rock are various birds and animals, including bighorn sheep and horned toads, human figures, plants, handprints, and geometric designs. Because of the diversity of the images depicted here, it is believed that the panel has been used by several cultures over several thousand years. One could assume, therefore, that ancient Americans revered this as a sacred, or at least a significant, place.

Unseen by many visitors are the numerous petroglyphs scattered over the cliff face behind Atlatl Rock. Many are single images, often hard to see due to erosion, but there is one spectacular panel on a high, flat, heavily patinated cliff.

Petroglyph Canyon

From the Atlatl Rock turnoff, continue east on NV 169 about two miles until you come to the turnoff for the visitor center, a paved road to your left. From the visitor center, follow the signs to Mouse Tank. The parking lot for Mouse Tank and the Petroglyph Trail (Canyon) is on your right.

Some believe the interpretive signs next to the parking lot are outdated, but the interpretations of the rock art images are interesting just the same. The Petroglyph Trail leads to Mouse Tank, a rock catch basin that holds water much of the year. As you enter Petroglyph Canyon, which is actually a narrow arroyo, you will begin to see petroglyphs on the rocks to your left. Images appear regularly along the full length of the ¼-mile walk to Mouse Tank, mostly on your left. This little canyon is quite narrow in spots, and the walls are fairly high, which makes taking pictures of some of the panels a challenge. Probably the best time for photography is midday or early afternoon, when the sun is still high in the sky.

The images here are not as diverse as those at Atlatl Rock, and the rock art doesn't appear to cover as long a time span. They are predominantly images believed to represent the early Virgin River Puebloan culture, similar to those found in areas more heavily dominated by the Ancestral Puebloans. One motif of particular interest is of four human figures holding hands.

Why this small gully would contain such an abundance of rock art is a bit of a mystery. It would be a terrible place to camp most of the year, with little sunlight in the winter and flash floods in the spring. Furthermore, anybody camping here would have no defense against an attack from above. The most likely explanation is the catch basin, Mouse Tank, at the end of the gully, where hunting parties could come for water and possibly to ambush game going there to drink. The petroglyphs could be signs saying any number of things, such as "No Trespassing," "Welcome, Brother, this is a good place to hunt," or even "Look at the huge bighorn sheep I killed here!"

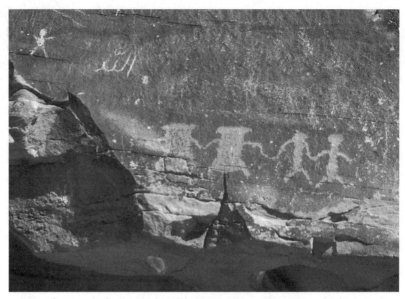

One of several glyphs with a "four men" motif in Petroglyph Canyon

Picnic Glyphs

Across the road from the Mouse Tank parking lot is a small covered picnic area, behind which is a rock face with many glyphs, to the left as you face the cliff. A stretch of about 200 yards is covered with scattered petroglyphs, and hardly anybody ever sees them. The glyphs can be seen from the pavement, but they are hard to spot because most of them are very old and the patina obscures them. The best time to see them is in the morning.

Most of the images here are fairly typical of the area, but there are at least two panels showing unusual images. The first is a blanket motif, about 50 feet to the left of the picnic area at about eye level. The image is a fairly intricate geometric pattern of several vertical repeating designs bordered on the top and bottom with horizontal lines.

It has been suggested that this pattern represents a fringed blanket, as the design is similar to those of typical southwestern Indian blankets. If it does represent a blanket, this fact might be used to help date it. Would the people who made it have had textile-weaving technology or traded with people who did? There is an almost identical image found in Red Rock Canyon about 70 miles west. The patterns are almost identical, so it is almost certain that they were made by the same people, perhaps the same person. The uncommon glyph ties these two sites intimately together, which is a very rare occurrence. Seldom is it possible to positively tie the glyphs from one site to those of another, even in the same region.

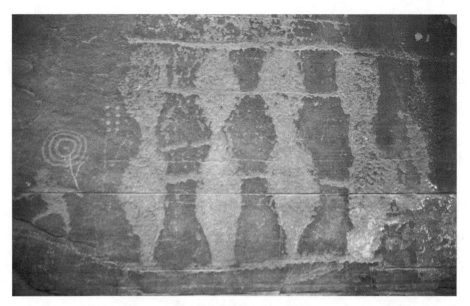

The blanket motif in this petroglyph at Valley of Fire State Park also appears in glyphs at Red Rock.

Another set of panels at this site is also unusual. It includes some images that closely resemble the blanket glyphs. High on the main cliff face is a panel of pictographs that appear to have originally been done in red with a white border. I couldn't tell if the border was part of the original glyph or if someone had recently outlined it in chalk—a practice extremely harmful to glyphs. There are numerous other petroglyph images here, many on a large rock face that cannot readily be seen from the ground—you must climb up on a large boulder immediately in front of it to get a good view. Please take care not to step onto the petroglyph rock itself, as you may inadvertently damage it.

The Cabins

The turnoff for The Cabins is about 2 miles east of the one for Petroglyph Canyon. Take the main park road, NV 169, to the sign for The Cabins, on a side road on the left. At the end of the road is a small parking area with a restroom and a trash can.

Many people come here to hike up the gullies leading from the parking area and to view The Cabins, a small rock structure built on a bench overlooking the parking lot, built by the Civilian Conservation Corps (CCC) during the Depression. What many visitors don't see, however, is the large petroglyph panel on the rock face immediately behind The Cabins. It is an intriguing and diverse panel, and like Atlatl Rock, it appears to cover a greater span of time than those in Petroglyph Canyon.

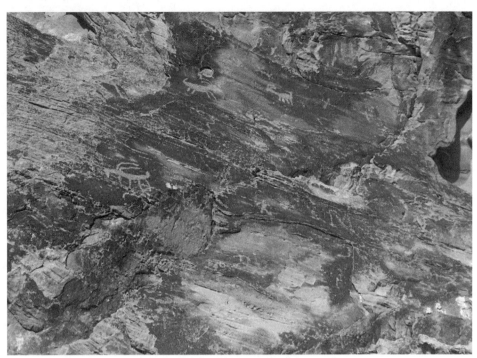

Although The Cabins is a popular spot for tourists, many do not see the large petroglyph panel on the sandstone cliff immediately behind the structure.

The Lone Rock site

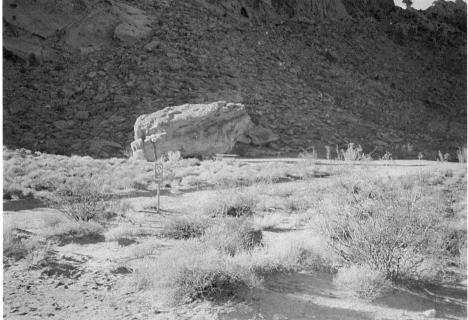

One interesting glyph here is an unusual bighorn image with long, gently curving horns and a long, downward-curving snout. I have noticed at least one similar image at Valley of Fire. The patina, or desert varnish, covering the face of the sandstone here is quite black, and the petroglyphs stand out in vivid contrast.

Lone Rock

On your way out from The Cabins site, just before you reach the main road, you will see a huge rock off to your right, at the base of a prominent outcrop. Follow the dirt road here to a parking area with one picnic table and a trash can. At the end of the parking area are several boulders. The one to the right, which is about four feet high with an almost vertical face, has numerous fascinating petroglyphs on it.

Site NV-7

WHITE RIVER NARROWS ARCHAEOLOGICAL DISTRICT

Map locators: DeLorme 62 C4; NV DOT Quad. 9-3, R62E-T1S
Information: Bureau of Land Management, Ely, (775) 289-1800
Fees: None.
Directions: From Hiko, take NV 318 north to White River Narrows Archaeological District in the Weepah Springs Wilderness. There is a prominent BLM sign marking its southern boundary on NV 318, but the rock art area is a few miles north of the sign, where the road goes through a shallow, rocky gorge. The sites can be accessed from the road as described below.

Most of the rock art panels at White River Narrows are carved petroglyphs, including anthropomorphs and zoomorphs. Hunting images abound. The three major sites that I know of are easy to find and easy to explore, making this a great place to visit. Going north on NV 318, the first site is on your left, a little way down a side road that leads into the hills. The site is near the dirt road, just a few hundred yards from the pavement, at the bottom of a cliff to your right. You will see a small BLM sign there warning that it is illegal to disturb archaeological sites. Beyond the site, the road is closed by a gate.

The second site is a little farther down the highway, on the left (west), where a point of rock comes close to the road. It is easy to spot because somebody has written their name on the rock in large white letters.

The third site is near the other end of the canyon, on the right. It is a small panel and can easily be seen from your car in the afternoon when the sun is on the rock. There is another small BLM sign near the base of this panel.

Willow Spring. See Red Rock Canyon National Conservation Area.

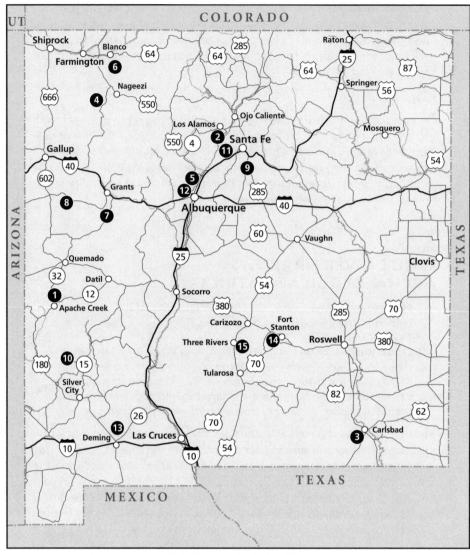

New Mexico Rock Art Sites

1. Apache Creek/Gila National Forest	8. El Morro National Monument
2. Bandelier National Monument	9. Galisteo
3. Carlsbad Caverns/Rock Shelter	10. Gila Cliff Dwellings
4. Chaco Canyon	11. La Cieneguilla
5. Coronado State Monument	12. Petroglyph National Monument
6. Crow Canyon/Largo Canyon/Dinetah	13. Pony Hills
7. El Malpais National Monument	14. Rio Bonito Petroglyph Trail
and Conservation Area	15. Three Rivers Petroglyph Site

NEW MEXICO

New Mexico has some fantastic rock art sites from a variety of periods and cultures. Since Archaic times, the Land of Enchantment has seen numerous Indian cultures come and go, change and evolve.

Around 100 B.C., two pueblo-building cultures developed in New Mexico. The Basketmaker Anasazi lived in the northwest part of the state, and the Mogollon people settled in the southwest part. The Mogollon eventually divided into two subcultures, the Mountain Mogollon, who lived in southwestern New Mexico and southeastern Arizona, and the Desert Mogollon, who occupied southeastern New Mexico and western Texas. Meanwhile, the Basketmakers evolved into the Ancestral Puebloans, who occupied the southern Colorado Plateau. In New Mexico, that encompasses the state roughly north of Grants and west of Albuquerque. Rock art from all of these cultures may be found in New Mexico, as well as from later cultures, including Apache and Navajo.

One site I wanted to include, Puye Calendar Cave, was once a popular tourist attraction, and native ceremonies were frequently held here for visitors—until one fateful day in the 1970s. One afternoon, after the tourists had left, a large black cloud appeared out of a clear sky, and a single bolt of lightning struck two women in native costume who had been performing that day, killing them both. As quickly as it appeared, the cloud vanished, and the sky was clear once more. No ceremonies for tourists have been held here since. Furthermore, the cave has been closed for several years due to a fire, and it will remain so until further notice. Thus I have omitted it from the book.

SITE PRESERVATION

Several of New Mexico's rock art sites are models of creative protection. Petroglyph National Monument, on the outskirts of Albuquerque, is an outstanding example of a large rock art site improved for public visitation. It is the only national park established for the sole purpose

of protecting and preserving rock art. Even so, some officials want to build highways through the park. The Three Rivers Petroglyph Site, in central New Mexico, is another beautifully developed site with parking, a picnic area, and a visitor center.

Making sites visitor-friendly is one strategy in the effort to preserve rock art, but New Mexico uses other methods as well. At Coronado State Monument, the deteriorating painted murals from a kiva have been removed and placed in a building for protection and display. At El Morro National Monument, in addition to the usual fences, signs, and trails, park officials have installed a "graffiti rock" where people can carve their initials.

Moreover, the New Mexico Historic Preservation Division has an exciting new program called New Mexico SiteWatch. A network of private citizens around the state receive training and adopt historical and archaeological sites to help monitor vandalism. Contact the New Mexico Historic Preservation Division, (505) 827-6324; Web site, www.nmhistoricpreservation.org/programs/sitewatch.html/.

To report vandalism in New Mexico, call any local BLM office or the New Mexico state office, (505) 438-7514.

Petroglyph National Monument is a wonderful site near the extensive urban development around Albuquerque.

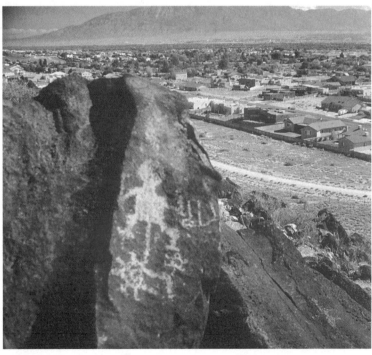

NEW MEXICO SITES

Site NM-1
APACHE CREEK/GILA NATIONAL FOREST

Map locators: DeLorme 36 C4
Information: Gila National Forest, Reserve Ranger District, (505) 533-6232
Fees: None.
Directions: From the town of Apache Creek, at the intersection of NM 12 and NM 32, cross the bridge just south of the Apache Creek store over the (often dry) Tularosa River and follow the dirt road to an unimproved campground. The parking area for the Apache Creek Archaeological Interpretive Site is just beyond. There is also a site along Apache Creek Road (NM 32), just past milepost 8.

In west-central New Mexico, along the Tularosa River near the community of Apache Creek, are numerous ruins of the Mimbres Mogollon people. In some of these, local residents have found sealed jars of beans and ground corn. The corn is still edible, and people have successfully planted the beans in their gardens.

Many of the ruins are on private property. At some of them and at other places in the area are rock art panels. The two major sites are described below.

Apache Creek Archaeological Interpretive Site

The ruins at this location contain ancient walls and great kivas. Along the nearby mesa top is a trail with interpretive signs. The trail leads past many rock art panels scattered along the rimrock.

Apache Creek Road

The site on Apache Creek Road was probably a significant rock art site at one time, but all that is left is one large petroglyph panel. Most of the site was destroyed when road crews blasted through to build the road.

This is one of those sites that is not officially "public" and has no improvements, signs, or fences. In spite of this, and in spite of the fact that it is easily accessible and well known, at least by locals, it remains in pretty good shape.

See also Gila Cliff Dwellings.

Site NM-2
BANDELIER NATIONAL MONUMENT

Map locators: DeLorme 23 B9 and C9
Information: Bandelier National Monument Visitor Center, (505) 672-3861, ext. 517; Bandelier National Monument Information, 24-hour recording, (505)672-0343; Web site, www.nps.gov/band/

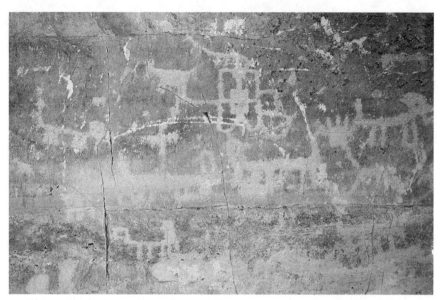

This petroglyph panel can be seen from your car on Apache Creek Road.

Fees: Entrance fee.
Directions: From Santa Fe, take US 285 north to NM 502 west (Los Alamos). Take the NM 4 turnoff (White Rock and Bandelier) south and west about 8 miles to the main headquarters area. Locations of individual sites are described below.

More than 2,400 habitation sites have been discovered in Bandelier National Monument. The Ancestral Pueblo people of Bandelier were farmers, pottery makers, and weavers of cotton garments. They were not able to grow the cotton here, though, and had to trade for it with communities to the south. The Ancestral Puebloan people had left the Bandelier area by the time the Spanish arrived here, but they had not moved very far away. Their descendants still live nearby in modern pueblos.

Visitors can see rock images scattered throughout the park, and much of it is easily accessible with only a short hike. The rock is compacted volcanic ash, called *tuff*, and because images made on tuff do not have the contrast that those on basalt show, you have to look harder to find them. Tuff is also very crumbly, so do not touch any images and please stay on the trails. Stop in at the visitor center to obtain the Main Loop Trail guide and other information. The trail closes at dusk.

Main Loop Trail

The closest panel to the visitor center is only about 400 yards along the Main Loop Trail, but the images are not easy to spot—in some light conditions, they are almost invisible. In any case, due to their distance, you will

need binoculars to see them. Standing at Stake 6 or 7, find the reconstructed house along the base of the cliff, then look up the cliff almost to its top. On a very flat, smooth section of the rock is a petroglyph. The figure, a circle with short spokes projecting outward, may represent the sun. Above it is an animal that at first looks like a bird, but it actually has four legs. The petroglyphs are estimated to be at least 500 years old.

Continuing on the 1-mile trail past Tyuonyi Pueblo takes you up steep, narrow stairs to an area where the Ancestral Puebloan people carved small cave rooms (*cavates*) into the cliff and built masonry homes in front of most of them. Stake 13 marks a cavate apparently used as a kiva. Painted on the back wall is a long, black zigzag representing Awanyu, the water serpent, and a face is visible near the end of the serpent's tail.

Farther along the Main Loop Trail, up Frijoles Canyon, are both pictographs and petroglyphs at the site called Long House. These are the most readily seen images in Frijoles Canyon. Petroglyphs in a step motif inside a second-story cavate can be seen from the trail. Above Stake 19 you will find "smiley faces," and Stake 20 marks an extensive panel that includes humans, animals, birds, spirals, serpents, and other images. At Stake 21 is an area of the cliff face that used to be the back room of a home, which was plastered and decorated with step figures in red pigment. It is protected from weather and vandalism by a thick sheet of glass.

Falls Trail

About 1¾ miles south of the visitor center are a couple of images, including what appears to be a tepee, painted on a cliff face near the Lower Frijole Falls, but park officials are not sure they are authentic.

Painted Cave

Painted Cave contains some of the best-preserved pictographs in Bandelier, and there are petroglyphs here as well. Reaching Painted Cave requires an 11-mile hike each way over steep, rugged, dry country into Capulin Canyon; a wilderness permit, obtained at no charge from the visitor center, is required. Most hikers make this a two-day trip. Visitors may not climb up to the cave, but it is possible to get good photos from its base.

The images include animals, humans, a church with a bell, handprints, and other motifs. It is important to know that Painted Cave is still used by neighboring Pueblo people, who add new images and redo old ones when appropriate.

Tsankawi

Tsankawi, a separate section of Bandelier, is about 11 miles northeast of the main park area and has never been fully excavated or surveyed. From the park entrance, follow NM 4 through the town of White Rock and continue 2½ miles to a traffic light with a sign for the truck route. Just past this junction on the right is the Tsankawi parking lot. Trail guides are available just inside the gate. The area closes at dusk.

From the parking lot, the trail leads to the mesa top and past the un-excavated village along the sunny side of the mesa. The hike requires a bit of agility, as it includes climbing around rocks and negotiating three 12-foot ladders. The first petroglyphs are on the cliff face to the left as you approach the second ladder. Numerous other glyphs (some of which have been vandalized) are scattered all along, on cliff walls and boulders. Most of them date from the occupation of the village and include images of people, animals, handprints, flute players, spirals, and other motifs. The site seems to announce the entrance to the village, just as billboards along the freeway outside modern cities advertise motels and fast-food restaurants.

On the mesa top here are the remains of a pueblo that the Ancestral Puebloans inhabited from about A.D. 1400 to the mid-1500s, contempora-neous with Tyuonyi. Parts of the pueblo might have been three stories tall and may have contained over 350 rooms. People at nearby San Ildefonso Pueblo regard Tsankawi as one of their ancestral homes. They ask that visitors stay on the trail and treat the area with respect.

Site NM-3
CARLSBAD CAVERNS NATIONAL PARK/ROCK SHELTER

Map locators: DeLorme 56 F1
Information: Carlsbad Caverns National Park, (505) 785-2232; Web site, www.nps.gov/cave/
Fees: Entrance fee.
Directions: At the town of Carlsbad, take US 62/180 south to the well-marked Carlsbad Caverns turnoff, which leads west about 7 miles to the park entrance.

Most of the rock art in Carlsbad is in the form of pictographs, but there are some petroglyphs as well. The pictographs are drawn in several colors, especially white, black, yellow, and red. At the Natural Entrance to the Carlsbad Caverns, a short walk from the visitor center, is a red and black pictograph panel, but the images are very faded and barely discernible. Up Slaughter Canyon is the Painted Grotto, where the pictographs are much more profuse and much better preserved. The Slaughter Canyon Trail leads past the grotto entrance, but it is not marked, so get directions and/or a map, or take a park tour. Be aware that it is a backcountry hike. The multi-colored images in the grotto include ambiguous zoomorphs and geometric forms. They are thought to be Chihuahuan.

By the way, there is also some rock art at the Rock Shelter, which can be explored without paying the park entrance fee. The turnout for the shelter is marked along the road to Carlsbad Caverns. There is an interpretive sign telling about the shelter, which was once inhabited by native people, though it doesn't say anything about the rock art.

This small rock shelter along the road to Carlsbad Caverns has petroglyphs and an interpretive sign.

Cebolla Wilderness Petroglyph Area. See El Malpais National Monument and Conservation Area.

Site NM-4
CHACO CANYON

> **Map locators:** DeLorme 13 H8
> **Information:** Chaco Culture National Historic Park, (505) 786-7014; Web site, www.nps.gov/chcu/
> **Fees:** Entrance fee.
> **Directions:** From Nageezi, go south on Reservation Roads 45A and 7650 for about 25 miles. Follow signs to visitor center. Locations of individual sites are described below.

Chaco Culture National Historic Park is a must-see for anyone interested in ancient Puebloan life. There are a number of pueblos to explore, and the Great Kiva at Casa Rinconada is very impressive. Visitors can walk around the ancient pueblos and look at the ruins up close.

Chaco Canyon was heavily populated from about A.D. 850 to after 1125, and it seems to have been a hub of Early Puebloan culture. Recently, a very well-engineered ancient road was discovered that directly links Chaco with ruins about 55 miles to the north. Other similar roads are believed to have linked Chaco with as many as 150 outlying Pueblo communities, some as far away as Colorado, Utah, and Arizona.

There is also some good rock art here. The sandstone walls of the canyon were an important place for the people to inscribe significant events in their history, write messages for their gods, and record celestial occurrences.

Una Vida

The best-known and most easily accessible rock art site in Chaco Canyon is right behind the Una Vida pueblo ruins, near the visitor center. A fairly easy ⅓-mile trail goes through the pueblo and leads to the glyphs. The rock art is found on the sandstone cliff face above and behind the ruins. Among the images are anthropomorphs, geometric forms, and four-legged animals that may be bighorn sheep.

Pueblo Bonito

A rock art panel on the cliff behind Pueblo Bonito, near the visitor center, contains images of six-toed footprints and other petroglyphs. Although not common, six-toed footprint images have been found at other sites.

Supernova

A famous rock art site in Chaco Canyon is the Supernova site near Peñasco Blanco, at the northwest end of the canyon. The glyph is believed to depict the supernova that created the Crab Nebula on July 4, 1054.

The Una Vida Ancestral Puebloan ruins at Chaco Canyon

Below the Supernova panel, on the vertical face of sandstone rock, is a panel believed to record the appearance of Haley's Comet in the year A.D. 1066. The comet is depicted by three concentric circles, almost a foot in diameter, trailing a stream of red fire to the right. The red is very faded. Near the comet are a cresent moon and a handprint.

The Supernova site is accessible via a 6½-mile hike, and visitors must register and obtain a permit at the visitor center. There are also other rock art sites along the main trail to Penasco Blanco.

Also found here but not open to the public is a site high on Fajada Butte. It was used as a solstice marker. Unlike most solstice markers, in which the rising or setting sun casts shadows or rays of light on glyphs to mark the seasons, at Fajada Butte the midday sun shines a beam of light between two boulders onto petroglyphs to indicate the solstices and equinoxes.

Comanche Gap. See Galisteo.

Site NM-5
CORONADO STATE MONUMENT

Map locators: DeLorme 23 G7
Information: Coronado State Monument, (505) 867-5351
Fees: Entrance fee.
Directions: From Albuquerque, take I-25 north about 10 miles to exit 242 (NM 44) west and follow the signs to Coronado State Monument. Murals are on view at the visitor center.

Ancient Kuaua (meaning "evergreen" in Tewa) Pueblo, at Coronado State Monument, is one of only a few places where the public can see beautiful and rare kiva murals. The pueblo is believed to have been built by the Ancestral Puebloan in the late 1300s, who migrated here from Chaco Canyon in search of more fertile lands along the Rio Grande. When the Spanish explorer Francisco Vásquez de Coronado came into the area in 1540, the Ancestral Puebloan had disappeared.

Archaeologists excavated the Kuaua ruins in the 1930s, discovering 1,200 rooms and several kivas, at least one of which had amazing murals adorning its walls. In order to preserve the art, the mural walls were removed intact. They are on display at the museum. The original murals are badly eroded, and much of the detail has been lost to time, but next to each is a painting with an artist's interpretation of what the original might have looked like.

The overlying theme of the murals is definitely water. Lightning, water gourds, and waterbirds are prominent in most of them. One realistically depicts a man urinating.

Besides the original murals at the visitor center, there is a self-guided tour on a 400-yard trail through the ruins. The kiva itself has been reconstructed, and visitors are allowed to enter it via a ladder from the traditional hole in the center of its ceiling. Reproductions of the original murals decorate its walls.

Interpretive display of one of the murals salvaged from a kiva at the Coronado State Monument. The murals all have themes linked to water and rain. This is an unusual depiction of a man or god urinating into an overflowing pot, with possible lightning bolts coming out of it.

"Spitting, spurting, or spraying medicine is one of the most common ways of applying it."

Site NM-6

CROW CANYON/LARGO CANYON/DINETAH

Map locators: DeLorme 13 D10
Information: Bureau of Land Management, Farmington, (505) 599-8900
Fees: None; tours available.
Directions: From Blanco, east of Farmington on US 64, take County Road 379 southeast, a good road that follows Largo Canyon for about 40 miles. There are rock art panels scattered throughout the area, some of which are described below. As most of the sites are a bit far-flung, a guide is recommended.

Southeast of Farmington, Largo Canyon is a major drainage of northwestern New Mexico, and humans have lived here for centuries. Once inhabited by the Ancestral Puebloan, this area boasts many petroglyph sites.

The history of the area is quite interesting. The Navajo people who lived here in the 1700s were under constant threat of attack by the Utes. The Navajo defenders constructed their *pueblitos* (small pueblos) on top of large boulders, mesa tops, and cliff faces for protection. Many pueblito ruins remain throughout the canyon. An excellent brochure is available at the Farmington BLM office called "Pueblitos of Dinetah," about the rock art and ruins in the region.

Anthropomorphic images of supernatural spirits are common in the Largo Canyon area. Among them is the Ghaan 'ask'idii, the humpbacked god (not to be confused with the humpbacked flute player, Kokopelli). The god wears a

horned headdress, and feathers seem to radiate from his hump. He usually carries a staff and is often associated with glyphs of corn, bighorn sheep, or sheep tracks. He is considered the god of plenty. Hourglass and recurved bow motifs are also common in Largo Canyon.

About 19 miles south of Blanco, down Largo Canyon, is a very popular rock art area at Crow Canyon. It is off the main road and across Largo Wash at Rock Crossing, where there is a small parking area on the north side of Crow Canyon. The site has no amenities except the parking area, where there is a guest register to sign. There are many petroglyphs in this canyon, most less than a mile walk from the parking area. The main panels are at the mouth of the canyon, on the north face.

At this site you will find animal, human, and spirit or ceremonial images. One of the more interesting figures is a well-executed image of an anthropomorph with square eyes, a long feathered headdress, a bow and arrow in one hand, and a club or ax in the other. The bow is of a fairly modern recurved style used by the Apaches and Navajos. The figure is believed to represent the Navajo deity Neizghani, or Monster Slayer, who cleared the earth of monsters so that the people could emerge from the underground. He and his twin, Born of Water, were the mythical sons of Changing Woman, who is believed to have come from what is called Gobernador Knob nearby. Monster Slayer is often represented by a recurved bow glyph, and Born of Water is often represented by an hourglass shape.

Besides the main Crow Canyon site, there are a number of additional rock art panels farther up the canyon. Tours are available through regional archaeological groups and private outfitters.

Dinetah Pueblitos. See Crow Canyon.

Site NM-7
EL MALPAIS NATIONAL MONUMENT AND CONSERVATION AREA

Map locators: See below.
Information: Northwest New Mexico Visitor Center, (505) 876-2783; Bureau of Land Management, Grants, (505) 287-7911; Web site, www.nm.blm. gov:80/aufo/el_malpais/el_malpais_more.html
Fees: Donations appreciated.
Directions: From Albuquerque, take I-40 west to exit 89 (NM 117) and go south to the El Malpais BLM Ranger Station. Directions to individual sites are described below.

There are numerous petroglyph sites in this area, but most of them are remote and many are not open to the public. The rock art, of both Ancestral Puebloan and Mogollon origin, is mostly found in the Cebolla Wilderness petroglyph area. Images include large and small zoomorphs, geometric designs, celestial symbols, handprints, and more. I will describe two of the

main public sites here, the BLM Ranger Station site and the North Pasture site. There are also several ancient pueblos in the park. Visit the ranger station for more information on these sites and others.

BLM Ranger Station

Map locators: DeLorme 29 B9; USGS NM-1075 (Los Padres)

There are two ways to reach this site from the BLM ranger station, about 10 miles south of I-40 on NM 117. You can walk across the highway from the station and head toward the ridge to the west. When you get to the top of the ridge, continue down to its base, then follow it south toward the Sandstone Bluffs area. You will easily recognize the site when you see it, at the bottom of a sandstone bench. The other way is to turn onto the Sandstone Bluffs Road and park at the first curve in the road. Walk northwest until you come to a fence. Cross the fence and walk downhill to an old homestead site. From there, go north along the bottom of the ridge for about 75 yards until you come to the panel on your right.

North Pasture

Map locators: DeLorme 29 D8; USGS NM-1275 (North Pasture)

The North Pasture site is a little farther from the highway than the others. From the ranger station, continue south on NM 117 for a few miles until you come to an unmarked dirt road (Lobo Canyon Road) on your left, near milepost 31. You can see a large windmill not far from the road at North Pasture Tank, and there is an unlocked gate to go through. Be sure to close it behind you. Take the road about 3 miles until it crosses a cattle guard at a fence. Park and follow the fence about ¼ mile to the rock bluffs on your right. From the base of the bluffs, it's about ¼ mile up a modest slope to the cliff where the rock art is.

Site NM-8
EL MORRO NATIONAL MONUMENT

Map locators: DeLorme 29 A6
Information: El Morro National Monument, (505) 783-4226; Web site, www.nps.gov/elmo/
Fees: Entrance fee.
Directions: From Grants, take NM 53 south and west about 42 miles. To reach the rock art, go to the visitor center and take the ½-mile path around the base of the cliff.

When the Ancestral Puebloan abandoned the Colorado Plateau between A.D. 1250 and 1400, a band of them wandered south through eastern New Mexico and discovered a great sandstone promontory with a pool of water at its base. They settled here for a while and built a small village on top of the mesa. At the base of the mesa is a special place called Inscription Rock, where people have been leaving their mark for over 500 years. The Zuni

Indians called it *A'ts'ina*, or "Place of Writings on Rock." Spanish explorers named it *El Morro*, "The Headland." Among those who inscribed the rock are ancient Ancestral Puebloan, more recent Zuni, and Spanish explorers. Later still, American soldiers, emigrants, and cowboys left their signatures.

As a preservation measure, the visitor center offers a "graffiti rock" near the entrance for guests to scratch their names in.

Site NM-9
GALISTEO

> **Map locators:** DeLorme 24 F1; USGS NM-0709 (Galisteo)
> **Information:** Museum of Indian Arts and Culture (Santa Fe),
> 505-476-1250; Web site, www.miaclab.org/index.html
> **Fees:** Guided tours available; fees vary.
> **Directions:** From I-25 near Santa Fe, take US 285/NM 553 (exit 290) south
> to NM 41. Follow NM 41 south 5 miles.

The Galisteo Basin, south of Santa Fe, was inhabited by the Southern Tewa from late 1200 until the Pueblo Revolt in the late 1600s. Most of the rock art in the area is on private land, but tours of Comanche Gap, San Cristobal Ranch, the pueblos, and several other sites can be arranged through the Museum of Indian Arts and Culture in Santa Fe.

The Tewa built several major settlements, including Pueblos Blanco, Colorado, and Largo, and produced much rock art throughout the area. The handprints of Comanche Gap are well known. At Arroyo San Cristobal, masks are common, as well as corn glyphs and spear-swallower images.

Site NM-10
GILA CLIFF DWELLINGS

> **Map locators:** DeLorme 37 H6
> **Information:** Gila Cliff Dwellings National Monument, (505) 536-9461;
> Web site, www.nps.gov/gicl/
> **Fees:** Entrance fee for ruins. "Trail to the Past" is free.
> **Directions:** From Silver City, take NM 15 north about 40 miles. The road
> is narrow and winding, so allow extra travel time. There is also access via NM
> 35, recommended for RVs. There is a parking area at the trailhead. At the
> Lower Scorpion campground, ¼ mile south, is the "Trail to the Past."

The Mogollons first settled in this area about A.D. 100. The oldest ruins here are of pit houses; later, the Mogollons built pueblos in open areas on the mesas. Later still, they built cliff dwellings, five of which still stand today. The rare Mogollon cliff dwellings were built in the late 1200s, only one generation before the Mogollon disappeared in the early 1300s.

The Mogollons farmed corn, beans, and squash, hunted, and gathered local plants for food. They made excellent pottery, wove cotton blankets and

clothing, and traded with their neighbors. Like the other ancient Mogollon people, by the time of the arrival of the first Spanish explorers, they had disappeared, possibly having been assimilated by other Puebloan groups. When the first European explorers arrived, only the nomadic Apaches lived in the immediate area.

From the parking area at the end of the road on the West Fork of the Gila River, a box at the trailhead contains leaflets describing points of interest along the 1-mile loop trail through the ruins, including the numerous red pictographs. (See color plate 6.) In the Lower Scorpion campground, ¼ mile south, the "Trail to the Past" leads to a good pictograph site. The 100-yard-long trail is wheelchair accessible and offers a couple of interpretive signs along the way. There is no charge to use the campground, which has tables, barbecue pits, drinking water, and flush toilets from mid-May to mid-October.

See also Apache Creek.

Site NM-11
LA CIENEGUILLA

Map locators: DeLorme 23 E10; USGS NM-1762 (Tetilla Peak)
Information: Bureau of Land Management, Taos, (505) 758-8851
Fees: None.
Directions: Call the BLM for a map to the site.

La Cieneguilla (also spelled Cienega) Pueblo is approximately 8 miles southwest of Santa Fe, past the airport, near the village of La Cienega along the upper Santa Fe River. The ruins and rock art are scattered in side canyons all along this stretch of the river. The site includes world-class Rio Grande–style rock art, pueblo ruins, and intact portions of the Spanish El Camino Real (King's Highway). The black basalt cliffs have 4,000 petroglyphs within a mile. A fence at the west end of the mesa marks the border of the public land.

La Cieneguilla, which means "little swamp" in Spanish, has been inhabited periodically since the end of the ice age. The Cieneguilla ruins were occupied periodically for over 300 years, from the late 1200s to the late 1500s. The site is considered a very important New Mexico archaeological property, providing an interpretive link between American Indian and Hispanic histories.

The area is being stabilized as a Bureau of Land Management Area of Critical Environmental Concern, and a plan is in effect to turn La Cieneguilla into an interpretive archaeological site for the public, with a parking area, paths, signs, and other improvements.

Largo Canyon. See Crow Canyon.

Site NM-12
PETROGLYPH NATIONAL MONUMENT

Map locators: DeLorme 58 E1 and 23 H6
Information: Petroglyph National Monument, (505) 899-0205; Web site, www.nps.gov/petr/; City of Albuquerque, (505) 873-6632
Fees: Parking fee for Boca Negra Canyon; none for other areas.
Directions: The park is just northwest of Albuquerque. Take I-40 to Unser Boulevard and go 3 miles north to the visitor center. Directions to individual sites are described below.

In the Rio Grande valley, on the west side of metropolitan Albuquerque, Petroglyph National Monument is dedicated to the display and preservation of a large petroglyph area with several major sites, including the 17-mile-long West Mesa Escarpment and its five volcanic cones. The area contains more than 15,000 petroglyphs, most of them along the basalt cliffs and boulders of the escarpment, made in the Rio Grande style. People have inhabited this area for over 10,000 years, and some of the images may be over 5,000 years old. It is believed that the majority were made between A.D. 700 and 1350 by Ancestral Puebloan farmers.

There is a wide variety of images here, many found nowhere else. A particularly interesting glyph is a four-pointed star with hands and feet and what looks like a crown. Another image found in the area is parrots or macaws; one glyph shows two parrots facing each other, joined at the breast. Some of the designs here are similar to those used by the Mogollon people, such as the cloud terrace image, evidence that the southern Mogollons influenced the people in this valley.

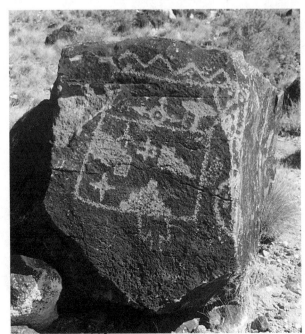

This cloud terrace image at Petroglyph National Monument is similar to Mogollon glyphs found at Three Rivers.

The most popular petroglyphs are in Boca Negra Canyon. The three established trails through the petroglyph fields in this canyon are Mesa Point, Macaw, and Cliff Base. At the monument's visitor center, be sure to get a copy of the trail guide, which details most of the major panels along each trail.

The Mesa Point Trail is the longest and steepest, leading to the top of the mesa. It offers the best view of the Rio Grande valley and lots of unusual glyphs, including several macaws, masks, shields, and many other designs. Also look for grinding spots, called bedrock metates, on flat surfaces. The Macaw Trail is a short and easy trail. As the name suggests, you will see images of macaws, as well as yucca pods—a staple food source—and other images such as masks.

The Cliff Base Trail is somewhere in between the other two in terms of difficulty and in what it has to offer. It winds a little way up the hillside and passes many nice glyph panels. Watch for stars, simple shields, and masks.

There are also some good petroglyphs in Rinconada Canyon, near the southern end of the monument. At the northern end of the mesa is another excellent rock art area called the Piedras Marcadas Canyon. Rangers regularly guide tours there; check with the visitor center for details.

A yucca pod glyph at Petroglyph National Monument

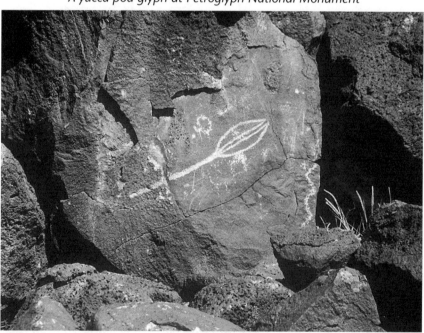

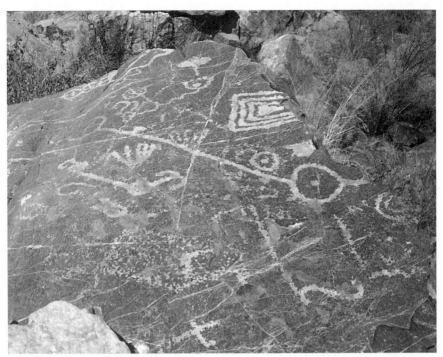

One of the main panels at the Pony Hills site. Note the number of unusual motifs.

Site NM-13
PONY HILLS

Map locators: DeLorme 45 G9
Information: Mimbres Museum, (505) 546-2382
Fees: None.
Directions: From I-10 at Deming, take NM 26 northeast about 5 miles to County Road A16, then go north about 9 miles to a dam. Park near the base, walk over the dam, and follow the slope about 100 yards to a group of very large boulders with petroglyph panels. The trail to the site is very faint.

Scattered on the boulders at the Pony Hills site are a number of interesting petroglyph panels. Depicted here are flute players, horned serpents, shields, masks, and anthropomorphic and zoomorphic figures, typical Mogollon images. They are believed to be about 600 to 1,200 years old.

One small sign marks the site. Other than this, there are no improvements or protection. However, this site is regularly visited by locals, including groups of schoolchildren on field trips. The site's "high profile" might explain why there has been little vandalism here.

Site NM-14
RIO BONITO PETROGLYPH TRAIL

Map locators: DeLorme 40 F4
Information: Bureau of Land Management, Roswell, (505) 627-0210
Fees: None.
Directions: This trail is at Fort Stanton, about 60 miles west of Roswell, off US 380. The site is easy to reach via the well-maintained trail, but the directions to the trailhead are a bit complex; call for the free brochure and map to the site.

At Fort Stanton, in the Rio Bonito riverbed, is a rock art trail maintained by Boy Scout Troop 72 from Roswell. They even built a footbridge across the river so visitors won't have to get their feet wet. At about the midpoint of a 2¹⁄₁₀-mile loop trail is Petroglyph Rock. Etched into the rock are about 750 Mogollon petroglyphs estimated to be more than 1,000 years old. This rock is about the only thing in this area that the Mogollons left behind to mark their passing.

The rock has numerous and diverse images, many abstract. One of them may be a representation of the water god, Tloloc, possibly to commemorate a particularly wet year and bountiful corn harvest. Some of the newer glyphs are thought to be from Apache warriors or hunters who came here after the reign of the Mogollon farmers. Other images could be clan markings, laying claim to the area and its water.

San Cristobal. See Galisteo.

Site NM-15
THREE RIVERS PETROGLYPH SITE

Map locators: DeLorme 40 G1
Information: Bureau of Land Management, Las Cruces, (505) 525-4300
Fees: Entrance fee.
Directions: From Carrizozo, take US 54 south 17 miles to Three Rivers. Turn east on County Road 579 (at the Three Rivers store) and go about 5 miles to the parking area, on your left. There is a 1-mile trail to the sites.

Three Rivers Petroglyph Site has some of the best and most extensive examples of Jornada Mogollon style rock art anywhere. More than 21,000 petroglyph images of animals, birds, humans, fish, insects, plants, masks, and geometric and abstract figures are scattered on boulders over fifty acres. The site has ample parking; a picnic area with ramadas, tables, and trash cans; restrooms; and a small visitor center. The brochure gives a good description of many of the more prominent glyphs at the site, several of which are numbered with markers.

From the picnic area adjacent to the parking lot, a 1-mile, signed loop trail along the ridge winds through hundreds of boulders decorated with thousands of glyphs. One motif I found particularly interesting was a circle

outlined by a row of evenly spaced dots, appearing on scattered panels. There was always a design in the center of the circle, but the design varied from glyph to glyph. These dotted circle patterns may have been clan markers.

About 200 yards south of the petroglyph area, near Three Rivers Creek, are the remains of a Mogollon village. The village is believed to have been established at least 1,000 years ago and was last inhabited about 600 years ago.

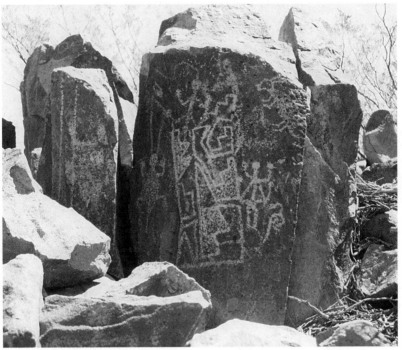

This blanket-design glyph is one of over 21,000 petroglyphs at the Three Rivers Petroglyph Site.

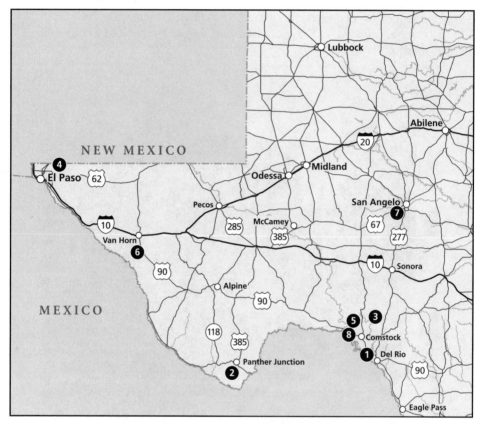

Western Texas Rock Art Sites

1. Amistad National Recreation Area
2. Big Bend National Park
3. Devils River
4. Hueco Tanks State Historical Park
5. Lewis Canyon
6. Lobo Valley Petroglyph Site
7. San Angelo State Park
8. Seminole Canyon State Park

WESTERN TEXAS

Texas is different from other southwestern states. For one thing, Texas has no BLM land. Other than local, state, and national parks, Texas seems to be mostly private property. Most Texas ranchers do not want unknown people on their property, and trespassers may be dealt with severely. Thus it is difficult to gain access to much of the rock art in the region; in fact, I had to drop several sites for lack of information. Of the few sites on public land, most are restricted. Many of the best-known rock art sites in the region are available only by guided tour. In addition, the distances between sites are vast, and there are no roads into many areas. Some sites are accessible only by water, and others require a four-wheel-drive vehicle.

Some of the rock art in western Texas is spectacular, however, and well worth the effort to see it. What follows is all the information I could gather about the most popular sites in the region. In some cases I list companies and organizations offering tours for the site, but this information is not to be taken as a personal recommendation.

Western Texas has various types of rock art, but one in particular, known as the Pecos River style, is unique to the region. This Archaic style was used exclusively by the people of the lower Pecos River for over a period of perhaps 6,000 years, between about 7000 to 1000 B.C. The period of highest population density in the region, from 2000 to 1000 B.C., produced the greatest amount of rock art. Pecos River rock art is characterized by stylized, polychrome pictographs, considered by many to be among the finest pictographs in the world.

Other Archaic cultures also left a great deal of rock art to mark their presence. In Alamo Canyon and Alamo Mountain, near Hueco Tanks, hunting scenes are common, showing bighorn sheep and deer, often with spears running through them. Anthropomorphs with hourglass bodies also often hold spears. Other Archaic rock art motifs in the area are pictographs of geometric designs.

Historic rock art, made after 1600, often depicts missions, guns, and horses with Indian or Spanish riders. Most Historic rock art in western Texas is Mescalero Apache, primarily pictographs, but some is thought to be Chiricahua Apache and Comanche. Apache rock art was typically drawn in charcoal.

Much of the rock art in Texas is thought to have been made by shamans practicing an ancient mescal-bean ritual. The scarlet seeds of the Texas mountain laurel, commonly called mescal beans, contain a substance that causes a visionary trance. The Mescalero Apache were named by the Spanish for this tradition.

SITE PRESERVATION

As mentioned above, there is no BLM-controlled government land in Texas; in fact, there is very little federal land at all. There is rock art in some state parks, however. Access to the sites is often restricted to protect the rock art. In addition, the Texas Parks and Wildlife Department initiated a graffiti-eradication program in 1995. At Hueco Tanks State Historical Park, one of the premiere rock-climbing spots in the country, more than two-thirds of the park is restricted to guided tours only. In the areas that are open to the public, visitation is limited to fifty persons at a time.

The Witte Museum in San Antonio, which started researching the lower Pecos River area in the 1930s, now has a permanent exhibit devoted to rock art. The Texas Antiquities Code, passed in 1969 by the state legislature, supports cultural research on all state-owned lands. There are also several private, nonprofit organizations in Texas devoted to the study and protection of the state's rock art sites. The Texas Archeological Society's Rock Art Task Force is a volunteer group dedicated to encouraging and advancing research in the field of rock art, specifically Texas's Prehistoric and Historic pictographs and petroglyphs; preserving rock art through recording, adding greatly to our knowledge of the past; working for the protection and preservation of rock art sites through cooperative interaction with private landowners and appropriate state and federal agencies; and promoting nondestructive examination of rock art through education and awareness programs.

The Rock Art Foundation (RAF) is a Texas nonprofit organization established in 1991. The foundation exists to promote the conservation and study of the Native American rock art in the lower Pecos region of southwestern Texas. Among the RAF's goals are educating public and private sectors about the endangered status of rock art in Texas; conducting restoration and preservation research; acquiring endangered sites for transfer to agencies capable of ensuring their integrity; locating and documenting previously unrecorded sites; fostering harmonious

relations with landowners for site management and supervised visitation; and archiving photographic collections.

To report rock art vandals, call Texas Parks and Wildlife Division, (800) 792-1112. The Web site is www.tpwd.state.tx.us/. Contact information for the Texas Archaeological Society and the Rock Art Foundation can be found in the Resources list.

WESTERN TEXAS SITES

Site TX-1
AMISTAD NATIONAL RECREATION AREA

Map locators: DeLorme 86 B4
Information: National Park Service, (915) 292-4544; Web site,
www.nps.gov/amis/; tour information, (915) 292-4464
Fees: Guide recommended; call to register.
Directions: From Del Rio, take US 90 northwest 10 miles to Amistad National Recreation Area Visitor Information Center.

On the Rio Grande, northwest of Del Rio, is the Amistad National Recreation Area. Amistad has camping and picnicking facilities, several marinas, and nature trails. The recreation area extends 25 miles up Devil's River Canyon, 14 miles up the Pecos River, and 74 miles up the Rio Grande. Artifacts found in the area indicate that man has been here for perhaps 12,000 years. Within Amistad are numerous rock art sites, most of which can be reached only by boat.

One of the major sites is Panther Cave, a large rock shelter famous for its elaborate Prehistoric pictographs of felines. It is near the upper reaches of Lake Amistad, along the west bank of Seminole Canyon, just above its confluence with the Rio Grande. The site is named for the nine-foot-long leaping panther painted here, and at least four other cats are discernible in the mass of overlapping figures that cover the rear of the main shelter.

The pictographs of Panther Cave are predominantly painted in the Archaic Pecos River style. Several anthropomorphic figures wear headdresses resembling feline ears, which might represent a shamanistic cat cult or a territorial or clan marker. The frequent painting over of previous images at Panther Cave suggests considerable reuse of the site, perhaps for religious ceremonies.

Panther Cave is accessible only by boat. Visitors with their own boats may visit Panther Cave at any time. There is also a tour that goes by truck and boat. A chain-link fence has been constructed across the front of the main shelter to deter vandalism.

Parida Cave is another Pecos River–style pictograph site at Amistad, on the Rio Grande River. It is usually accessible only by boat, except when the water is low. When it is accessible by foot, the trail is unmaintained and extremely primitive. Check with park rangers before embarking on this potentially hazardous 3-mile hike.

Site TX-2
BIG BEND NATIONAL PARK

Map locators: See below.
Information: National Park Service, (915) 477-2251; Web site, www.nps. gov/bibe/
Fees: Entrance fee. Camping available.
Directions: From US 90, take US 385 south to Big Bend National Park headquarters. Directions to individual sites are described below.

Big Bend National Park, situated along the Rio Grande, has been inhabited for thousands of years. The oldest archaeology site in Big Bend is nearly 10,000 years old. The glyphs here are mostly abstract curvilinear designs. Many were made using a peculiar pecking/abrading technique not found in other regions. Red pictographs are also found here, but most are badly faded. Other rock art includes simple black pictographs believed to have been made by the Apache. Most of the rock art cannot be attributed to any particular group, but it is thought that native people established permanent settlements and agriculture in the Big Bend area sometime around 1200, and the Apache came in around 1700, followed by the Comanche.

There are three sites in Big Bend National Park that are accessible to the public: Chimneys Trail Glyphs, Hot Springs, and Indian Head Mountain.

Chimneys Trail Glyphs
Map locators: DeLorme 75 D8; USGS TX-0666 (Castolon)

About 2⁴⁄10 miles along the well-marked trail from the Chimneys West campground are panels of rock art along a rock wall of the southernmost tower of the Chimneys. The panels are not marked so you must hunt for them. The images are mostly petroglyphs, with a couple of pictographs.

To reach the trailhead from the park headquarters at Panther Junction, take TX 118 west to Maverick Junction, then turn south and go about 8 miles to the Chimneys West campground.

Hot Springs
Map locators: DeLorme 75 D11; USGS TX-5245 (Rio Grande Village)

Hot Springs is close to a very large cold spring that is the source of Tornillo Creek. A 75-foot-high limestone bluff on the north bank of the Rio Grande, just below the mouth of the creek, contains rock art panels. The red, yellow, and black pictographs are 2 to 8 feet above the ground. The stone is badly cracked, so some images have no doubt been lost, but the images that are left are easily seen. The designs are very simple, mostly geometrical patterns, but a few may be anthropomorphic. In addition to the pictographs is one small petroglyph panel.

To get to the site from the park headquarters at Panther Junction, take TX 118 about 20 miles southeast to the well-marked turnoff to Hot Springs, which is about 2 miles down a good dirt road. A few miles west is the Rio

Grande Village Visitor Center, where you can obtain a booklet about this site. There is an improved path to the glyphs with a few signs.

Indian Head Mountain

Map locators: DeLorme 75 C8; USGS TX-3752 (Terlingua)

Indian Head Mountain, northeast of Study Butte (Terlingua), on the border of Big Bend National Park, is a popular rock-climbing spot. Several good rock art panels can be reached on an easy 1-mile hike. The trail goes past several sites and ends at Indian Head Spring.

The first site is in and around a rock shelter at the base of the mountain. Petroglyphs appear on boulders outside the shelter, and pictographs inside the shelter. A few hundred yards beyond the rock shelter is a "map" rock. Past the shelter and toward the spring are more panels, some of them 50 to 100 feet above the path.

From park headquarters, take TX 118 west to the small community of Study Butte (Terlingua). Take Indian Head Road to its end near the park boundary and park your car there. Cross the fence and follow the trail east. A few hundred yards along the trail is a large sign written in several languages. The rock art begins a few hundred yards farther.

Site TX-3
DEVILS RIVER

Map locators: DeLorme 66 †4

Information: Rock Art Foundation (for Curly Tail Panther and Cedar Springs/Mystic Shelter tour information), (888) 762-5278; Web site, www. rockart.org/tours.html; Texas Parks (Devils River State Natural Area information), (800) 792-1112; tours, (830) 395-2133; Web site, www.tpwd.state. tx.us/park/devils/

Fees: Guide required; call to register.

Directions: From Del Rio, take US 277 north 45 miles, turn left on Dolan Creek Road, and go 18 ⁶/₁₀ miles to the Devils River State Natural Area entrance. Sites are accessible by guided tour only. The Rock Art Foundation tours usually leave from National Park Service Headquarters near Amistad National Recreation Area, just north of Del Rio on US 90, but call to be sure.

Man has inhabited the banks of Devils River, north of Amistad National Recreation Area, for thousands of years. The Rock Art Foundation offers periodic tours to two well-known sites.

Curly Tail Panther/Devils River

Visitation to pictograph sites in Devils River State Natural Area is on a pre-approved basis only. The area has no picnic tables, concessions, or other amenities often found in state parks. Pictographs cover many of the rock shelters here.

The Curly Tail Panther site is high up the cliff face on the east side of Devils River. It is a steep walk from the rim and a challenging hike along

the cliff face, but it has magnificent scenic views and impressive rock art. The large, red Curly Tail Panther pictograph was painted on the wall of a rock shelter.

Cedar Springs/Mystic Shelter

This is a daylong tour with stunning scenery and a good deal of Pecos River–style rock art, offered only three times a year. Because it negotiates very rough terrain along Devils River, it requires a four-wheel-drive, high-clearance vehicle. You will park at Cedar Springs and walk a short distance to that site. Afterward you can hike downriver about 1½ miles to Mystic Shelter, a rock shelter with numerous pictographs.

Galloway White Shaman Preserve. See Seminole Canyon State Park.

Site TX-4
HUECO TANKS STATE HISTORICAL PARK

Map locators: DeLorme 62 E4

Information: Hueco Tanks State Historical Park reservations, (512) 389-8900 (day use) or (915) 849-6684 (camping); visitor center, (915) 857-1135; Web site, www.tpwd.state.tx.us/park/hueco/

Fees: Entrance fee. Guide required for most rock art, free with paid entry; register at visitor center.

Directions: From El Paso, take US 62/180 about 30 miles east to Hueco Tanks State Historical Park Information Center. Most sites are accessible on foot by guided tour only; self-guided tours for some sites can be arranged through the visitor center.

The numerous natural crevices and basins in the rocks at Hueco Tanks State Historical Park have provided caches of clear drinking water for thousands of years. The park also contains more than 6,000 pictograph images, most of them well preserved. Grafitti is abundant here, but there has been little damage to the rock art. Most of the sites require guides. The tours are generally about an hour long and require a mile-plus walk.

About 1,500 years ago, agriculture was introduced into the Hueco Tanks area. People began to establish permanent villages and grow corn, squash, beans, and cotton. Experts believe, partly based on the rock art style found here, that these people were of the Jornada Mogollon subculture. Most of the rock art at Hueco Tanks, carbon-dated from about A.D. 650 to 1250, is Mogollon, as are the 240 painted kachinalike masks found here.

There are more white pictographs at Hueco Tanks than anywhere else in the world. Yellow, black, and red are also common colors, and blue was occasionally used. Although there are a few scattered Paleo-Indian abstract petroglyphs in the nearby Franklin Mountains, no petroglyphs have been found at Hueco Tanks, probably because the rock is granite and difficult to carve.

Not all sites at Hueco Tanks require a guide. Visitors who watch an orientation film and obtain a permit can view sites in the North Mountain area on their own. The park's map clearly shows several rock art sites along the trail around North Mountain. There is also a large rock shelter just a few yards west of the visitor center that contains a few rock art designs.

Another famous panel that can be seen without a guide is under a large rock overhang along the well-used trail to the main tank. Many people call this the Serpent site because of the twelve-foot snake that once ran across the panel. Unfortunately, very little is left of the original painting due to graffiti and subsequent efforts by well-meaning park officials to remove the defacement with sandblasting in 1969, which did more harm than good. This is a good example of a misguided conservation effort. A park ranger told me that, according to local Indians, the pictograph depicted a battle between twenty Kiowas and a group of Mexican soldiers in about 1839.

Site TX-5
LEWIS CANYON

Map locators: DeLorme 66 I2
Information: Texas Parks, (800) 792-1112; Rock Art Foundation tours, (888) 762-5278; Web site, www.rockart.org/gallery/rock24.html
Fees: Guide required; call to register.
Directions: Sites are accessible by guided tour only. Rock Art Foundation tours usually leave from National Park Service Headquarters near Amistad National Recreation Area, just north of Del Rio on US 90, but call to be sure.

Lewis Canyon is a valley traversed by an intermittent stream. The creek begins a mile southwest of Everett Ranch headquarters in central Val Verde County and runs southwest for 19 miles to the Pecos River. Its flow has sharply dissected massive limestone to form a rugged and winding valley. The canyon contains Archaic and Prehistoric petroglyphs as well as Historic pictographs. One particularly large petroglyph site contains over 900 abstract designs.

The petroglyphs are from two distinct periods. The older ones appear at lower elevations and are dominated by curvilinear lines and other abstract designs, as well as the atlatl motif. They are thought to be Archaic, dating before A.D. 600. The more recent, higher-elevation glyphs were done in a more haphazard fashion and include what may be an image of a bow and arrow, indicating an age after A.D. 600.

A guide is required to visit the rock art in Lewis Canyon. The tour, offered only three times a year, starts at Seminole Canyon, and the two-hour drive includes several miles on back roads (four-wheel-drive vehicle required). The tour takes you to within about 10 yards of the main petroglyph site and includes a side trip along the Pecos River to a pictograph site.

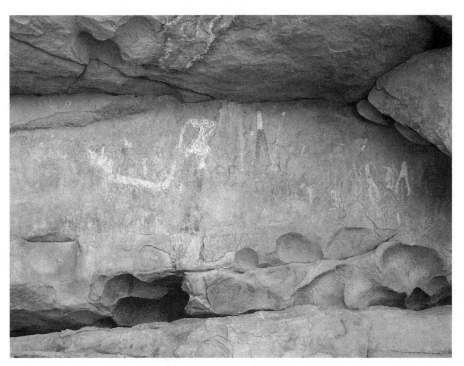

*The once-magnificent Serpent pictograph panel
at Hueco Tanks State Historical Park*

Site TX-6
LOBO VALLEY PETROGLYPH SITE

Map locators: DeLorme 62 B6
Information: Texas State Historical Association, (512) 471-1525; Web site,
www.tsha.utexas.edxu/
Fees: None.
Directions: From Van Horn, take US 90 about 12 miles south to Farm
Market Road, Road 1523. Go a little over 5 miles south to Road FM2017, a
winding dirt road. Turn right (west) and go about 3 miles to the slope at the
base of the mountains. The site is at the base of a mesa near the mouth of a
small canyon, about 3½ miles southeast of the High Lonesome Peak quarry.
The glyph boulders are on the north side of the mouth of the canyon.

The Lobo Valley Petroglyph Site is in southwestern Culberson County, at
the base of the Van Horn Mountains. The rock art is on about fifty large,
scattered boulders, a few of which bear petroglyphs of snakes or humans,
but most of the glyphs are geometric patterns, such as meanders, rectilin-
ear, and curvilinear abstract designs. Circles and diamond shapes are also
common. The site, which is not fenced or posted, is on private land, but

it is on the National Register of Historic Places and visitors are permitted. Contact the Texas State Historical Association for information on this site.

The Lobo Valley Petroglyph Site is important both for the large number of petroglyphs and for their age. The glyphs are believed to be Archaic, perhaps more than 2,500 years old. A few images are believed to be less than 1,500 years old, as they depict a bow. The style is not related to the Pecos River style, the Jornada Mogollon style, or the Historic style commonly found in surrounding areas of the region.

Archaeological surveys of the area have uncovered no evidence of trade or other exchanges with neighboring cultures. Neither are there ceramic shards or evidence of farming. Evidently the inhabitants lived as Archaic hunter-gatherers long after agriculture had been introduced into other areas of the region.

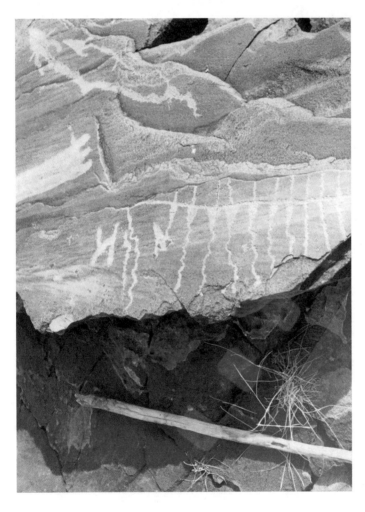

Petroglyph boulder at Lobo Valley site —Photo courtesy of Harold Haynes

Panther Cave. See Amistad National Recreation Area.

Site TX-7
SAN ANGELO STATE PARK

Map locators: DeLorme 55 G7
Information: Visitor Center, (915) 949-4757
Fees: No entrance fee; tours available.
Directions: From San Angelo, take US 67 southwest to Farm Road 2288 and go northwest to the park entrance. Directions to village available at entrance.

Adjacent to the city of San Angelo, San Angelo State Park is situated on the shores of the O. C. Fisher Reservoir. The property contains 7,677 acres, most of which will remain undeveloped. Near the south shore entrance is an ancient village site with petroglyphs, as well as dinosaur tracks. Some archaeologists believe man has been in this area for over 18,000 years.

Visitors can see the village and rock art dating to A.D. 600 on a self-guided tour that is less than a 100-yard walk. Guided tours for ten or more visitors may also be arranged.

Site TX-8
SEMINOLE CANYON STATE PARK

Map locators: DeLorme 66 K2
Information: Texas Parks and Wildlife, (432) 292-4464; tour reservations, (888) 525-9907
Fees: Entrance fee. Guide required for rock art; call to register.
Directions: From Comstock, take US 90 west 9 miles to Seminole Canyon State Park. Seminole Canyon can also be reached by boat from Lake Amistad in Amistad National Recreation Area; the National Park Service maintains a dock in Seminole Canyon for visitors. Sites are accessible on foot by guided tour only.

Seminole Canyon State Park was established in 1980 as an archaeological and historical preserve, and it contains a great deal of rock art. Ranger-guided tours are offered to the various sites in the canyon. Several special, seasonal tours can also be arranged.

One can find examples of every pictograph style known in the lower Pecos River region at Seminole Canyon. The 2,100-acre park holds seventy-two recorded sites spanning a range of about 9,000 years. The predominant rock art style is the Archaic Pecos River style, and excellent examples can be found at its most famous site, Fate Bell Shelter.

Fate Bell Shelter
The Fate Bell Shelter tour, offered twice daily, involves a fairly rugged hike to the bottom of the canyon, then up to the shelter to view the rock paintings. Fate Bell Shelter, a state archaeological landmark, is a huge rock shelter

approximately 150 yards long and 40 feet deep. It contains some of the state's most exceptional Pecos-style pictographs of the middle Archaic period. Most of the images at Fate Bell are believed to have been made about 4,000 years ago, though the area has been occupied for over 8,000 years.

White Shaman (Galloway White Shaman Preserve)

The White Shaman is one of the most often photographed pictograph sites on the lower Pecos River. The religious principles of the Prehistoric inhabitants of the lower Pecos region and of the New World in general are portrayed here. The journey of the shaman into the spirit underworld, his spiritual death, and his rebirth speak of humanity's perpetual search for answers to life's mysteries.

Visitors see the detailed White Shaman pictograph on the two-hour guided hiking tour of the Galloway White Shaman Preserve into the Pecos River canyon. Also on the tour is the Enduring Spirit solstice marker, a fifteen-ton, carved-limestone shaman effigy with cutouts to mark the summer and winter solstices. The Rock Art Foundation constructed a memorial brick walkway around this site in 1997.

Other Tours

The Upper Seminole Canyon tour, includes hiking in a closed area of the park. Hikers will be able to view both rock art and some original 1882 railroad sites. Another tour, the Presa Canyon tour, is an all-day hike in the lower canyons. Participants view rock art sites in another closed area of the park. One of the best examples of Prehistoric aboriginal art, the Red Linear pictograph style, can be found at Vaquero Shelter in upper Presa Canyon.

UTAH

Utah has more public sites than any other southwestern state, and the rock art is diverse. Two distinctive Archaic styles appear in Utah, the Barrier Canyon style and the Glen Canyon style. Both are seen in the southeastern rivers area of Utah and into northeastern Arizona and southwestern Colorado; the former is believed to have been made between 4000 and 500 B.C., the latter between 1000 B.C. and A.D. 500. The Prehistoric Great Basin style can also be found in Utah as well as in Nevada.

Around A.D. 500, Fremont Indians became the prominent culture in Utah. The Fremont were an agricultural culture similar in some ways to the Ancestral Puebloan who inhabited the Four Corners area at around the same time. They lived in large villages, but they did not build elaborate adobe or rock-and-mortar structures as the Ancestral Puebloan did. As a consequence, they did not leave behind ruins for us to visit today. All that remains of most of their villages are depressions where their pit houses were built, a few rock grain bins, their rubbish piles (middens), and their distinct rock art.

Much Fremont rock art depicts mysterious ghostlike images or majestic emperors adorned in jeweled costumes. There is a legend about a sacred Indian mine called Carre-Shinob, which was hidden 600 years ago by the ancient Fremont people. In this mine were stored priceless treasures of jewelry and other artifacts made of gold, silver, and precious stones. It is said that the descendants of the Fremonts have kept the location of Carre-Shinob a secret out of respect for the ancient ones. Only a select few of their own tribes are said to know of the vast beauty and wealth this chamber holds.

Throughout Utah, on rock walls hidden deep within forbidding canyons, are pictures of elaborately costumed figures adorned with ornate jewelry such as necklaces, earrings, armbands, breastplates, belts, and crowns. These pictures on the rocks are not the typically simple pictographs and petroglyphs found elsewhere; they look more like images of Egyptian pharaohs or Aztec emperors. It's not hard to imagine that

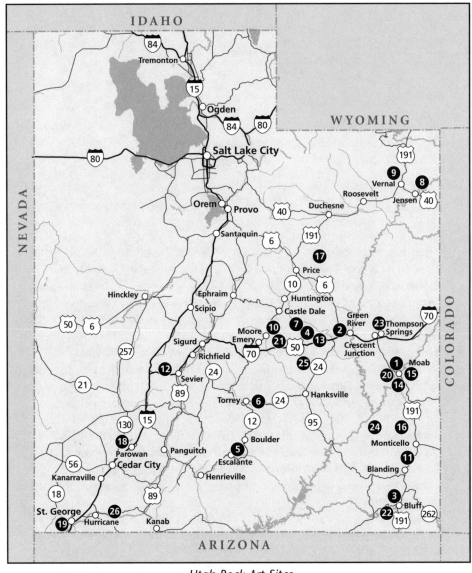

Utah Rock Art Sites

these pictures are of a people whose artisans were skilled in working with precious metals. Are these images on stone further evidence of the existence of the treasures of Carre-Shinob?

SITE PRESERVATION

The state of Utah has done a great deal to preserve its rock art. There have been numerous restoration projects here to repair damage from vandals. Many sites have been stabilized and are now open for public visitation. Three of the most prominent restored sites in Utah are Buckhorn Wash, Sego Canyon, and Courthouse Wash.

Utah actively pursues vandals and looters. To report vandalism, call any BLM office, the BLM state office at (801) 539-4001, or BLM Law Enforcement at (800) 722-3998.

UTAH SITES

Site UT-1
ARCHES NATIONAL PARK

Map locators: DeLorme 40 D3
Information: Arches National Park, (435) 719-2299; Web site, www.nps.gov/arch/
Fees: Entrance fee.
Directions: From Moab, take US 191 north to the Arches National Park visitor center exit (main entrance). Locations of individual sites are described below. One site, Courthouse Wash, is reached from the highway rather than via the park entrance; see directions below.

Probably the most famous pictograph panel in Arches National Park is the one at Courthouse Wash. There are Barrier Canyon–style horned anthropomorphic figures here, and a newer white shield image that was painted over some of the older, Barrier Canyon–style pictographs. These older images would not have been discovered had it not been for some recent vandalism to the site and the subsequent restoration efforts. During the effort to remove the recent graffiti, the shield was partially washed away, revealing the older image underneath. Courthouse Wash also has some petroglyphs of various images.

While Courthouse Wash is inside the park boundary, you can access it from US 191, a few miles north of Moab, just beyond where the highway crosses the Colorado River. From the parking lot, walk across the wash and take the gravel footpath about ½ mile up the wash. At the panel, leave the wash and walk uphill to the base of the cliffs.

Another good rock art site in Arches is near Wolfe Ranch, off the trail to Delicate Arch, about 14 miles from the park entrance. From the Wolfe Ranch/Delicate Arch parking lot, walk about 300 yards east along the trail, past the ruins, to another trail on the left that's just past the bridge over Salt Wash. This trail goes about 50 yards to some low cliffs and the site. The panel is believed to be Ute hunting-magic art, showing horse-mounted warriors hunting bighorn sheep.

Site UT-2
BLACK DRAGON CANYON

Map locators: DeLorme 39 C5; USGS UT-2003 (Spotted Wolf Canyon)
Information: Bureau of Land Management, Price, (435) 636-3600
Fees: None.
Directions: From Green River, take I-70 west about 14 miles, between mileposts 145 and 144 on the north side. The best access is from the westbound lane. There is no official exit ramp. Turn off the highway onto the dirt road, go through the gate, and follow the road north for about a mile to the mouth of Black Dragon Canyon, on your left (west). The main site is in a

large recess about ½ mile beyond the mouth of the canyon. If you don't have a high-clearance vehicle, you may have to walk the last ¼ mile to the site, depending on road conditions.

If the access roads from the freeway are blocked, there is another, longer way in. From I-70, take UT 24 south about 7¼ miles and turn onto the dirt road on the right (west). Continue several miles to a three-way intersection and turn right. You will have to cross a couple of shallow washes with deep sand. Follow the road several miles north to the tunnels under I-70. Take the left-hand tunnel under the freeway and follow the road north to the mouth of the canyon, on your left (west).

Narrow Black Dragon Canyon has a fascinating pictograph of a so-called black dragon. In addition are geometric shapes, the red "praying dog" pictograph, human figures, and others. Black Dragon Canyon is one of San Rafael Reef's winding, narrow sandstone corridors. Archaic, Barrier Canyon, and Fremont rock art adorns the sandstone walls and rock shelters, indicating that people have used this spot for thousands of years.

Typical Barrier Canyon–style rock art scatters the main cliff face. The red anthropomorphic pictographs, high up on the cliff, are faint and ghostlike. In a recess to the far right of the main pictograph panels are petroglyph panels consisting of groups of dots, short lines, zigzags, and bird tracks in complex arrangements. The tally marks show a predominance of even-numbered groupings.

Bloomington. See Petroglyph Park.

Site UT-3
BLUFF AREA

Map locators: DeLorme 22 C3 and 23 C4
Information: Bureau of Land Management, Monticello, (435) 587-1500
Fees: None.
Directions: Locations of individual sites are described below.

On the north side of UT 163 near Bluff are several rock art sites along the San Juan River. Among the styles are Basketmaker, Prehistoric Puebloan, modern Navajo, and Ute rock art. Most of them are best viewed in the morning or early afternoon.

The first site is on UT 163 about ²⁄₁₀ mile east of its junction with US 191. The petroglyphs are on a large boulder about 75 yards from the highway, next to a wooden corral. There is just enough room here to park your car on the shoulder. As this is private property, you will have to be satisfied to view the glyphs with binoculars from the road. The site has both Prehistoric Puebloan and recent Navajo petroglyphs. Most noticeable is the large glyph of a horse and saddle, elaborately pecked by a Navajo named Randolph Benally around 1909.

Another site along UT 163 is about 2⁴⁄₁₀ miles east of US 191, at the end of a short dirt road to the north. At the fork, stay to the right and follow

the road to the base of the cliff, where you can see Ancestral Puebloan and Navajo petroglyphs. The bottom of the panel appears to have worn away, and some of the images have been lost. A partial glyph at the bottom of the panel might have been an atlatl pecked by an Archaic hunter.

Local residents may be able to guide you to additional sites along the washes that drain into the San Juan River.

Site UT-4
BUCKHORN WASH

Map locators: DeLorme 39 B4; USGS UT-0132 (Buckhorn Reservoir)
Information: Bureau of Land Management, Price, (435) 636-3600
Fees: None.
Directions: There are several ways into this area, but one of the best is from Castle Dale. Take UT 10 east about a mile, then turn on 401 Road (Green River Cutoff) and go about 18 miles. At the intersection, take the right (south) fork (332 Road, or Buckhorn Draw Road) toward the San Rafael campground. The main site is 3 miles down this road on the left.

The main Buckhorn Wash site is primarily a Barrier Canyon–style site on the San Rafael Swell area of central Utah, about 4 miles from the San Rafael River. This is one of my favorite Utah sites. There are many truly remarkable pictographs here along a 162-foot-long sandstone cliff face, and they are very representative of the Barrier Canyon style. Most of the red painted figures are anthropomorphs; some are very unusual. Some of the figures have fingers that extend into long wavy lines or are oversized. Several appear to be holding snakes.

There are also a number of petroglyphs, which are believed to have been made by the Fremont Indians. One panel consists of over 250 dots and may have been used as a calendar. Tally marks are common in rock art. In Historic times, explorers, pioneer ranchers, cowboys, and modern people have visited this site. Many left their names and dates on the rock also.

An unusual feature of the glyphs here is the use of several different sizes of anthropomorphs in one panel. Perhaps the smaller figures are an attempt at perspective, intended to give the impression that they are farther away.

One petroglyph panel near the pictographs is very old and is completely repatinated. The figures include quadrupeds, one with a head on each end and another that is quite large with complex antlers, probably an elk. In 1996 the site was stabilized, improved, and restored. This project is more fully described in chapter 3.

A smaller petroglyph panel, often called the Cattle Guard site, is about 3 miles up Buckhorn Wash from the main site. It is in a rock shelter on the north side of the wash, behind a large sand dune. There is a pullout here, and a crude trail leads to the dune and the site, where you can see Archaic-style glyphs. An interpretive sign marks the site.

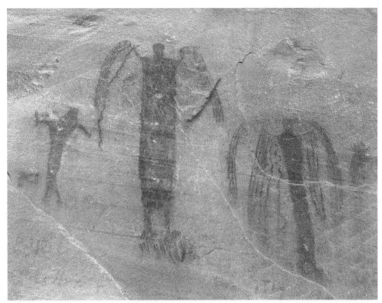

These red pictographs at Buckhorn Wash are in an unusual type of Barrier Canyon style. The human figures do not have detailed heads, but one has snakes (or water, or wings?) emerging from his head and shoulders.

This bighorn sheep petroglyph at Buckhorn Wash looks very similar to those of the Glen Canyon Linear style.

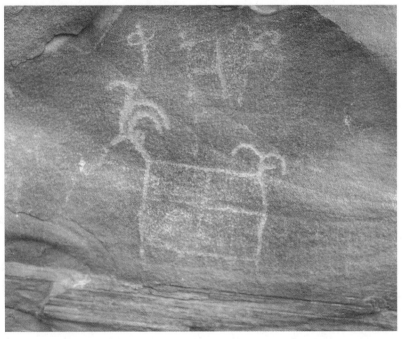

Site UT-5

CALF CREEK
(at Grand Staircase-Escalante National Monument)

Map locators: DeLorme 20 A1
Information: Escalante Interagency Visitor Center, (435) 826-5499
Fees: Day use fee. Camping available.
Directions: From Escalante, take UT 12 east to the Calf Creek Recreation Area, between mileposts 75 and 76.

In the Grand Staircase-Escalante National Monument, near the confluence of Calf Creek and the Escalante River, are many rock art panels. The four most prominent panels are along lower Calf Creek. Two sites are near the trailhead at the end of the road, and the other two sites are about halfway along the 2¾-mile Calf Creek Falls Trail. A BLM brochure with a map of the site locations is available, and there are trail markers to help you find your way. Among the images are Fremont–style red and black pictographs of horned anthropomorphs.

In addition, a little over 2 miles southwest of Calf Creek is the Boynton Overlook, where you can see the Hundred Hands pictograph panel with binoculars. The panel is on the far canyon wall, just upriver from the mouth of Calf Creek.

Site UT-6

CAPITOL REEF

Map locators: DeLorme 28 B1 and B2; USGS UT-1611 (Twin Rocks) and UT-2154 (Golden Throne)
Information: Capitol Reef National Park, (435) 425-3791; Web site, www.nps.gov/care/; Wayne County Travel Council, (800) 858-7951
Fees: None for some sites. Park entrance fee for scenic drive. Camping available.
Directions: From Torrey, take UT 24 east 11 miles to Capitol Reef National Park. Directions to individual sites are described below.

Along UT 24 at milepost 81, about 1½ miles east of the Capitol Reef National Park visitor center, is a clearly marked petroglyph pullout where visitors can see some excellent Fremont rock art. Two wooden walkways lead along the base of the Wingate Sandstone cliff, which contains both petroglyphs and pictographs. This site has some of the most interesting rock art at Capitol Reef, but much of it is high up on the cliff face and hard to see because of the lack of contrast. However, do not attempt to climb the talus slope to get closer. Use binoculars to view the rock art and a telephoto lens for photographs.

Even the petroglyphs visible from the walkway are badly weathered and difficult to spot. About 500 feet down the walk are a large, beautifully done image of a bighorn sheep and, on a large detached slab, the head and shoulders of a nearly life-size human figure.

The Capitol Gorge Trail also has some Fremont petroglyphs, but they have been vandalized. Nevertheless, the trail has some worthwhile sights. From the visitor center, take the Scenic Drive south about 8 miles to the Capitol Gorge trailhead. A short walk down the trail takes you into the narrow canyon. A little farther on are the petroglyphs, on the north wall (left). About ¼ mile farther down the trail is the Pioneer Register. In 1884 Mormon pioneers built the first road through Capitol Gorge. Early pioneers using the route recorded their passage on the canyon walls at the Pioneer Register. Another mile down the gorge, on the left, are the Tanks, where erosion has carved pockets in the rock. These indentations hold rainwater, probably one of the things that attracted the Fremont people to this area.

Site UT-7
CEDAR MOUNTAIN

Map locators: DeLorme 39 B4
Information: Bureau of Land Management, Price, (435) 636-3600
Fees: None.
Directions: From Castle Dale, take UT 10 east and north about a mile, then turn east on 401 Road (Green River Cutoff) about 12 miles. At the intersection, turn left (north) onto 332 Road (Lawrence to Tan Seeps Road). Go about 2½ miles to Lower Cedar Mountain Road (335 Road). Near this turnoff is a cattle guard and a gate. To reach the sites, you have to go through this gate and another one. Please close them behind you. Locations of individual sites are described below.

There are four petroglyph sites along the southern base of Cedar Mountain. At one time there were interpretive signs at each location, but vandals have damaged or destroyed most of them. Unfortunately, much of the Fremont rock art here has also suffered some vandalism, but the sites are still worth visiting.

All four sites—Silent Sentinel, Daisy Chain, 45 Degree Rock, and Railroad Rock—are on boulders along a 2-mile stretch of Lower Cedar Mountain Road (Road 335). This is a dirt road and should not be traveled in inclement weather. For the Silent Sentinel site, go east on Lower Cedar Mountain Road a little over 2½ miles and turn right onto a dirt road (really just tire tracks) on the left. If you don't have a high-clearance vehicle, you might have to hike the last few hundred yards to the end of the path. Here you can see two main panels and other scattered glyphs. The site's namesake is a three-foot-high shield figure on a large boulder to the right. There is another panel on the right under an overhang on a large boulder at about eye level. Look for other glyphs among the scattered boulders.

The Daisy Chain site is a little over ½ mile east of the Silent Sentinel turnoff. Look for a large, lone boulder sitting beside the road on the left. Among the images found at this site are three Fremont anthropomorphic figures holding hands. About ²⁄₁₀ mile east of Daisy Chain is the 45 Degree Rock site. Follow the tire tracks on your left for several hundred yards to the large

boulder tilted at a sharp angle. Here you will find humpbacked figures, a large snakelike creature, bighorn sheep, and other designs.

Not quite ½ mile east of the 45 Degree Rock site on Lower Cedar Mountain Road is Railroad Rock, a large boulder about ²⁄₁₀ mile north of the road. Here you will find graffiti from the 1800s and a few Fremont petroglyphs on the north face of the boulder.

Courthouse Wash. See Arches National Park.

Site UT-8
DINOSAUR NATIONAL MONUMENT

Map locators: DeLorme 57 C4 and C5
Information: Dinosaur National Monument Visitor Center, (435) 781-7700; Web site, www.nps.gov/dino; Vernal Chamber of Commerce, (800) 421-9635
Fees: Entrance fee in summer (Utah side of park only).
Directions: From Jenson, take UT 149 north 7 miles to Dinosaur National Monument. Directions to individual sites are described below.

Dinosaur National Monument has several good rock art sites open to the public. The Cub Creek sites are the most accessible, found along the paved Cub Creek Road within a few miles of the Dinosaur Quarry visitor center. The pamphlet on Tilted Rocks gives more detail on the Cub Creek sites. The rock art on this road is mostly of Fremont origin. There are also petroglyph panels elsewhere in the park; ask for information at the visitor center.

Traveling east from the visitor center on Cub Creek Road, the first site is the Swelter Shelter, about a mile east of the Dinosaur Quarry turnoff. A good trail with interpretive signs leads a short distance to the alcove where you will find pecked and faintly painted 1,000-year-old images of humans, animals, and geometric designs, probably of Fremont origin. Other artifacts found here have been dated to the 7,000-year-old Archaic culture.

About 10⁶⁄₁₀ miles from the visitor center is another rock art site, on the north side of the road. At least one panel is visible from the road, on a large boulder high overhead, but you must climb up the slope to see the rest. Again, these are Fremont-style images.

The most prominent Cub Creek site is 10⁸⁄₁₀ miles east of the visitor center on the north side of the road. Here are mostly Classic Vernal–style petroglyphs, common throughout northeastern Utah, probably about a thousand years old. From the parking area you can see two large lizard petroglyphs on a cliff face high up the slope on the left. Lizard figures are not commonly found in this area. They may have been a clan marker.

Another unusual image here is a giant figure of Kokopelli, uncommon in Fremont rock art. The god is hard to make out because his head is almost gone and the lower part of his body is faint. What can be seen are the three lines representing his arms and flute, chipped into a darkly patinated area

high on the cliff. There is a good trail up the hill to the base of the cliff for a better view. Binoculars will help to see the detail from the road.

About ³⁄₁₀ mile farther down Cub Creek Road, near the Josie Morris cabin, are the last petroglyphs on the route. These glyphs, often referred to as the Three Princesses panel, are on a low rock face to the left. This popular petroglyph site was vandalized in 1999. Fortunately, the culprit was caught.

Site UT-9
DRY FORK CANYON/MCCONKIE RANCH

Map locators: DeLorme 56 C2
Information: Vernal Chamber of Commerce, (800) 421-9635
Fees: Donations accepted (McConkie Ranch).
Directions: From Vernal, take Utah 121 (500 North Street) west to 3500 West Street (Dry Fork Road). Go north about 6½ miles to McConkie Road, on your right. This leads a short distance across the river to the parking lot. Marked trails lead to the sites.

Dry Fork Canyon is renowned for its abundant and magnificent rock art. Along the Dry Fork River just northwest of Vernal is a wall of cliffs that runs down both sides of the canyon. On these walls are over a hundred panels with hundreds of pictographs and petroglyphs in Archaic, Fremont, Shoshone, and Ute styles. Fremont petroglyphs and pictographs here, of the Classic Vernal style, are believed to be as old as 1,500 years. Most of this magnificent rock art is on private property, but one of the best areas, on the McConkie Ranch, has been developed for public visitation by the owner.

The ranch has some of the most spectacular examples of Prehistoric petroglyphs in existence. Spanning more than a mile, these glyphs represent a wide variety of forms, including elaborate anthropomorphs, shields, zoomorphic images, astronomical images, and geometric shapes. In Historic times, both Eastern Shoshone and Ute people are known to have inhabited this region. The Eastern Shoshone–style rock art contains the shield-bearing warrior motif.

Visitors can walk to many of the panels along the base of the cliff via two ½-mile trails. Most of the figures found along both trails are in the Classic Vernal style. Some figures are holding hands, and others hold masks or heads. Some of the anthropomorphs have shields, but most have the trapezoidal torsos of the Classic Vernal style. Among the Classic Vernal images is one of Kokopelli, rare in Fremont styles, as well as complex panels of anthropomorphs in elaborate costumes with headdresses, necklaces, and other ornamentation. In addition, there are circles, shields, rakes, and other images.

The trail north of the ranch's parking area follows the cliff base along the top of the talus slope to the famous Three Kings Panel. The most widely known example of Classic Vernal–style rock art, the Three Kings has been

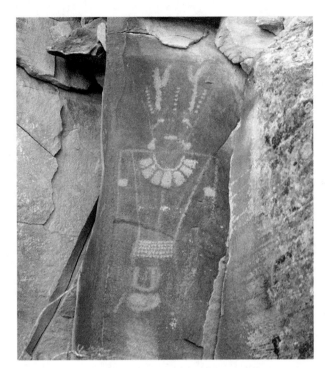

One of the more unusual and elaborately adorned anthropomorphic figures at the Dry Fork Canyon site. The headdress includes a pair of forked antlers.

called the best petroglyph panel in the world. Direct access to the Three Kings panel is not possible because it is about 40 yards up a cliff face. The official trail ends about 150 yards from the panel. Do not attempt to climb onto the cliffs—use binoculars to see the glyphs' details. The largest figure, sometimes called the Sun Carrier, is well over six feet tall.

Site UT-10
DRY WASH

Map locators: DeLorme 38 C2
Information: Bureau of Land Management, Price, (435) 636-3600
Fees: None.
Directions: From Moore, on Old State Route 10, take Dry Wash Road (803 Road) southeast about 4 miles to a place where the road goes around a rocky point on the left. Just around the curve, two distinct panels can be seen from the road.

Several large boulders on the north side of Dry Wash Road, near Moore, have petroglyph panels. A little over 4 miles east of Moore, travelers can see a glyph of a ten-foot-long snake from the road. Also look for a Kokopelli-like figure without his flute.

Site UT-11
EDGE OF CEDARS MUSEUM

Map locators: DeLorme 22 A3
Information: Edge of Cedars Museum, (435) 678-2238; Web site,
www.utahoutdooractivities.com/cedars.html
Fees: Entrance fee.
Directions: The Edge of Cedars Museum is on the northwest side of Blanding, off US 191.

While Edge of Cedars State Park has no actual rock art sites, the museum has an extensive exhibit, called "Spirit Windows," which reproduces rock art of several styles. The museum also has the largest Puebloan pottery display in the Four Corners region and many other artifacts from the prehistoric Southwest. On the park grounds are pueblo ruins and a kiva.

Site UT-12
FREMONT INDIAN STATE PARK

Map locators: DeLorme 26 A3
Information: Fremont Indian State Park, (435) 527-4631; Web site,
www.utah.com/stateparks/fremont.htm
Fees: Museum entrance fee; none for sites.
Directions: From Sevier, take I-70 west to exit 17 and follow the signs to the visitor center. Trail guides are available at the center.

Over 700 rock art panels of both petroglyphs and pictographs have been found within the Fremont Indian State Park, in Clear Creek Canyon. Many of the park's fourteen trails lead past rock art sites, and some have interpretive signs. A free trail guide is available at the visitor center.

Among the better-known petroglyph and pictograph sites here are Reed Rock, Hunkup's Train, Sheep Shelter, Clear Creek Canyon, and the Cave of a Hundred Hands. The styles include Archaic, Fremont, and Historic images. Among these are blanket design and handprint pictographs, steam locomotive and bighorn sheep petroglyphs, and numerous other motifs common to the area. Much of the rock art is above the loose talus slope along the highway, best seen with binoculars. The most accessible sites are along the paved Parade of Rock Art, a ³⁄₁₀-mile loop trail behind the museum and visitor center.

In addition to the rock art, the park has the largest Fremont Indian site ever discovered in the state of Utah, the Five Fingers Ridge Village. The village had over forty pit houses, twenty storage areas, and several work areas. Archaeologists have ascertained that the Sevier Fremont occupied the village from about A.D. 1000 to 1250. There may have been 150 to 250 people living here at a time. It is known that they raised corn, beans, and squash; hunted deer, sheep, elk, and bison; and gathered wild plants.

Grand Staircase-Escalante National Monument. See Calf Creek.

Site UT-13
HEAD OF SINBAD

Map locators: DeLorme 39 C4
Information: Bureau of Land Management, Price, (435) 636-3600
Fees: None.
Directions: From Green River, take I-70 west about 30 miles to exit 129. Take the gravel road (332 Road) west and south for about 4 miles, to a dirt road on the right (west). Take the dirt road and go about 5 miles, crossing over an earthen dam. At the next intersection, turn right (northwest), cross a cattle guard, and continue another 5 miles, keeping to the right, to the freeway underpass. From the underpass, keep right for about a mile to the site. If you don't have a high-clearance vehicle, you may have to walk the last ½ mile or so. The road to the site is rough and may be impassable in wet weather.

A rock art area on the San Rafael Swell called the Head of Sinbad has Barrier Canyon–style pictographs of great detail. As is characteristic of the Barrier Canyon style, the images are large, ghostlike figures, with tapered, elongated bodies. This style of anthropomorph is sometimes referred to as the Carrot Man.

Located near I-70 but involving nearly 20 miles of driving on unpaved roads to reach, two pictograph panels are 20 feet off the ground and tucked under an alcove on a south-facing cliff. The far left portion of one panel is obscured by minerals leaching out of the cliff. The main site has been fenced for protection.

One small panel has amazing detail and looks like it was painted yesterday instead of 1,000 years ago. Small birds, snakes, and other figures surround the larger figures, and one of the large figures has a petroglyph etched into its chest. One anthropomorphic figure is thought to be a rain spirit or shaman. His outstretched arms seem to be pointing to rain clouds, and the snakes—believed by many to be a water symbol—are typical of the Barrier Canyon style.

Other, less spectacular panels are reported to be in the area, all within about a fifteen-minute hike of I-70, but there are no developed roads to any of them.

Site UT-14
KANE CREEK

Map locators: DeLorme 30 A3; USGS UT-1925 (Moab)
Information: Bureau of Land Management, Moab, (435) 259-6111
Fees: None.
Directions: Locations of individual sites are described below.

The rocks and low cliff faces along lower Kane Creek Road have dozens of petroglyph panels that can be seen from the road, which is fortunate because many of them are on private land. There is one public site on the

route, at Moon Flower Canyon, but there are also rock art panels all along the way on the low cliff to your left. Since they are mostly on private property, you will have to be content to look at them from the road through binoculars.

To reach Moon Flower Canyon, take Kane Creek Road south from Main Street in Moab (look for the McDonald's on the corner). It is about 3 miles, staying to the left, to the mouth of Moon Flower Canyon, where you will find a parking area. The large rock art site is on the rock cliff at the south side of the canyon's mouth. A fence protects the site, and there is an interpretive sign. The rock art has been badly vandalized, but many images are still clearly visible, including various human and animal forms and abstract designs.

There are two additional sites on Kane Creek Road beyond the Moon Flower Canyon site. The first, 1²⁄₁₀ miles south of Moon Flower, is easily missed, as it faces the river. The glyphs here are similar to those at Moon Flower Canyon and have also been vandalized. The other site is 1⁷⁄₁₀ miles farther, after the road turns to gravel, just past a parking area for mountain bikers. Look to the right for a large single boulder on a flat area below the road. The boulder has rock art on all four sides, the most famous being the "birthing" glyph. The local Native Americans say the glyph represents the birth of a powerful deity, or spirit-being, according to an ancient legend of their people.

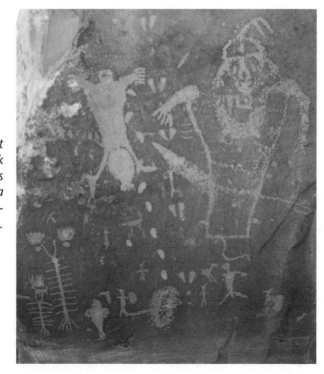

This glyph at Kane Creek purportedly tells of the birth of a powerful spirit-being.

McConkie Ranch. See Dry Fork Canyon.

Site UT-15
MOAB GOLF COURSE

Map locators: DeLorme 30 A3; USGS UT-2094 (Rill Creek)
Information: Moab Golf Course, (435)-259-6488; Moab Information Center, (435) 259-8825; Web site, www.a.blm.gov/utah/moab/rockart.html
Fees: None.
Directions: From Moab, take US 191 about 4 miles south to the golf course turnoff. Take Spanish Trail Road to Westwater Drive. About ½ mile down is a small pullout on the left. Please avoid the private driveway.

The glyphs here, at the northeast corner of the Moab Golf Course, are believed to be from the Formative Period. They appear on a large sandstone rock from the ground up to about thirty feet. Here you will see anthropomorphic figures, bighorn sheep, and dogs or coyotes on red sandstone. On the far right you will see the glyph commonly called the Reindeer and Sled.

Moon Flower Canyon. See Kane Creek.

Site UT-16
NEWSPAPER ROCK STATE PARK

Map locators: DeLorme 30 D3
Information: Bureau of Land Management, Monticello, (435) 587-1500; San Juan County Visitor Center, (800) 574-4386; information also available at a private Web site, www.so-utah.com/souteast/newspapr/homepage.html
Fees: None for entry. Camping available.
Directions: From Monticello, take US 191 north about 12 miles to UT 211. Go west to the well-marked site, between mileposts 7 and 8.

Not to be confused with the Newspaper Rock site in Arizona, Utah's Newspaper Rock is a petroglyph panel that spans over 2,000 years of human activity etched into a sandstone cliff face along Indian Creek. Represented are Basketmaker, Ancestral Puebloan, Fremont, Navajo, Ute, and modern cultures. This is a very developed site, virtually on the pavement, with a parking lot, restrooms, and interpretive signs.

The panel contains some striking glyphs, including zoomorphs such as bison, bighorn sheep, turtles, horses, and flying squirrels. Many anthropomorphs, including various shaman glyphs and a bird-man, are represented as well. You can also see animal tracks, hoofprints, abstracts, and hunting scenes in addition to the messages from frontier passersby. It's a very busy place.

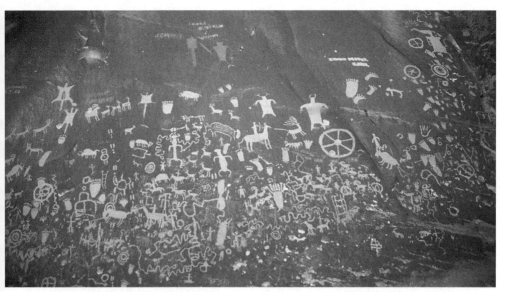

People have been leaving marks at Newspaper Rock for over 2,000 years.

Site UT-17
NINE MILE CANYON

Map locators: DeLorme 47 D4 and C5
Information: Bureau of Land Management, Price, (435) 636-3600; Castle Country Travel Region, (800) 842-0789; Nine Mile Ranch, (435) 637-2572
Fees: None.
Directions: From Price, take US 6/191 about 8 miles southeast to the Nine Mile Canyon turnoff. Go about 21 miles north to the prominent bridge across Minnie Maude Creek. Continue east. Locations of individual sites are described below. Guide brochures are available at Nine Mile Ranch, up the road past the sites.

Nine Mile Canyon is reported to have the greatest concentration of rock art sites in the United States, with thousands of petroglyphs and pictographs, many dating back over 2,000 years. The BLM plans to make improvements in this area for visitors, including parking lots, restrooms, and interpretive signs in major areas throughout the canyon, but lack of funding has held the project back.

Both Fremont and Ute styles are found here. Nine Mile Canyon, despite its name, is 40 miles long and has more than 10,000 sites scattered along its entire length. One 2-mile stretch contains over 150 sites, each with more than 100 glyphs. The panels show a great variety of images, including owls, bison, bighorn sheep, snakes, shaman, horses, and warriors. Some imaginative viewers even claim to see ancient astronauts.

Beginning at the Minnie Maude Creek bridge, the first panels are about 4⁸⁄₁₀ miles east, on a rocky point to the left (north) side of the road. A wooden fence marks the site, which contains several panels of mostly human and animal figures. For the next 15 miles or so, you can see rock art scattered along the left side of the road. Some of the panels are high up on the cliff face above the road. In addition are the ruins of several Fremont granaries and pit-house villages.

About 10⁴⁄₁₀ miles east, the road curves around a rocky point, and just beyond, on the hillside about 50 yards from the road, is a large group of boulders with a couple of good petroglyph panels. At milepost 34, about 11⁸⁄₁₀ miles from the bridge, is another good area for spotting glyphs, and 1⁴⁄₁₀ miles farther are many more glyphs, most of which you will probably need binoculars to see. Among the images you will see are anthropomorphs, snakes and other animals, and geometric patterns.

About 22 miles east of Minnie Maude Creek is Rasmussen's Cave, which is actually a large rock shelter. It is on the left, about 20 yards up the slope from the road. Inside the shelter are some excellent pictographs. Unfortunately, the most impressive one, of a large red elk or deer, has been severely damaged by someone who painted over it in large black letters, This Is Private Property, No Tresspassing [sic]. The message no longer applies, but sadly, the damage lives on. More rock art appears on the cliff face adjacent to the cave, as well as on boulders outside the entrance. Just a few hundred yards beyond Rasmussen's Cave, at the mouth of Daddy Canyon, is a public toilet near a corral, and rock art can be found on both sides of the canyon.

Less than a mile farther down is a major fork in the road where Cottonwood Canyon comes in. Take the right fork and go a short distance up the creek to a panel on a rock outcropping about 10 feet above the road. Called the Hunter panel, it is probably one of the most popular sites in the canyon. It depicts a lone hunter armed with a bow, along with numerous bighorn sheep.

After returning to the main road, you can continue for about ½ mile to the last site, a petroglyph of a bird in flight. The county road ends about here, at a gate, and you have to return the way you came.

Site UT-18
PAROWAN GAP

Map locators: DeLorme 25 D6
Information: Bureau of Land Management, Cedar City, (435) 586-2401
Fees: None.
Directions: From Cedar City, take UT 130 north about 14 miles. Between mileposts 19 and 20, turn right onto Gap Road and go about 2½ miles east. The site is adjacent to a large parking area behind a chain-link fence. There are signs but no trails. The BLM office has pamphlets on the site.

The Parowan Gap is a narrow cleft through the Red Hills in southwestern Utah. Its entrance is decorated with numerous petroglyphs. In ancient times, the residents of the Parowan Valley used the gap as part of a giant solar calendar. Within the little valley are several stone cairns lined up with the gap in the hills. The sun's shadow falls on these alignments at sunrise during the summer and winter solstices and the equinoxes.

On the northeast side of the gap, many boulders are covered with Archaic, Fremont, and (probably) Ute petroglyphs. Many of the glyphs have a direct relationship to the solar calendar. Looking closely at the glyphs, you will find some have tick marks on them. These marks count the number of days for certain periods of the year. Some have more than 180 marks, and some have 45. One glyph has five vertical lines in a row, representing the four quarters of each six-month period between solstices; the center mark is the equinox. Often the spacing is unequal, which visually represents how the sun's shadow moves as it nears the solstices.

Many of the glyphs are Archaic and include many geometric images. Later glyphs depict lizards, snakes, bighorn sheep, bear tracks, and anthropomorphic figures.

Site UT-19
PETROGLYPH PARK/BLOOMINGTON

Map locators: DeLorme 16 D3
Information: St. George Chamber of Commerce, (435) 628-1658
Fees: None.
Directions: From St. George, take I-15 south to Bloomington, exit 6. The park is across the river, at the corner of Bloomington and Navajo Drives.

Just across the Utah state line on I-15 is a little suburb of St. George called Bloomington. Here a petroglyph site in a residential area has been made into a small, fenced city park. In the middle of the park is a huge boulder with numerous images pecked onto it, including Prehistoric Puebloan human and abstract figures.

Site UT-20
POTASH ROAD

Map locators: DeLorme 30 A3
Information: Bureau of Land Management, Moab, (435) 259-6111; Moab Information Center, (435) 259-8825; Web site, www-a.blm.gov/utah/moab/rockart.html
Fees: None.
Directions: North of Moab off US 191 are several rock art sites along the Potash Scenic Byway (UT 279). Directions to the sites are described below.

The Potash Scenic Byway (UT 279) follows the west bank of the Colorado River. There are four main Ancestral Puebloan and Fremont rock art sites along this road, but many of the panels have been vandalized.

The first site is about 5²/₁₀ miles south of UT 279's intersection with US 191, on the west side of the road. There is a prominent Indian Writing sign at the large turnout, as well as an interpretive sign. The glyphs are about 25 feet up on the red sandstone cliff. Among other images, of particular interest is one of six human figures holding hands. The second site is about 200 yards farther down the road. It is also marked with an Indian Writing sign. This site consists of faint, vandalized images of a bear, bighorn sheep, and hunters.

The third site is a little over 6 miles from the intersection, ¾ mile from the previous site. Just past a dirt road leading up the hill to the right (north), pull off the road. The site is barely visible with the naked eye, but behind the bushes is a metal sighting tube. Looking through it, you can see the tracks of a three-toed Allosaurus on a loose slab high up on the talus slope. The glyphs, both above and to the left of the dinosaur tracks, can be seen with binoculars. Alternatively, the dirt road leads to a parking area. The glyphs are on the cliffs to the northeast, just above the far side of the parking area.

The last site along this byway is called the Jug Handle Arch site, named for the arch attached to the cliff face. It is about 7½ miles down the road from the previous site, at milepost 2, near the mouth of Long Canyon. There is a parking area off the road. The glyphs are up on the cliffs to the north.

Site UT-21
ROCHESTER PANEL

Map locators: DeLorme 38 C2
Information: Bureau of Land Management, Price, (435) 636-3600
Fees: None.
Directions: From Emery, take UT 10 northeast to 801 Road (Old State Route 10). Turn east and look for a good gravel road to the right (south), 805 (Emery Tower) Road, which leads about 3½ miles to the parking area for the trailhead. Take the ¼-mile trail south to the site, in a group of boulders near an overlook at the confluence of Muddy and Rochester Creeks.

Near the confluence of Rochester and Muddy Creeks, not far from the towns of Moore and Emery, is a well-known panel of petroglyphs in the rare Archaic Rochester Creek style. Many believe this to be one of the finest examples of petroglyphs in Utah. This site is promoted for visitation by Emery County and the Museum of San Rafael in Castle Dale.

There is one large panel that faces east, and several other smaller panels scattered about the area. The main panel contains many images, some explicitly sexual in nature. Other glyphs depict fantastic creatures, including one that looks like a horned alligator and one of a hippopotamus or warthoglike creature.

Site UT-22
SAND ISLAND

Map locators: DeLorme 22 C3
Information: Bureau of Land Management, Monticello, (435) 587-1500; San Juan County Visitor Center, (800) 574-4386
Fees: None for entry. Camping available.
Directions: From Bluff, take UT 163 west about 3½ miles. Between mileposts 22 and 23, look for the well-marked exit to Sand Island Recreation Area. The main petroglyph site is in camping area B, at the northwest corner of the park.

Along a cliff bordering the San Juan River, 3 miles west of Bluff, is the Sand Island Recreation Area. There is an easily accessible petroglyph panel here with many glyphs that are 800 to 2,500 years old. This panel is representative of the many other rock art sites along the San Juan River, but most of them are accessible only by boat or raft.

This ½-mile-long stretch of sandstone cliff has hundreds of petroglyphs in various panels. Part of the area is fenced to keep vandals out, and part is open for closer observation. To get close to the open part requires a steep climb.

The glyphs are a combination of Archaic, Basketmaker, and Prehistoric Puebloan designs, including several of Kokopelli, other anthropomorphs, snakes, elk, deer, and bighorn sheep. Also found are "fetish heads," or masks, and geometric designs.

Site UT-23
SEGO CANYON

Map locators: DeLorme 40 B2
Information: Bureau of Land Management, Moab, (435) 259-2100
Fees: None.
Directions: From Crescent Junction, take I-70 east to Thompson Springs, exit 185. Go north through town, over the tracks, and continue 3 miles up the canyon to the end of the paved road. The site is developed and well marked.

Sego Canyon, a large and archaeologically significant site, is well interpreted and easy to get to, with paved access right up to the parking lot. Its improvements include several interpretive signs, a toilet, trash cans, a gravel parking lot, and low wooden barrier fences. Barrier Canyon (500 B.C.-A.D. 500), Fremont, and Ute styles are all present here. The Barrier Canyon pictographs, a pre-Fremont style, have large human forms that sometimes look like spacemen with antennas and bug eyes, holding weird-looking objects. (See color plates 7 and 13.)

The Fremont people put their petroglyphs on the same wall as some of the Barrier Canyon pictographs. The Fremont had a very distinctive style of rock art. It typically showed large anthropomorphic figures with trapezoidal bodies, often adorned with elaborate jewelry, ceremonial robes, and headdresses. These costumes may indicate that the glyphs are shamanistic.

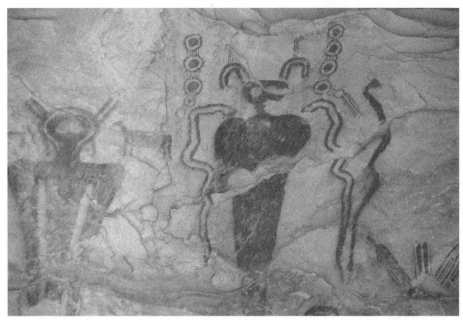

Typical Barrier Canyon–style pictographs at Sego Canyon. Common to this style are strange humanoid figures. (See color plate 13 for detail.)

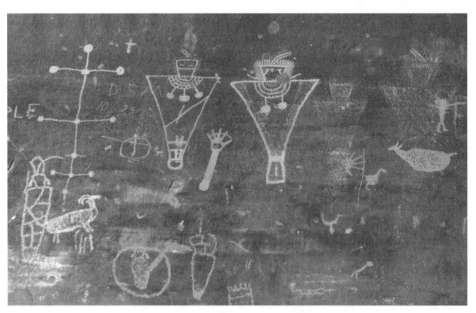

Fremont petroglyphs at Sego Canyon

The painted Historic Ute art is on a separate panel southwest of the other art. Ute pictographs contain images of cowboys, horses, buffalo, and shields in red and white. Descendants of the artists may live at the Ute Indian Reservation farther up Sego Canyon.

Restoration work has been done on this site, particularly on the main Barrier Canyon–style panel, due to heavy vandalism. Close inspection of the images will reveal some of the touch-up work.

Site UT-24
SHAY CANYON

> **Map locators:** DeLorme 30 D3
> **Information:** Bureau of Land Management, Monticello, (435) 587-1500; San Juan County Visitor Center, (800) 574-4386
> **Fees:** None.
> **Directions:** From Newspaper Rock Recreation Site (see site UT-16), continue north on UT 211 almost 2 miles (between mileposts 5 and 6), to a small turnout on the south side of the road. An unimproved trail across Indian Creek leads about 200 yards to the site, along the base of the cliff on the north side of Shay Canyon. There is little or no rock art on the boulders at the bottom of the slope; the main panels are higher up. The site extends for several hundred yards up the canyon.

About 2 miles west of Newspaper Rock, at the confluence of Shay Canyon and Indian Creek, is an extensive petroglyph site. Glyphs of several styles can be seen on several boulders and along the cliff face. Prehistoric Puebloan-style human and animal figures are the most prominent, including one panel depicting deer "dancing" to the music of several flute players.

In addition, this is the only site in this book that has Glen Canyon Linear–style petroglyphs. They are very old, heavily repatinated, and may be hard to see, depending on the light. Also look for a large glyph on one boulder, called the Shay Mastodon, which actually looks more like a hippopotamus, since it has no tusks or trunk.

Site UT-25
TEMPLE MOUNTAIN WASH

> **Map locators:** DeLorme 39 D4
> **Information:** Bureau of Land Management, Price, (435) 636-3600
> **Fees:** None.
> **Directions:** From Green River, take I-70 west to UT 24. Go south about 29 miles to Temple Mountain/Goblin Valley Road, then west about 5 miles to a three-way intersection. Continue straight ahead on Temple Mountain Road (just past the mouth of the wash) for another mile and look for a small dirt road on your right leading to a turnout above the road. The pictographs are on the north canyon wall, about 35 feet above the base of the cliff.

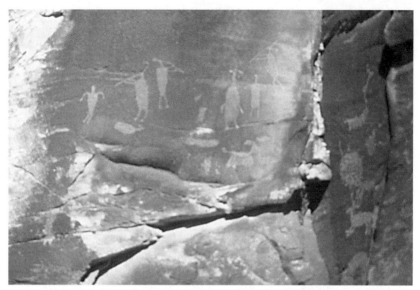

This unusual panel at Shay Canyon shows a flute player and what appear to be two deer dancing on their hind legs.

Of the many rock art sites on the San Rafael Swell, perhaps the best known is the Temple Mountain site, probably because it is so near the road. Most of the images here are of the Barrier Canyon style, both Barrier Canyon– and Fremont-style rock art can be seen. One tall anthropomorph holds a snake, a typical Barrier Canyon motif. Next to this image is an image of a dog on the back of what may have been a large Barrier Canyon–style zoomorphic figure. The bottom of the panel has worn away.

The lone red anthropomorph to the left of the large Barrier Canyon panel has fine horizontal lines on its face and appears to be wearing earrings, a common Fremont motif. The bottom of this image has also flaked away.

Site UT-26
ZION NATIONAL PARK

Map locators: DeLorme 17 D6
Information: Zion National Park, (435) 772-3256; Web site, www.nps.gov/zion
Fees: Entrance fee.
Directions: From St. George, take I-15 northeast to UT 9 and continue east to Zion National Park's south entrance. There are several rock art sites in Zion, but only one is open to the public. It is about ¼ mile in from the south entrance, opposite the campground. Park on the shoulder of the main

park road at about the middle of the camping area. The site is about 100 yards uphill, across the road. Facing uphill, look for a cluster of three large, reddish sandstone boulders. There is a small sign at the base of the boulder, but you can't see it until you are practically standing over it.

Remains of cultures dating back over 7,000 years have been found in Zion, and the probable descendants of these groups still live in the area today. The Virgin River Puebloans, living on the western edge of Ancestral Puebloan territory, away from the trade and cultural centers of their time, did not build huge structures or undertake large-scale agriculture. The remnants in and around Zion are of simple dwellings, food-storage bins, rock art, and artifacts such as tools, pottery, basketry, and clothing. The culture had disappeared from Zion by around A.D. 1200.

A site called "Sacrifice Rock" was so dubbed because of the vandalism there. It is unfortunate that this site was not better protected initially with interpretive signs, improved pathways, and a barrier. The petroglyphs on Sacrifice Rock consist primarily of a large spiral, a possible bighorn sheep, and large bird tracks, possibly turkey. The glyphs are thought to have been made by the Virgin River Puebloans. Some speculate that the spiral may have had astronomical significance, but since the Virgin River Puebloans never engaged in large-scale agriculture, the usual reason for astronomical markers, there is some doubt about this theory.

BAJA CALIFORNIA

Most of the sites listed in this chapter I visited in the winter of 1995, on a six-week camping trip with my friend John, a seventy-plus-year-old retired telephone worker. We had a marvelous time exploring, fishing, watching baby whales, and making friends with the local natives, most of whom spoke virtually no English. We experienced flash floods, bad roads, and searingly hot days, but, thankfully, not once did we suffer from the digestive distress that so often plagues tourists.

John had a working vocabulary of about twenty Spanish words, and I knew slightly more, including how to swear like a native, thanks to several Mexican friends I worked with as a youth. We got along famously with the people, who were warm, generous, and endowed with a keen sense of humor, though I fear most of the jokes were on us!

John has passed on, but I will never forget him or our trek into Baja's outback.

NATIVE CULTURES OF BAJA

Unfortunately, there has not been as much in-depth archaeological research into Baja as in other parts of North America. It is not known for certain whether or not Paleo-Indians inhabited Baja, but it is likely that they did. It is certain, however, that several different cultures have inhabited Baja for at least 8,000 years. Some of them left petroglyphs, pictographs, and elaborate polychrome murals. None of the Baja cultures were Puebloan, nor were any of them temple builders like the Mayans or Aztecs of mainland and Yucatan Mexico. The people here lived mostly as nomadic hunter-gatherers into Historic times.

The oldest culture that archaeologists have been able to identify in Baja is the San Dieguito culture. These people are thought to have been living in Baja and southern California about 7,000 to 9,000 years ago. They were either late Paleo-Indians or early Archaic hunter-gatherers, typical of the people who lived in the Southwest at that time. However, there is no evidence I know of to suggest they ever hunted megafauna; it is possible that no megafauna existed this far south.

The next culture to appear in Baja, about 4,000 years ago, were the La Jolla people. The La Jollanos were a middle Archaic people who relied heavily on fishing for their sustenance. It is thought that both the La Jolla and the San Dieguito cultures may have coexisted in different areas of Baja and southern California for about 1,500 years; some believe the two cultures may have been related. About 2,000 years ago, both the San Dieguito and La Jolla people apparently disappeared. They were either replaced by or assimilated into the Yuman culture, sometimes called the Yumano. The Yumano used superior tools and fishing nets. In addition, they developed a simple ceramic technology before pottery developed in the Southwest.

The Yuman speakers are thought to have evolved into several groups, including the Pai Yuman of northern Baja and the southern California desert; the River (or Delta) Yuman, or Patayan, of the lower Colorado River; and the Peninsular Yuman of central Baja. Among the Pai Yuman were the Kiliwa, Paipai, Tipai, and Kumeyaay; they later expanded into Arizona and beyond, where they became the Yavapai, Havasupai, and others. The Patayan are thought to be the ancestors of the Historic tribes of the lower Colorado River, including the Yuma (Quechan), the Mojave, and the Cocopa. The Peninsular Yuman included the late Prehistoric Comondu culture, believed to be ancestral to the Cochimi. Some credit the Comondu culture with the famous cave paintings of the Great Mural region of central Baja, though the debate remains controversial.

After the arrival of the Spanish in Baja in 1530, many of the indigenous people died, mostly because of European diseases, but many were also killed by the Conquistadors when they revolted against Spanish domination. By the time the Spanish missionaries arrived in the early 1700s, only the Cochimi remained in central Baja, a people whose technologies were not much more advanced than their Paleo-Indian ancestors. When the Spanish asked them about the Great Murals, the Cochimi claimed they were painted by their ancestors, whom they called "the Giants."

In the far southern part of Baja were the Guaycuras. Excavations in the region have uncovered many skulls, most of which were fractured, indicating a violent death. The dead were interred in caves. After the flesh had decayed and the bones dried, the bones were decorated with the same red paint used to make pictographs. Then all the bones were gathered into a pile, and the skull was placed on top. Most of these grave sites have been plundered, many by American archaeologists.

The Guaycura people had little technology. Their primary weapon was a long spear with a fire-hardened wooden point. They wore no clothes except for a sash around their waist, possibly with a short apron of dried palm leaves. They used long, forked sticks to pick pitahaya cactus fruit.

Many researchers believe that neither the Cochimi nor the Guaycura produced any rock art, but others disagree. We may never know for sure.

Most of the people living in Baja today are descendants of the Cochimi and Guaycura peoples and the Spanish with whom they intermarried.

ROCK ART IN BAJA

Baja rock art is unique in many respects. Both the style and content of much of it is found nowhere else. In addition to petroglyphs and pictographs, there are numerous polychrome murals in central Baja, including the distinctive cave paintings of the famous Great Mural region. It is not known who made these murals; some simply call the artists "the Painters." The murals are found in arroyos throughout the mountain ranges of central Baja, in caves and rock shelters and on cliff faces. The Great Mural region includes the ranges of the Sierra de San Francisco, Sierra de Guadalupe, Sierra de San Juan, and Sierra de Borja. The Sierra de San Francisco is the main area for the Great Mural cave paintings—those in the other ranges often differ in style and content.

Many of the Great Mural cave paintings are polychrome images with various stylized motifs. Colors include black, red, white, ocher, and yellow. The numerous large human male figures on the murals have been called *Los Monos*, meaning "man images" or "painted men." Many are done in bicolored stylized patterns, usually red and black. Some are divided vertically with one side red and the other black; others have stripes or crosshatch designs on their bodies. Few are simple outlines. Most stand with arms up. (See color plate 1.)

The male figures are often shown pierced with as many as ten spears or long arrows. (See color plate 8.) One theory regarding these images suggests that they depict a shaman during a ritualistic "death" as he enters the spirit world. Others think they portray enemies killed in battle. Yet another theory asserts that they indicate some sort of black magic practices, similar to sticking pins into voodoo dolls. There are also a few female images, usually depicted with their breasts protruding to the sides from under their armpits. (See color plate 10.) The female figures are not usually as stylized as the male ones. Occasionally pregnant females are represented, usually drawn in profile.

After human figures, animal images are the second most common design in the cave paintings. Deer and goats are most often painted in red, and mountain lions are always painted in black. There are birds, sea creatures, at least two kinds of snakes, and occasionally rabbits. I saw one image that looked like a penguin. Geometric designs are nonexistent in these cave paintings.

The age of the Baja cave paintings is the subject of much speculation, but it is likely that they are many centuries old. One site is believed to depict the supernova of the Crab Nebula, which occurred almost 1,000 years ago. The most recent paintings are probably at least 500 to 700 years old, but most researchers think none are more than 2,000 years old, which lends credence to the theory that the Yuman people made them.

Other than the cave paintings, I have seen only a few pictograph sites in Baja. These vary greatly in style and content. One abstract polychrome style employs complex, abstract patterns, some of which suggest plants, others possibly blanket patterns. The colors of these are distinct, in shades more pastel than I have seen anywhere else. One pictograph site in southern Baja has a row of red handprints. At another, the ceiling and walls of a small cave are covered in simple geometric designs of black and red.

Petroglyphs can also be found in Baja, and many of the motifs are very different from those in the United States. Animals and sea creatures predominate. Fish, whales, dolphins, and turtles abound at some sites. Also seen are highly stylized figures, geometric designs, and vulva symbols. In one cave, a volcanic tuff outcrop was completely covered with deeply grooved vulva images.

SITE PRESERVATION IN MEXICO

Most petroglyph sites in Mexico are not protected and do not require a guide, but visitation to the Great Mural cave painting sites is strictly regulated. In nationalizing the cave paintings and a couple of other significant rock art sites, the Mexican government has ensured a significant amount of protection to the priceless rock art. At the entrances to these protected sites are prominent signs in both English and Spanish, advising that visitors must be accompanied by an official INAH (Instituto Nacional de Antropologia e Historia) guide. In most cases, visitors must sign a guest register and pay a fee for the guide. These guides frequently speak little or no English. Requiring a local guide to accompany visitors is a very effective way to protect sites from vandalism and from unintentional damage. In addition, it creates a minor source of income for a few people.

The laws regarding visitation of the Great Mural sites are outlined in a document called "Rules and Regulations for Visitors, Guides and Coordinators within the Archaeological Zone of the Sierra de San Francisco." This document, as well as campsite regulations and other information, is available from Centro INAH (see below).

BEFORE YOU GO

For the rock art enthusiast, Baja is an exciting place to visit, but there are some special considerations, especially for first-time visitors. Tourist information is available from the INAH, as well as from the Secretariat de Turismo (below). Allow at least a month for a reply to written correspondence. If you wish to visit the cave paintings of the Great Mural region, it is recommended that you start making arrangements a year in advance.

Centro INAH, Baja California Sur
Av. 16 de Septiembre, No. 152
La Paz, Baja California Sur (Mexico)
CP 23000
Telephone: (011) 91-112-27389

INAH San Ignacio, Baja California Sur
En el Complejo Misional
Baja California Sur (Mexico)
Telephone: (011) 91-115-40222

Secretariat de Turismo
Web site, www.turismobc.gob.mx

In addition to contacting these organizations, you could also call private outfitters in southern California and the bigger Mexican cities about tours. One of these agencies, Ecoturismo Kuyima in San Ignacio, is a Mexican company that specializes in tours of cave painting sites:

Ecoturismo Kuyima, San Ignacio
Telephone: (from within Mexico), 01-615-154-00-70;
Web site, www.kuyima.com/eindex.html

Whether you opt for a professional tour or decide to strike out on your own, there are a few things to be aware of. If you have never traveled in Mexico or any other developing country, it may be difficult for you to adjust to the rugged conditions outside the resort areas. The back roads are not regularly maintained, and road conditions vary considerably, depending on the weather. Many sites are in or across sandy arroyos, which are easy to get stuck in. If you go on your own, you will need a high-clearance vehicle to reach most of these sites, and some trips should be attempted only by an experienced desert traveler. If you go, be sure to carry extra oil and gas, and lots of water. Should you get stuck or break down, it could be a couple of days before anyone comes by to lend you a hand, so take along some nonperishable food too, just in case.

On the bright side, I have always found the people of Baja's outback to be friendly and helpful. If you stop at a rancho for help or directions, I have found that hard candy for the children helps break the ice very well. The adults appreciate modest gifts as well. Do *not* offer money for courtesies, however—only for gas or an item.

FINDING THE SITES

Exploring rock art sites in Mexico is a real adventure. Information is not readily available, so the listings for Baja have less information than the ones for the United States. There are no phone numbers for the sites, and it can be difficult to get information if you don't speak Spanish. Finding many of the sites requires hiring a local guide. Fees vary, depending on the going rate.

Reaching many of the sites in Baja requires a several-hour trek, and some even require several days on mules. Most cave painting sites are at least 20 miles from the nearest pavement, and it usually takes a long, dusty ride on bad, unmarked roads to even reach the trailhead. Other petroglyph and pictograph sites are much easier to locate, and some are even visible from the pavement. For this book, I have listed only the more easily accessible sites. And, just to be safe, I have not given explicit directions to some of the most fragile sites.

There is no DeLorme map for Baja, thus I have listed no map locators. The AAA map from the southern California AAA is probably the best one available. But locating sites on the map is only the first step. Trails in Mexico are not marked, and neither are most of the roads, other than the primary highways. In addition, the roads frequently divide, and many of these splits are not shown on a map.

The two main highways of northeast Baja are Mex. Hwy. 2 and Mex. Hwy. 5. The former is an east-west highway across northern Baja, just south of the border. Mex. Hwy. 5 is a paved road from Mexicali to Puertecitos. It follows the eastern edge of the peninsula. Northwestern Baja is easily explored off Mex. Hwy. 2, which follows the Pacific Coast for many miles south before swinging inland onto the western high desert. The northern portion of this highway is poorly maintained and usually has gaping potholes in it. Fortunately, it gets better as you travel south. There are no cave painting sites in this region, but there are two other accessible rock art sites, one with petroglyphs and the other with pictographs.

Baja California Norte (north) sites are listed first, followed by Baja California Sur (south). To simplify alphabetization, I have used English words in the headings (e.g. Santa Marta Ranch, not Rancho Santa Marta). The Great Mural region, with the famous Baja cave paintings and other rock art sites, includes El Ratón/Pintada Caves (site BC-8), San Borjitas (site BC-10), and La Trinidad Ranch (site BC-13), among others.

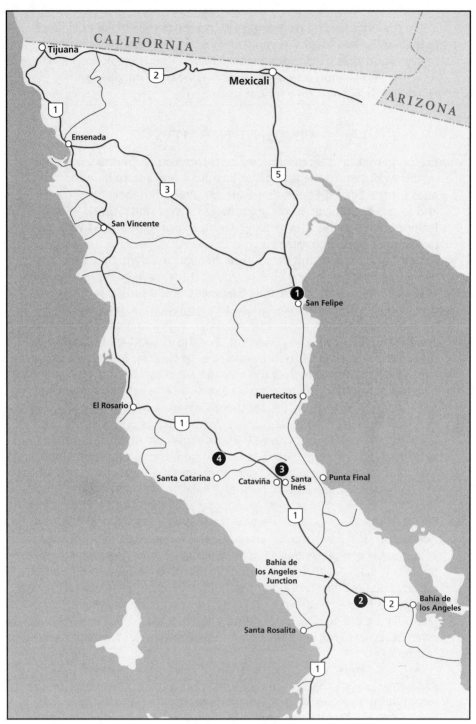

Northern Baja California

1 El Diablo Mountain
2 Montevideo
3 Palmerito Arroyo
4 San Fernando Arroyo

BAJA CALIFORNIA SITES (NORTH)

Site BC-1
EL DIABLO MOUNTAIN

Directions: From San Felipe, take Mex. Hwy. 5 north 7 miles to El Dorado Ranch. Sites are in arroyos at the base of Sierra el Diablo. Guided tour advisable, available at El Dorado Ranch and Beach Club, Colorado office, (800) 404-2599.

There are several arroyos at the base of Mount el Diablo, some of which contain rock art, both pictographs and petroglyphs. These sites are difficult to reach. Only ATVs, sand rails, and some four-wheel-drive vehicles can negotiate the primitive roads leading to the base of the mountains. In addition, there are no trail or road markers, and one arroyo looks much like the next. Luckily, visitors can usually arrange for a guided tour of the area through the El Dorado Ranch and Beach Club, just north of San Felipe. There is also a Mexican tourist office in San Felipe that can help you with arrangements.

The people who made the rock art here are believed to have been related to the Cocopa of the Colorado River delta region or possibly to the southern California desert Kumeyaay people. One of the pictographs is a polychrome with red and black geometric designs. Most of the petroglyphs I have found here are small Archaic-style glyphs, near the mouths of arroyos, often facing south or east. Some of these arroyos have year-round running water, and one has a waterfall. There is also a hot springs in the area.

Site BC-2
MONTEVIDEO

Directions: From Cataviña, take Mex. Hwy. I south about 65 miles to the Bahía de los Angeles junction (kilometer marker 280). Head east about 27 miles to the dirt road to Agua de Higuera and Mission San Borja, near kilometer marker 40, across from a large dry lake bed. Turn right (south). After almost 2 miles, the road splits. Take the left fork, which leads through an impressive cardon cactus "forest," and go a little over 6 miles farther. The site is just off the road. (Note: There is a lot of loose sand in the area, so take care parking.)

This spectacular pictograph site is one of my favorite sites in the world. It consists of many polychrome abstract pictographs painted on the rock faces and under overhangs of a fifty-foot-high rock outcrop. Some of the colors used here are unusual shades that I have never seen anywhere else, and the geometric designs are fascinating as well. Some of the designs are

suggestive of Southwest blanket and pottery designs. (See color plate 9.) At least one suggests a flowering plant, and there is an anthropomorph about three feet tall.

Site BC-3
PALMERITO ARROYO

Directions: From Cataviña, take Mex. Hwy. I north to a dirt-road turnoff a few hundred yards north of kilometer marker 171. From here, follow the arroyo on foot about ¼ mile east, up a pile of boulders. The cave is atop a rocky point that juts into the arroyo. There is a sign at the cave entrance, which can be seen from the road.

Arroyo Palmerito crosses Mex. Hwy. 1 just north of the small village of Cataviña. This arroyo has a small stream running through it most of the year. The site is in a rock shelter, and a large white sign, in Spanish, at the opening tells of its archaeological significance. There are geometric designs on the ceiling in red and black, and the mostly abstract images on the sides are painted in red, yellow, orange, white, and black. A few pictographs adorn the rocks just outside the cave entrance also.

This small cave at Arroyo Palmerito contains numerous geometric designs in multiple colors.

Site BC-4
SAN FERNANDO ARROYO

Directions: From El Rosario, take Mex. Hwy. I about 37 miles southeast to a dirt road on the right (west) near kilometer marker 114. Follow it a little over 4½ miles, past the ruins of an old mission (San Fernando Velicata), and stop just before the road crosses the streambed of Arroyo San Fernando. The main petroglyph site is on a cliff face there.

There is a good petroglyph site at a place where a dirt road crosses Arroyo San Fernando. It is a beautiful spot with a year-round creek that provides for lush vegetation up and down the little valley. The glyphs, thought to have been made between A.D. 1000 and 1500, are mostly abstract forms and resemble the Archaic styles commonly found in areas of southern California. Some designs may represent Spanish ships and Christian crosses of the missionaries.

There is quite a bit of spray-paint graffiti here, but fortunately I saw no petroglyphs defaced. There are additional petroglyphs on the large boulders near the road as you approach the site.

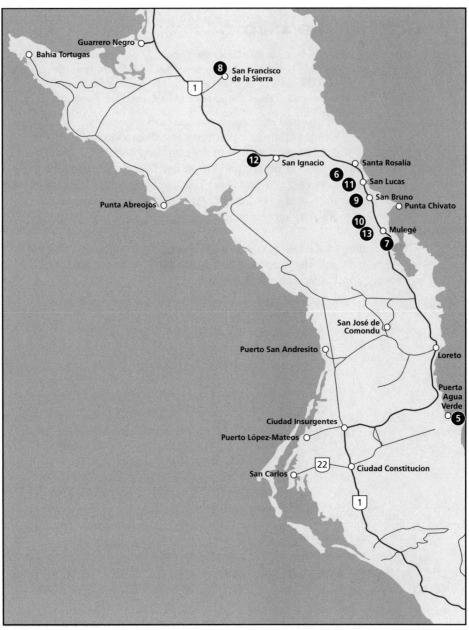

Southern Baja California

5	Agua Verde	10	San Borjitas Cave
6	Candalaria Ranch	11	San Lucas
7	Concepción Bay	12	Santa Marta Ranch/
8	El Ratón Cave/Pintada Cave		El Palmarito Cave
9	Pollo Arroyo	13	La Trinidad Ranch

BAJA CALIFORNIA SITES (SOUTH)

Site BC-5
AGUA VERDE

Directions: From Loreto, take Mex. Hwy. I south about 34 miles to a graded dirt road on the left that leads to Puerta Agua Verde, which is about 25 miles southwest. From the village, a trail leads about a mile to the site, in a cave near the beach.

South of Loreto is a fishing village called Puerta Agua Verde, which has a pictograph site nearby. The trail to the site goes past a little cemetery and leads to a cave containing fifty-two handprints. The cave is about a mile from the village, about 150 yards from the beach.

Site BC-6
CANDALARIA RANCH

Directions: From Santa Rosalía, take Mex. Hwy. I south about 5½ miles to kilometer marker 188, where an unpaved road leads west about 20 miles west to Rancho Candalaria, a small homestead at the end of the road. You must stop at the ranch and pay the owner to guide you to the site, which is a nearby fifty-foot-high boulder.

Near Santa Rosalía is a pictograph site called Candalaria, along the foothills of the mountains. At Rancho Candalaria is a beautiful panel in the typical Great Mural cave painting style, although the main paintings are not in a cave. The site is a huge boulder, larger than a house, with a small hollow under it.

There are a few small pictographs inside the hollow and on the back of the boulder, but the main panel is high up on the outside of the rock above the opening. Here you can see a detailed red deer and a goat. (See color plate 11.) The images were obviously made by "the Painters" of the Great Mural region, but the other pictographs were likely made by a different culture because the size, content, and style differs from that of the Great Mural painters.

On the back of the boulder are a couple of small figures, including one about a foot high that my guide called a *pinguino* (penguin), which I believe was meant to represent the cardon cactus spirit found more commonly in rock art to the south of this site. The cardon spirit is a ghostly figure believed to transform at night from a cactus into a supernatural being. The small figures inside the hollow are painted in red and brown.

Site BC-7
CONCEPCIÓN BAY

Directions: From Mulegé, take Mex. Hwy. I south to kilometer markers 106 (for Arroyo Ramada) and 109 (for Arroyo del Burro), along the west shore of Bahía Concepción. A dirt road leads down into Arroyo Ramada; this site is visible from the edge of the road. The Arroyo del Burro site is easily seen from the highway, on the uphill side, opposite an old dry cistern.

Burro Arroyo

Arroyo del Burro is an excellent petroglyph site that you can actually see from the pavement. The glyphs are extensive, similar to the Pollo site. A stylized triggerfish and numerous other zoomorphs are found here, as well as anthropomorphs, including Cardon Spirit figures.

Another interesting and unusual feature at this arroyo is the "bell rock," a boulder that when struck by another stone makes a distinct ringing sound. This rock once contained a number of petroglyphs, but most of them have been destroyed by tourists beating on them with rocks.

Ramada Arroyo

Arroyo Ramada is just southwest of a beach called Playa el Coyote. The site is on a road through an area that has been used extensively as a trash dump. In the arroyo is a rock outcrop with three shallow caves, or rock shelters, that contain remnants of pictographs. Little more than faint red stains mark the images once painted here, but in one of the shelters I found two small, dark gray images that appear to be large-headed lizards.

Site BC-8
EL RATÓN CAVE/PINTADA CAVE

Directions: If you do not take a tour from San Ignacio, you can drive to San Francisco de la Sierra and find a guide there. The Cueva del Ratón site is just outside the village of San Francisco de la Sierra, but visiting Cueva de Pintada requires advance preparations, as it involves an overnight camping excursion and you must have a registered guide. To get to San Francisco de la Sierra from San Ignacio, take a sturdy, high-clearance vehicle on Mex. Hwy. I north about 44 km (27½ miles) to kilometer marker 118, where a dirt road on the right (east) leads about 37 km (23 miles) to the village.

Cueva del Ratón is the only Great Mural site you can drive to. It is protected by a chain-link fence with a locked gate, so you must hire a guide in San Francisco de la Sierra to unlock it. In this large rock shelter, you will find paintings of large anthropomorphic and zoomorphic figures, including a red deer, a pronghorn antelope, and a black mountain lion.

To see Cueva de Pintada, one of the best-known and most spectacular Great Mural sites, you must register with INAH and have a guide. The tours, which leave from San Francisco de la Sierra, require overnight camping and

Glyph of a cardon cactus spirit at Arroyo del Burro

Two zoomorphic pictographs on the back wall of a rock shelter in Arroyo Ramada, near Bahía Concepción

involve rigorous hikes or mule rides of several hours per day. These excursions often include other cave painting sites in Santa Teresa Canyon, such as Cuevas las Flechas, la Soledad, los Músicos, and la Boca de San Julio.

Cueva de Pintada has an amazing 500 feet of painted walls. The gigantic men and animals are typical of the ancient Sierra de San Francisco cave paintings. The great variety of images in these huge polychrome murals are painted and repainted in many different colors. Among the motifs you can see are sea creatures, land mammals, reptiles, and headdressed los Monos.

Site BC-9
POLLO ARROYO

Directions: From Santa Rosalía, take Mex. Hwy. 1 south to kilometer marker 179. Go west 1³/₁₀ miles on a rough dirt road along Arroyo del Pollo until you reach a rock wall. Proceed on foot up the hill to the site, on a rocky point jutting out into the arroyo.

A little bit south of San Lucas, along Arroyo del Pollo, is a wonderful petroglyph site. The main site is a field of smallish boulders that extends from just above the road to well up the mountainside. Among the great assortment of images are deer tracks etched deeply into the rocks, vulva symbols, geometric patterns, and numerous zoomorphic glyphs. There is an incredible variety of animals depicted here, such as turtles, whales, fish, dolphins, and bighorn sheep. A few anthropomorphic figures also appear. There is also a rock wall constructed partway across the wash, and a few of the rocks in the wall have petroglyphs.

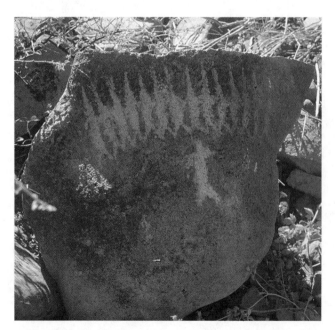

One of my favorite panels at Arroyo del Pollo shows what appears to be a line of fourteen swordfish hung above a proud fisherman's head.

Site BC-10
SAN BORJITAS CAVE

Directions: From Mulegé, in a high-clearance vehicle, take Mex. Hwy. 1 north about 21 km (13 miles) to kilometer marker 157, and turn left (west) at the dirt road opposite the turnoff to Punta Chivato. The road forks several times; keep left. You will pass several ranchos with closed but unlocked gates on the way in (be sure to close the gates behind you). It's about 27 km (17 miles) to Rancho las Tinajas, at the end of the road. You must hire a guide at the ranch.

The famous Cueva San Borjitas is a large cave, about seventy-five feet wide and almost as deep, with a low ceiling that is literally covered with painted images. This is truly a remarkable site, with paintings similar to but much more varied than the traditional cave paintings found farther north.

The primary motif is of plump Monos (male anthropomorphs), of which there are over fifty, most with their arms outstretched. These images are painted in shades of red, black, brown, and white. Some are painted in solid colors; others have multicolor configurations. Many are pierced with two to six long arrows, some with obvious fletching (feathers). (See color plates 1 and 8.)

There are a few female images painted in black, with their breasts protruding to the sides from under their armpits. (See color plate 10.) There are also a few images of deer and fish near the back of the cave, crudely scratched into the soot-blackened ceiling. These were probably made by a more recent culture. At one side of the cave is a small outcrop of volcanic tuff that has been completely inscribed with vulva figures.

Site BC-11
SAN LUCAS

Directions: San Lucas is about 9 miles south of Santa Rosalía, just off Mex. Hwy. 1. Ask around at the village (try the campground or the restaurant on the highway) for a guide. The last ¼ mile to the site is on foot.

There is small pictograph site in a cave at the coastal village of San Lucas that I suspect few other Americans have seen. It still has portable (not bedrock) metates lying at the base of the rock shelter, a sure sign that *gringos* haven't been there. While the style of the paintings is similar to the Great Mural cave paintings, the scale is much smaller.

In addition, one image is quite distinctive, unlike any I have seen anywhere else. It is a small red anthropomorph in profile, holding a long staff or spear. The image is less than a foot tall, and most of the head and top of the staff have flaked off the rock. There is another panel containing a picture of a red deer and another animal done in black, possibly a cougar, which seems to be attacking the deer. The images are quite faded and flaked. (See color plate 12.)

Site BC-12
SANTA MARTA RANCH/EL PALMARITO CAVE

Directions: Hire a guide in San Ignacio or in Mulegé, or drive to the ranch and hire a guide there. From San Ignacio, take Mex. Hwy. 1 south/east about 21 km (13 miles) to kilometer marker 59, then drive north about 40 km (25 miles) to Rancho Santa Marta, near the end of the road. Visiting the site requires a somewhat strenuous hike of about 2 miles down the old El Camino Real.

This Sierra de San Francisco cave painting site, called El Palmarito (not to be confused with Arroyo Palmerito near Cataviña), has the red-and-black anthropomorphs and zoomorphs that are typical of the region. Images include sheep, deer, and rabbits.

Overnight tours of more remote sites, in Arroyo del Parral, also leave from Rancho Santa Marta. These sites include La Super Nova, thought to depict the supernova of 1054, and La Serpiente, which has antler-headed snakes in orange and black as well as human figures.

Site BC-13
LA TRINIDAD RANCH

Directions: From Mulegé, take the road to San Estanislao (Ice House Road), on the north side of town, west about 15 miles, following signs to San Estanislao and Rancho la Trinidad (the signs are not entirely reliable; it's best to ask directions in town or hire a guide). From the ranch, the tour is a challenging, 4-mile hike with several river crossings that may require swimming. A guide is required; inquire in Mulegé at any larger hotel or hire a guide at Rancho La Trinidad.

The Cardon Spirit blesses a killed deer in this panel at La Trinidad.

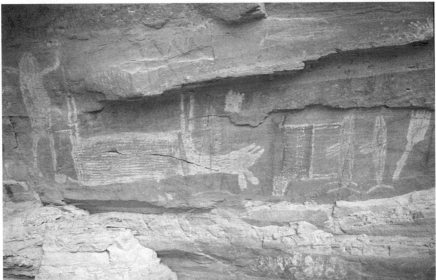

About fifteen miles west of Mulegé is a site near Rancho La Trinidad, in Arroyo Mulegé, which contains a year-round stream. The stream disappears underground at the edge of the desert, but many believe it resurfaces at Mulegé and is actually the source of the small river that empties into the Sea of Cortez.

There are a number of both petroglyph and pictograph panels on the rock walls and in the shallow caves of the arroyo. The site extends quite a way up the arroyo, and to reach some of the upper panels requires wading or even swimming across deep pools in the narrow arroyo.

One of the lower panels is quite interesting. According to the guide, it was a place where the natives asked the cardon cactus spirit to bless them with bountiful food. Depicted are items the natives frequently ate, such as a deer carcass, cactus fruit, and fish. Also shown is the image of the cardon spirit himself.

RESOURCES

Note: Phone numbers, Web sites, and other information given below are subject to change.

NATIONAL

American Rock Art Research Association (ARARA)
Arizona State Museum
University of Arizona
P.O. Box 210026
Tucson, AZ 85721-0026
Phone: (520) 621-3999
Toll-free: (888) 668-0052
Web site: www.arara.org

Bureau of Land Management (BLM) Law Enforcement (nationwide)
Phone: (800) 722-3998

National Park Service Hotline for Reporting Vandalism
Phone: (800) 227-7286

Petroglyphs.us
Web site: www.petroglyphs.us/

ARIZONA

Arizona Archaeological Council
P.O. Box 27566
Tempe, AZ 85285-7566
Phone: (520) 523-7044
Web site: www.arizona archaeologicalcouncil.org/index. html

Arizona Archaeological and Historical Society
Arizona State Museum
P.O. Box 210026
Tucson, AZ 85721-0026
Phone: (520) 621-6302
Web site: www.statemuseum. arizona.edu/aahs/aahs.shtml

Arizona Hotline for Reporting Vandalism (Arizona Game & Fish)
Phone: (800) 826-3257

Arizona State Parks Historic Preservation Office
Arizona State Parks SHPO
1300 W. Washington
Phoenix, AZ 85007
Phone: (602) 542-4009
Web site: www.pr.state.az.us/ partnerships/shpo/shpo.html

Arizona Tourism Office
Phone: (800) 842-8257

Bureau of Land Management
Arizona State Office
222 North Central Ave.
Phoenix, AZ 85004-2203
Phone: (602) 417-9200
Fax: (602) 417-9556

CALIFORNIA

Bureau of Land Management
California State Office
2800 Cottage Way, Room W-1834
Sacramento, CA 95825
Phone: (916) 978-4400

Society for California Archaeology
California State University, Chico
Chico, CA 95929-0401
Phone: (530) 898-5733
E-mail: info@scahome.org
Web site: www.scahome.org

COLORADO

Bureau of Land Management
Colorado State Office
2850 Youngfield St.
Lakewood, CO 80215
Phone: (303) 239-3600
Fax: (303) 239-3934

Colorado Historical Society
Office of Archaeology and Historic
Preservation (OAHP)
1300 Broadway
Denver CO 80203
Phone: (303) 866-3395
Fax: (303) 866-2711
E-mail: oahp@chs.state.co.us
Web site: www.coloradohistory
oahp.org

Colorado Hotline for Reporting
Vandalism (Colorado State
Archaeology Office)
Phone: (303) 866-3395

Colorado National Park Service
Phone: (303) 969-2000

Colorado Tourism Board
Phone: (800) 433-2656

Crow Canyon Archaeological Center
23390 Road K
Cortez, CO 81321-9908
Phone: (970) 565-8975
Toll-free: (800) 422-8975
Web site: www.crowcanyon.org

NEVADA

Bureau of Land Management
Nevada State Office
1340 Financial Blvd.
P.O. Box 12000
Reno, NV 89520-0006
Phone: (775) 861-6400

Nevada Rock Art Foundation
c/o Alanah Woody
305 S. Arlington Ave.
Reno, NV 89501
Phone: (775) 315-5497
Web site: www.nevadarockart.org

Nevada State Historic
Preservation Office
100 North Stewart St.
Carson City, NV 89701-4285
Phone: (775) 684-3448
Fax: (775) 684-3442
Web site: dmla.clan.lib.nv.us/docs/
shpo/

Southern Nevada Rock Art
Association
c/o Charles Molina
6224 New Kirk Ct.
Las Vegas, NV 89103
Phone: (702) 897-7878
E-mail: snraa@hotpop.com

NEW MEXICO

Bureau of Land Management
New Mexico State Office
1474 E. Rodeo Rd.
Santa Fe, NM 87505
Phone: (505) 438-7400
Fax: (505) 438-7435

New Mexico Heritage
Preservation Alliance
1210 Luisa St. #5
P.O. Box 2490
Santa Fe, NM 87504
Phone: (505) 989-7745
E-mail: info@nmheritage.org
Web site: www.nmheritage.org

New Mexico Hotline for
Reporting Vandalism
Phone: (505) 827-6320

New Mexico State Archaeology Office
Phone: (505) 827-3989

TEXAS

Friends of Hueco Tanks
6900 Hueco Tanks Rd. #1
El Paso, TX 79938
Phone: (915) 855-8609
Web site: rgfn.epcc.edu/users/
bf274

Rock Art Foundation
4833 Fredericksburg Rd.
San Antonio, TX 78229
Phone: (210) 525-9907
Toll-free: (888) 762-5278
Fax: (210) 525-9909
E-mail: admin@rockart.org
Web site: www.rockart.org

Texas Archeological Society
 6900 N. Loop 1604 W.
 CAR at UTSA
 San Antonio, TX 78249-0658
 Phone: (210) 458-4393
 Web site: www.txarch.org

Witte Museum
 3801 Broadway
 San Antonio, TX 78209
 Phone: (210) 357-1900
 Web site: www.wittemuseum.org

UTAH

Bureau of Land Management
 Utah State Office
 440 West 200 South, Suite 500
 Salt Lake City, UT 84101
 Phone: (801) 539-4001

Utah Hotline for Reporting Vandalism
(Utah BLM Law Enforcement)
 Phone: (800) 722-3998

Utah Rock Art Research Association
 P.O. Box 511324
 Salt Lake City, UT 84151-1324
 E-mail: troyscotter@comcast.net
 Web site: www.utahrockart.org

Utah Statewide Archaeological
Society
 c/o Ron Wood
 Division of State History
 300 Rio Grande
 Salt Lake City, UT 84101
 Phone: (801) 533-3529
 Web site: www.utaharchaeology.org

Utah Travel Council
 Phone: (800) 200-1160
 Web site: www.utah.com

GLOSSARY

adobe. Bricks or other building materials made of sun-dried mud, used by some Ancestral Puebloan people late in the development of their culture to make houses and other structures.

Anasazi. Navajo Indian name for the Ancestral Puebloan people who occupied the Four Corners region of the Southwest from about A.D. 400 to 1450. Often translated as "Ancient Ones," some argue that it more nearly means "enemy of our ancestors."

anthropomorphic. Having the general form or shape of a human, or definite human attributes such as limbs.

archaeology. The systematic study of past human cultures, based largely on the finding and analysis of artifacts.

Archaic. Relating to the period from about 5500 B.C. to A.D. 1.

artifact. An object fashioned or used by humans, especially one remaining from a particular period of time.

Athabascan. A family of languages that originated in northern Canada and spread through migration to the American Southwest by around A.D. 1500. Includes the Apache and Navajo languages.

atlatl. A spear or dart thrower, usually made of wood, believed to have been in general use in North America from about 9000 B.C. to around A.D. 500.

Basketmakers. A Transitional people of the Southwest who acquired an advanced basket-weaving technology by around 100 B.C. They are believed to be the predecessors of some Ancestral Puebloan cultures.

cairn. A small pile of stones, often in a crude cone shape, used to mark trails or other significant locations.

carbon dating. See *radiocarbon dating*.

cupules. Cuplike depressions ground into rock surfaces, believed by some to have been used for ceremonial purposes. Cupules are larger than pits but smaller than mortars.

curvilinear. A style of rock art typified by abstract designs incorporating circles, curves, and wavy lines.

desert varnish. See *patina*.

exfoliation. See *spalling*.

Fremont. A Prehistoric culture occupying much of northern and eastern Utah and northwestern Colorado from about A.D. 450 to 1250.

geoglyh. A large image, often human or animal, made on the earth's surface rather than on rock, often by removing pebbles or rocks to expose the earth or sand below, or by aligning rocks to form an outline on the ground. Also called an *intaglio*.

227

glyph. Short for *petroglyph.*

Historic. On the American continent, dating from the time of European contact in the New World. In the Southwest, this was A.D. 1540.

Hohokam. A Prehistoric culture that occupied the Phoenix basin and much of south-central Arizona from about 200 B.C. to A.D. 1500.

hunter-gatherers. People who obtain food primarily by hunting, fishing, and gathering seeds, nuts, berries, roots, and other wild plants.

hunting magic. A practice of using chants, spells, charms, or other magical means to ensure hunting success. Some believe that rock art images may have been used in these ceremonies.

ice age. A time of extensive glacial activity.

incorporation. See *rock incorporation.*

intaglio. See *geoglyph.*

kiva. A semisubterranean structure, either round, square, or retangular, used for ceremonial purposes by Puebloan people.

mano. A handheld stone used to grind dried cereal grains and seeds. See also *metate.*

metate. A flat or slightly hollowed stone surface on which grains or seeds were ground into powder. See also *mano.*

midden. A mound of debris and garbage, often black from charcoal fires and full of animal bones, pottery, broken stone tools, etc.

Mogollon. A Prehistoric culture that occupied much of eastern Arizona, western Texas, and southern New Mexico from about 300 B.C. to about A.D. 1450.

monochrome. Of one color.

Monos (los Monos). Stylized male anthropomorphic figures commonly found in pictographs in Baja California.

motif. A design element used frequently or repeatedly.

Numic. The family of Uto-Aztecan languages in the western Great Basin that includes the languages of the Ute, Southern Paiute, and Western Shoshone tribes.

Paleo-Indians. Ancient Americans who lived from about 7,500 to 15,000 years ago.

Paleolithic. Referring to the early Stone Age, about 8,000 to 15,000 years ago.

panel. A portion of a rock, usually flat, displaying either a single rock art image or an array of symbols.

Patayan. An agricultural or semiagricultural culture along the lower Colorado River beginning around A.D. 500. Also called Ancestral Yuman.

patina. The dark coating that forms on the surface of exposed rock from bacterial and chemical action over hundreds or thousands of years. Also called desert varnish.

petroglyph. An image pecked, chipped, abraded, or etched into rock.

pictograph. An image painted on rock.

pit-and-groove. One of the oldest styles of rock art, typified by rows of 1/2- to 3/4-inch pits and long, 1/2-inch-wide grooves deeply pecked, or ground, into the rocks, sometimes as deeply as 1/2 inch.

pit house. A primitive dwelling usually made of a brush or mud-covered wooden framework over a shallow circular or rectangular pit.

polychrome. Of two or more colors.

Prehistoric. Dating between the time that farming became common (A.D. 500) until the time of Spanish contact in the New World (A.D. 1500), or prior to written history in other parts of the world.

Protohistoric. The period of time between the decline of the early Puebloan cultures in the mid-1400s to the mid-1500s.

Puebloan. Of or pertaining to the Pueblo culture, usually represented by permanent settlements (pueblos), farming, textile weaving, and potterymaking.

radiocarbon dating. A dating method measuring the percentage of radioactive carbon-14 in organic material such as charcoal or bone. It can be used to date materials up to about 40,000 years old.

rectilinear. A style of rock art typified by straight lines forming abstract geometric shapes such as zigzags, rectangles, and grids.

repatination. The natural process by which layers of patina gradually build up over time.

rock art. The pecking, incising, or painting of designs onto rock surfaces, or the altering of the earth's surface to produce an image.

rock incorporation. The inclusion of a natural feature of the rock surface, such as a crack, bump, or depression, into a rock art design.

Salado. A Prehistoric culture that occupied the Tonto Basin and areas along the Salt River of Arizona from about A.D. 900 to 1400.

shaman. A religious or spiritual leader, sometimes called a medicine man.

shamanism. A Native American form of religion dependent on the shaman and his spiritual guidance.

Sinagua. Prehistoric Puebloan tribe that occupied an area in Arizona from Flagstaff down into the Verde Valley area from about A.D. 500 to 1300. They are referred to by many anthropologists as the Western Anasazi.

spalling. A natural process of erosion that causes chips or slabs of rock (spalls) to be stripped from the surface. These layers occasionally have rock art images on them.

Takic. The family of Uto-Aztecan languages in the southern California desert that includes the languages of the Cahuilla, Chemehuevi, Kumeyaay, and Serrano tribes.

talus. Rock fragments or boulders lying at the base of a cliff, usually coarse and angular.

tank. Natural water catchment basin.

tuff. A soft rock derived from hardened volcanic ash.

Yuman. The family of languages along the lower Colorado River from Nevada to the Delta region and parts of Baja California, which includes languages of the Mojave, Yuma, Cocopa, Yavapai, Havasupai, Halchidoma, and Maricopa tribes.

zoomorphic. Having the form of an animal, bird, reptile, insect, or fish.

BIBLIOGRAPHY

Barnes, F. A. *Canyon Country Prehistoric Rock Art*. Salt Lake City: Wasatch, 1995.

Bates, Roberta, and Julia A. Jackson. *Dictionary of Geological Terms*. New York: Doubleday, 1984.

Benson, Phil. *Native American Petroglyphs: Along the Trail*. Las Vegas: Southern Nevada Times Publishing, 1989.

Castleman, Deke. *Nevada Handbook*. Chico, Calif.: Moon Publications, Inc., 1998.

Cheek, Lawrence W. *Compass American Guides: Arizona*. Oakland, Calif.: Fodors Travel Publications, 1997.

Cole, Sally J. *Legacy on Stone: Rock Art of the Colorado Plateau and Four Corners Region*. Boulder, Colo.: Johnson Books, 1990.

Cressman, Luther S. *Petroglyphs of Oregon*. University of Oregon Monographs, Studies in Anthropology, no. 2. Eugene: University of Oregon, 1937.

————. *Prehistory of the Far West*. Salt Lake City: University of Utah Press, 1977.

Crosby, Harry. *The Cave Paintings of Baja California*. 2nd ed. El Cajon, Calif.: Sunbelt Publishing, 1997.

Dewdney, Sheldon. *Dating Rock Art in the Canadian Shield Region*. Occasional Paper 24, Art and Archaeology, Royal Ontario Museum. Toronto: University of Toronto Press, 1970.

Dorn, R. I., and D. S. Whitley. "Chronometric and Relative Age Determination of Petroglyphs in the Western United States." *Annals of the Association of American Geographers* 74, no. 2 (1984).

Fiero, G. William. *Nevada's Valley of Fire*. Las Vegas: KC Publications, 1985.

Goodman, Jeffrey. *American Genesis*. New York: Summit Books, 1981.

Grant, Campbell. *Rock Art of the American Indian*. Dillon, Colo.: Vista Books, 1992.

Hill, Beth, and Ray Hill. *Indian Petroglyphs of the Pacific Northwest*. Seattle: University of Washington Press, 1974.

Jennings, Jesse D., and Edward Norbeck. *Prehistoric Man in the New World*. Chicago: University of Chicago Press, 1974.

Johnson, Franklin R., and Bill Yenne, eds. *The Lost Field Notes of Franklin R. Johnson's Life and Work Among the American Indians*. Cobb, Calif.: First Glance Books, 1997.

Martineau, LaVan. *The Rocks Begin to Speak*. Las Vegas: KC Publications, 1994.

McCreery, Patricia, and Ekkehart Malotki. *Tapamveni*. Petrified Forest, Ariz.: Petrified Forest Museum Association, 1994.

Meade, Edward. *Indian Rock Carvings*. Sidney, British Columbia, Canada: Gray's Publishing Ltd., 1971.

Muench, M. David, and Polly Schaafsma. *Images in Stone*. San Francisco: Brown Trout Publishers, 1995.

Noble, David G. *Ancient Ruins of the Southwest*. Flagstaff, Ariz.: Northland Publishing, 2000.

Patterson, Alex. *Field Guide to Rock Art Symbols of the Greater Southwest*. Boulder, Colo.: Johnson Books, 1992.

Madison, Cheri Cinkoski. *Red Rock Canyon*. Las Vegas: KC Publications, 1999.

Schaafsma, Polly. *Indian Rock Art of the Southwest*. Santa Fe: School of American Research, 1995.

Slifer, Dennis. *Guide to Rock Art of the Utah Region*. Santa Fe: Ancient City Press, 2000.

Stuart, Gene S. *America's Ancient Cities*. Washington, DC: National Geographic Society, 1988.

Welch, Elizabeth. *Easy Field Guide to Southwest Petroglyphs*. Booklet. Phoenix: Primer Publishing, 1996.

———— and Peter Welch. *Rock Art of the Southwest*. Berkeley, Calif.: Wilderness Press, 2000.

Whitley, David S. *A Guide to Rock Art Sites: Southern California and Southern Nevada*. Missoula, Mont.: Mountain Press Publishing, 1996.

Woodward, John A. *Ancient Painted Images of the Columbia Gorge*. Ramona, Calif.: Acoma Books, 1982.

INDEX

Italics indicate photographs

Fossil Falls, 110, *110*
Fremont Indians: about, 24, 26, 28–29, 181; design styles of, 30; rock art of, 117, *202*
Fremont Indian State Park, 193
Fremont sites: in Colorado, 120, 121, 125, *125*, 127, *127;* in Utah, 185, 186, 188–91, 193, 196, 197–99, 201, *202,* 204

Galesteo, 161
geoglyphs, *5;* definition of, 5; Patayan, 28, 29. *See also* Blythe Intaglios
geometric designs, as symbols, 64–65. *See also* abstract motifs
Ghaan 'ask'idii, 158–59
Gila Cliff Dwellings, 161–62
Gila Petroglyph style, about, 24, 39
Glen Canyon Linear style: about, 20, 181; illustration of, *21*
Gobernador Representational style, about, 46
grafitti. *See* vandalism
Grand Canyon National Park, 87
Grapevine Canyon, 68, 133, 135–36, *136*
Great Basin Abstract style, about, 20, 181
Great Basin Desert, 133
Great Murals, about, 207–9
Grimes Point, 133, 136–37, *137*
Guaycura Indians, 207–8

Hachidoma Indians, 28, 46
handprints, 140; in Ancestral Puebloan rock art, 33, 34; in Basketmaker rock art, 25; in Historic California desert styles, 45; in Mogollon rock art, 40, 41; in Navajo style, 46; in Salado rock art, 38; sites with, in Arizona, 86; sites with, in Baja, 209, 217; sites with, in Colorado, 126, 129; sites with, in Nevada, 140, 142; sites with, in New Mexico, 153, 154, 159, 161
Head of Sinbad, 194
Hickison (Summit) Petroglyph Recreation Area, 133, 137–39, *138*
Hicklin Springs, 123
Hidden Valley Polychrome style, about, 25
Historic cultures: about, 44–48; design styles of, 45–46

Hohokam Indians: about, 24–25, 26, 28, 38–39, 83; design styles of, 24, 39; illustrations of, *93, 97, 99;* rock art sites of, 87, 92, 96–101
Homolovi Ruins State Park, *74,* 83, 88
Hopi Indians: about, 35, 41, 44, 87, 88; clan symbols and, 56; design styles of, 45; rock art interpretation and, 50, 91–92; rock art sites of, 87
horse motif, *10,* 46, *47,* 170; sites with, in Arizona, 85; sites with, in California, 106, 110; sites with, in Colorado, 121, 129; sites with, in Utah, 184, 186, 196, 197, 203
horses, 48
Hot Springs (Big Bend National Park), 173
Hovenweep National Monument/ Holly Group, 123–24
Hueco Tanks State Historic Park, 169, 170, 175–76
hunter-gatherer cultures, 15, 18, 22–23, 36, 41, 43
hunting scenes, 54, 57; sites with, 89, 96, 147, 160, 162, 169, 184, 196
hunting symbols (hunting magic), 51, 52, 53; sites with, 137, 139, 160, 184

Indian Head Mountain (Big Bend National Park), 174
Inscription Canyon (Barstow Area), 107
Inscription Rock at Davis Dam, 71, 88–89
intaglios. *See* geoglyphs
Irish Canyon, 124–25, *125*
irrigation, 26, 37, 38. *See also* agriculture; canals; dams

Jornada Indians (Desert Mogollon): about, 39–40, 42, 149; design style of, 41; rock art sites of, 166–67, 175–76

Kane Creek, 194–95, *195*
Kawaiisu Indians, 43; rock art sites of, 106, 107, 115
Kayenta Representational style, about, 33
Kern Nos. 317 and 878, 111
Keyhole Sink, 83, 89
Kiowa Indians, 48

Patayan Intaglios, about, 29. *See also* Blythe Intaglios

Patayan Petroglyph style, about, 29

patination: defined, 3; determining age or rock art by, 8

paw prints. *See* animal track motif

Pecos River Red Monochrome style, about, 43. *See also* Lower Pecos River style; Red Linear style

Penitente Canyon, 126

Petrified Forest National Monument, 83, 95–96, *96*

Petroglyph Canyon (Valley of Fire State Park), 143

Petroglyph National Monument, *32, 34, 63,* 149–50, *150,* 163–64, *164*

Petroglyph Park/Bloomington, 199

petroglyphs: definition of, 3; methods of producing, 3

Phoenix Parks and Recreation Department, 84

photographing rock art, 12–13

Picnic Glyphs (Valley of Fire State Park), 144–45

pictographs: about, 4–5; paint used for, 4

Picture Rocks Retreat, *96, 97*

Pima Indians, 39

pit-and-groove, 6, *6,* 9, 18, 95

pit houses, 26, 27, 29, 32, 33–34, 39; ruins of, 88, 124, 181, 193

plant motifs, 7, 23, 61, 64; sites with, 129, 142, 166, 209, 214. *See also* corn

Pollo Arroyo, 220

Pony Hills, 165, *165*

Potash Road, 199–200

pottery: 27, 56, 64, 119, 207, 214; artifacts, 140, 193, 205; Fremont, 29, 31; Hopi, 56; Mogollon, 40, *41,* 42, 161; Sinagua, 37; Salado, 38; Virgin River Puebloan, 36

Prehistoric cultures: about, 26–28; Ancestral Puebloan, 26, 28, 32–35; Fremont, 26, 28–31; Hohokam, 26, 28, 38–39; Mogollon, 26, 28, 39–42; nonagricultural, 27, 42–44; Patayan, 26, 28; Sinagua, 27, 36–37; Salado, 27, 37–38; Virgin River Puebloan, 35–36

preservation of sites, 67–79; in Arizona, 84; in California, 103; in Colorado, 117–18; funding for, 68, 72, 79; laws regarding, 70, 72;

in Mexico, 209; in Nevada, 133; in New Mexico, 149–50; personal participation in supporting, 67, 73, 78–79; strategies for, 72–77; in Texas, 170–71; in Utah, 183; restoration and, 67, 77–78; signage and, 73–75, *74, 75, 76;* visitor etiquette and, 11–12, 78; volunteer stewards and, 67, 78. *See also* damage to sites

puberty rites, 45, 52–53, 126

pueblitos, 158

Pueblo Bonito (Chaco Canyon), 156

Pueblo Grande Museum, 84, 100

pueblos: Ancestral Puebloan, 32, 34, 35; Historic, 44; Mogollon 42, 161; Prehistoric, 28; ruins of, in Arizona, 85, 88, 92, 100; ruins of, in Colorado, 119, 124, 128, 130; ruins of, in New Mexico, 152–54, 155–56, *156,* 157, 160, 161, 162; ruins of, in Utah, 193; Sinagua, 36; Salado, 37; Tewa, 161; Virgin River Puebloan, 36. *See also* cliff dwellings; pit houses

Puye Calendar Cave, 149

quadrupeds. *See* zoomorphs

Quechan Indians. *See* Yuma Indians

Quetzalcoatl, 64

rain: damage from, 8, 68–69; gods, 40, 41, 60–61, *60,* 62, 194; symbols, 30, 62, 63, 112, 157, 194

Rainbow Canyon/Etna Cave, 139

Rangely (Colorado) area, 117, 126–27

Red Linear style, about, 20. *See also* Pecos River style

Red Rock Canyon National Conservation Area, 139–41

Red Spring (Red Rock Canyon National Conservation Area), 140

representational styles, 7. *See also* anthropomorphs; astromomical motifs; zoomorphs

restoration. *See* preservation of sites

Rio Bonito Petroglyph Trail, 166

Rio Grande style: about, 34; illustration of, *32*

Rochester Creek style, about, 19

Rochester Panel, *7, 58, 69,* 200

rock art: as art, 56; as boundary markers, 56; as calendars, 54;

237

ABOUT THE AUTHOR

Ronald D. Sanders was born and lived in Oregon most of his life. An accomplished author and lecturer, he wrote articles for many magazines and had a newspaper column in the *Springfield Herald*. He moved to Nevada in 1998. In researching *Rock Art Savvy*, he took extensive tours of western rock art sites. Mr. Sanders died of complications from diabetes shortly before the publication of this book.